DATE DUE

'04			

DEMCO 38-296

ELAINE DE KOONING

The Spirit of
Abstract Expressionism

SELECTED WRITINGS

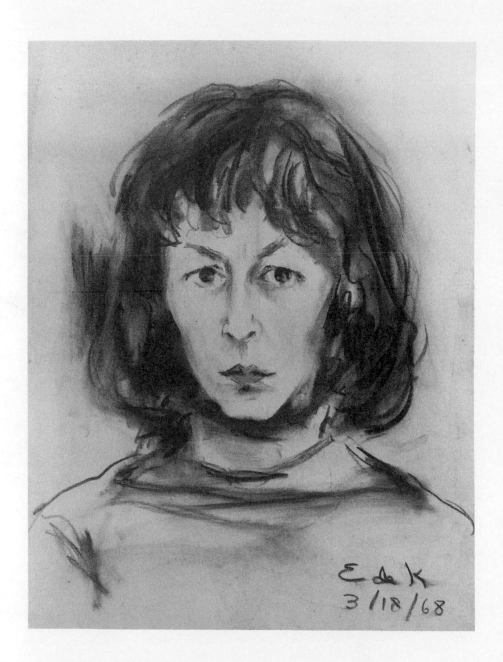

ELAINE DE KOONING

The Spirit of Abstract Expressionism

SELECTED WRITINGS

Essay by Rose Slivka

Preface by Marjorie Luyckx

GEORGE BRAZILLER NEW YORK

in 1994 by George Braziller, Inc.

by Rose Slivka copyright © 1993 by
says, see page 237, which constitutes
an extension of this copyright page. All photographs (except where noted)
are reproduced courtesy of Marjorie Luyckx.

For information, please address the publisher:

George Braziller, Inc.
60 Madison Avenue
New York, New York 10010

Library of Congress Cataloging-in-Publication Data:

de Kooning, Elaine.
 The spirit of abstract expressionism: selected writings/Elaine de
Kooning; preface by Marjorie Luyckx; essay by Rose Slivka.
 p. cm.
 Includes 28 critical essays, most published in *Art News* 1949–1967,
and previously unpublished selections from journals and letters.
 Includes bibliographical references.
 ISBN 0-8076-1337-1 (cloth)
 1. Abstract expressionism—United States. 2. Art, American.
3. Art, Modern—20th century—United States. I. Title.
N6512.5.A25D4 1993 93-36945
759.13'09'045—dc20 CIP

Frontispiece: Elaine de Kooning, *Self-portrait*, 1968,
charcoal on paper, 23¾ x 18 inches, Private collection

Design by Lundquist Design, New York

Printed and bound at Haddon Craftsmen, Scranton, Pennsylvania

First edition

CONTENTS

To what we shared in that special time. To the spirit of Abstract Expressionism, to the artists who formed her circle and sustained and inspired her.

Our thanks and acknowledgements go to Richard Minsky, Barbara Slate, Charlotte Slivka, Edmond Luyckx, Christopher Luyckx, and Isabelle Mertens for their encouragement and suggestions, and to Conrad Fried for his patient ear; to all those who provided information and permission to reproduce the illustrations in this volume: Rudolph Burckhardt, Lawrence DiCarlo, Jon L. Marberger, Ariel O'Hara, and Maureen O'Hara Smith; and to Adrienne Baxter, our editor at Braziller.

—M.L. and R.S.

Preface

Elaine de Kooning was a prolific writer. Between the long hours she spent painting and drawing, my sister wrote almost every day of her adult life. Not all of it for publication. She wrote in notebooks—all kinds and sizes, though never with lined pages (if they did have lines she ignored them). She had a tiny, clear handwriting and loved pens with fine writing tips. When she took on an assignment for an article, she would stop whenever an idea occurred to her during the day, no matter what she was doing, and jot it down. She would then lift whole sections from her notebooks for her articles, editing them meticulously, developing and augmenting her thoughts for publication. The right word was as vital to her as breathing.

In 1944 and 1945, when Edwin Denby was music critic for the *New York Herald Tribune,* Elaine often accompanied him to various ballet performances. (His apartment was around the corner from the studio where Elaine and Bill de Kooning were living at that time, and they were all great friends.) Denby was so impressed by her critical acumen that he began to send her to other theaters to cover the dance programs for him when more than one was being offered on the same night. They would later meet at the *Tribune* offices where the evening's critiques had to be submitted by midnight for inclusion in the next day's paper. Soon she was writing short reviews that were published in the *Tribune* over her initials, E. de K. In October 1946 she produced a feature article for *Mademoiselle* on all the ballet companies—their dancers, choreographers, impresarios, and theaters—on the New York scene that season. Writing under the aegis of Edwin Denby, who was a poet and a superb teacher, gave Elaine the basics that enabled her to apply her extraordinary critical gifts to covering the art world.

In 1945, long before she had ever published anything on art, Elaine was so excited by the Stuart Davis show at the Museum of Modern Art that she became curious about how he achieved his forms and began to write to clarify the works in her mind. She worked for a month and finally finished a ten-page article. She put it in Edwin Denby's mailbox. The next day she received a one-word telegram from Edwin: "Magnificent." She felt her mission was accomplished, put the article away, and didn't look at it again

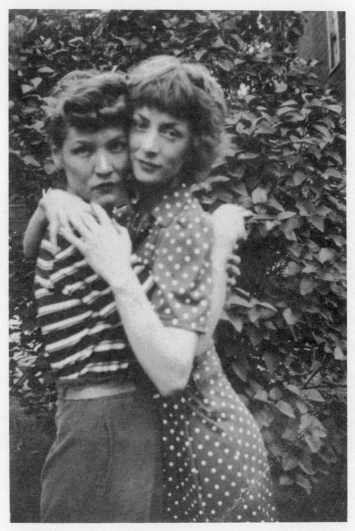

Marjorie Luyckx with her sister, Elaine de Kooning, c. 1944

until some twelve years later. Then she was writing regularly for *Art News* and Stuart Davis had a retrospective exhibition at the Walker Art Center in Minneapolis. She told Thomas B. Hess, then editor, about the article. He asked her to bring it up to date to include the current show. She called the piece "Stuart Davis: True to Life" and received a fan letter from the artist. We have included the article in this volume.

In 1948, Elaine commented to Renee Arb, a writer who reviewed Bill's first solo exhibition that year at the Egan Gallery, that she thought most of the criticism in *Art News* was amateurish, written by art history majors who

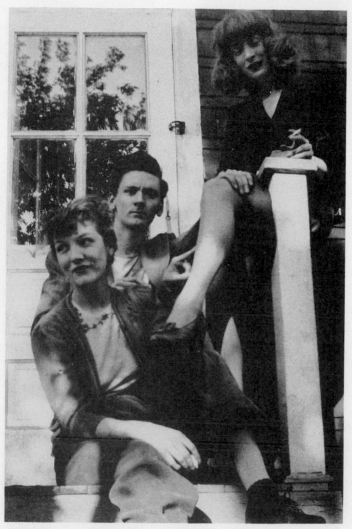

Marjorie Luyckx, Peter Fried, and Elaine de Kooning, c. 1939

knew little about art. When Renee repeated Elaine's observations to Tom Hess, he replied, "Tell her to come in and see me about writing some of her own." When she appeared at the office, Tom gave her a list of five shows to cover. Four of the artists she felt were mediocre to awful, though she wrote about them with care. The fifth was Alberto Giacometti, about whom she wrote an authoritative, passionate review, saying the exhibition seemed like the output of a civilization more than the work of one man. (She told me that Bill, too, was so moved by the show that he walked out of the gallery and around the block to quiet down—and then came back to

study the work more closely.) Tom evidently agreed with her opinions sufficiently to hire her as an editorial associate at *Art News* and handed her a list of twenty exhibitions to review for that month's issue. The policy of the magazine was for the reviewer to place the artist, describe the work, and then judge it. The pay was two dollars a review, whether it was two sentences or two hundred words long.

In writing those reviews and previews (covering work before a show was hung), Elaine was always conscious of the feelings of the artist. It was much more difficult to write about an artist's work, she once told me, if she went to the studio to view it instead of seeing it exposed on cold gallery walls. Seeing it in what was usually also the artist's living space, sometimes with his spouse and children present, and even sometimes under rather pathetic circumstances, made it difficult for her to separate the work from the life. She labored over each review, aware of the fact that three or four sentences might have to cover two or more years of work, and she resisted the temptation to pass off work that she didn't see much merit in with a quip. She carefully calculated why she didn't care for it, and searched for qualities others might find meritorious. Many of those tiny reviews that Elaine began to write in 1948 for *Art News* showed the extraordinary perception she was to exhibit in her later full-length articles.

In her painting Elaine was profoundly inspired by Arshile Gorky, nowhere more so than in her Black Mountain series, paintings she did in 1948 at the innovative college. Revering him, she wrote a superb analysis of his work and life in 1951, "Gorky: Painter of His Own Legend." Until then, few critics had fathomed the meaning and depth of his painting or the dark and arcane aspects of his life so perceptively. In her notes for that article, she wrote: "There are artists who stick pretty closely, like Mondrian, to one idea of form. Gorky could see everybody's. His talent and his temperament took care of his style. Unlike Mondrian, he loved the history of painting. He saw something wherever he looked. He saw Walt Disney. He saw the nasty coldness of lavender fluorescent lights. He saw the cheap, garish tints of Technicolor movies. He saw traffic lights and neon signs. His genius for seeing was breathtaking, for finally, he could see plants grow. If one is responsive at all to this man's work, it grows, it dazzles, finally it overwhelms. It becomes better and better, better than it is. Flaws vanish, every feature is exalted—the experience, like that of falling in love, allows no argument. One can only talk to someone who sees what he sees. No lover can prove his wild claims. He simply can find agreement with others who see, to the extent of their feelings, what he sees. Love, as an extension of consciousness, demands talent—seeing demands talent just as doing does."

In one of Elaine's unpublished notebooks, I found the following entry on the geometric abstractionist Burgoyne Diller, which shows the acuteness of her observations of the artist's life as well as his art. She had written the article "Diller Paints a Picture" for *Art News* in January 1953.

"Burgoyne Diller and his wife, a beautiful woman, were like a Scott Fitzgerald couple, tall, strikingly handsome, well-favored. Both of them drank to excess though always with the utmost good manners. Her couch, Rudy [Burckhardt] pointed out to me, was ominously full of burnt holes made by cigarettes.

"When I was interviewing Diller and Rudy was taking photographs of him and his work, we would often accompany him to a charming, neighborhood bar where we would eat smoked eel and Diller would drink boilermakers, one after the other. When I finally finished my article, I called Diller and asked if he would like to see it. 'There might be some detail you would want to correct,' I suggested. Diller was very pleased and when we met he told me that his dealer, Rose Fried, had said, 'Watch out for that Elaine de Kooning. She's one smart cookie and she's out to cut your throat.' I doubled up laughing, rather flattered at being thought of as 'one smart cookie.' He had some small but pertinent changes which I gratefully included, feeling they clarified points I was making. Diller was highly revered by artists. He had an important position with the WPA and his decisions were much admired. The last time I spoke to him, he had to keep turning away from me to hide his grimaces from the terrible pain he felt in his abdomen. Shortly afterward, he died of cirrhosis of the liver."

The only artist I can remember who disapproved of what Elaine wrote about him was Mark Rothko. He complained to Tom Hess that Elaine called him an "Action" painter in her article "Two Americans in Action: Franz Kline & Mark Rothko," published in the 1958 *Art News Annual*. The letter he wrote to Tom, dated November 14th of that year, states: "I reject that aspect of the article which classifies my work as 'Action Painting.' An artist herself, the author must know that to classify is to embalm. Real identity is incompatible with schools and categories, except by mutilation. To allude to my work as 'Action Painting' borders on the fantastic. No matter what modifications and adjustments are made to the meaning of the word action, 'Action Painting' is antithetical to the very look and spirit of my work. The work must be the final arbiter. Sincerely, Mark Rothko."[1]

In 1981, Elaine was interviewed on Rothko for the Archives of American Art and asked whether she applied the term to him "because it was coined in an *Art News* article and became a part of the *Art News* mythology?"

Elaine replied: "That wouldn't have mattered to me. What did matter was that Harold Rosenberg, who was a very close friend of mine, used it.

As a matter of fact, a year before Harold wrote his piece on Action painters [*Art News*, Dec. 1952], I wrote a piece on Arshile Gorky in which I spoke about how Gorky used his own autobiography in his work. Harold, who understood art only in terms of words, picked up the concept from my Gorky article—the idea of an artist using his own travail, and his role playing. The term 'Action Painter' I used because it had been kicking around the art world for some years and people knew then that it didn't mean style. It meant an attitude. It became a convenient term."

In 1953, when Elaine told Josef Albers she wanted to write a piece on him for *Art News* in the series "The Artist Paints a Picture" and that she would like to cover his color theories, Albers said, "I will make some paintings that express my color philosophy. I will call you when I have some work for you to see." Two weeks later, he invited her to his home. He did not have a studio and worked in his living room. He had made a great many small paintings on paper of a square within a square of another color. "I will call this series 'Homage to the Square,'" Albers said.[2] Rudy Burckhardt had come with her to photograph the paintings while she interviewed Albers, and he recalls that the painter kept chasing her around the table trying to kiss her, much to Rudy's amusement.

When Elaine wrote the catalogue essay for the Franz Kline retrospective shortly after he died in 1962, it was a gut-wrenching experience because she and Franz had been such very close friends. Her admiration and respect for him and his work finally surmounted the paralyzing grief and the article that finally emerged was remarkable. I remember endlessly calling and trying to appease her waiting editor as deadline after promised deadline passed into oblivion while she worked on, steadfastly refusing to let the article go until she was satisfied with every word of it. In it, she draws us into and reveals the magic underlying Kline's commanding caligraphic strokes.

Important as writing became to her sense of achievement, first and foremost, Elaine considered herself a painter. It was her principal occupation and the one on which she spent the most time. Aside from her published works, the voluminous writings in her notebooks are proof that verbalizing her thoughts was a very significant part of her being, but she painted almost from instinct. In doing a portrait she seemed to apply the brushstrokes in a wildly random manner and yet, sometimes suddenly, a startling likeness of the figure would emerge. If it didn't, she would set the canvas aside and begin on a second without changing the position of the sitter (and often a third or even a fourth). At the next sitting she would return to the earlier canvases and work on them until the likenesses she wanted came through— thus at times ending up with two, three, or four portraits of the same person in the same pose. Oddly, sometimes the likeness would appear immediately

after she began a portrait. She would also set it aside and begin another. Afraid of losing the image she had captured too easily, she would later return to the first canvas for completion. This happened in 1986 when she began the portrait of Aladar Marburger, her former student and subsequently her dealer. In her first charcoal sketch, she achieved so satisfying a likeness that in fear of losing it if she painted over it, she set it aside and began another, finally completing five canvases, each one an extraordinary resemblance. In the end, she portrayed much more than just the physical qualities of her subject. She captured what determined the character, the body language, the very being of the person, even when the portrait was faceless, as in her well-known series of "faceless" men. Often too, the work was more than a portrait; it was a well-composed painting in and of itself.

Elaine could write convincingly about artists in part because she was one. The following from her 1951 notebooks reveals her concern with the integrity and independence of the artist as a moral and mortal being:

"The artist . . . has only a sense of reality—the reality he makes for himself—the reality of his poetry or his way of seeing life. They are both without the sense of unreality that comes from accepting someone else's projection of what reality is. For the bureaucrat, reality is found in the morning newspaper—those disorderly and chaotic little facts that occur without reason, often affecting his life or his job. Reality is the radio with the advertisements that make claims that he accepts as false. Reality is the baseball game, Hollywood, Washington, D.C. Reality is conspicuous consumption. All of this, in short, is the reality that someone else has made for him.

"This to the artist is unreality which he either ignores like Poe, dispenses with like Thoreau, or uses for purposes of art like Faulkner, Gertrude Stein, or Scott Fitzgerald. For the sense of unreality to gain power or money in the unreal world, one must say, I take (choose) as my profession—then daring to do anything. Chance, therefore, comes into the life of the bureaucrat much more than it does into the life of the artist.

"The bureaucrat submits to, and if he's clever, learns to control forces outside himself. The artist doesn't fight them. He doesn't have to. He can ignore them. He controls everything, and going down to his premature grave, like Modigliani, or to his pauper's grave like Mondrian, or to a madman's grave like Van Gogh, he has won and has been successful. He didn't rebel against the world. The world rebelled against him and he didn't notice, except as one notices a fly that stings. The only thing the artist has to fight is time. The only luxury the artist knows is time. Like the bum on the Bowery, he assumes the utmost snobbery. He ignores life, but the bum doesn't project a substitute for life, whereas the artist does. He is a participant to that extent. He says to life, look, here's something else—and every now and then, someone does look. . . .

" . . . The character of bureaucratic art is determined, not by telling the artist what he must paint, but what he mustn't. This accounts for the curious, spurious, saccharine expression—the art of frightened men. The tyrannies of the present differ in this way from those of the past. In the past, the tyrant was stronger and so he gave his orders and he wanted something to boost his force. Now the tyrant doesn't want a boost from art. He just doesn't want to be attacked and he knows attack doesn't come from obvious subject matter, like Diego Rivera's silly little revolt. The dangerous people are those who think for themselves. Abstract Art in no way comments on the absurdity of bureaucracy and yet they are ten times more afraid of it than they are of left-wing painters who can be bought for a dime a dozen. But you can't buy a tough, hard, bitter guy like Gorky or Bill or Stuart Davis."[3]

Elaine's memoirs divulge the details of her life and work from her point of view.[4] Meanwhile, I see her from a relationship as sisters that was particularly close. With only eighteen months separating us in age, we shared a room and a bed and even much of our clothing. Our tastes in books, in people we knew, in friendships we developed, in places we went to, in games we played as children, seemed to be hinged on a single pole with only minor differences. (In high school in Brooklyn she went in for field hockey and was a star. I went in for swimming and made the team, but together we were the only two female students at Erasmus Hall who could climb the ropes all the way to the gymnasium ceiling.)

Being a year and a half older, however, gave Elaine an edge that made her the leader and me the follower in most, if not all, our early undertakings. She was bolder, more fearless, though my fears did not keep me from following her, almost as boldly, into any situation. Our relationship with our brothers, Conrad and Peter, was very close, too, and remained so throughout our lives, though we didn't share quite the same intimate confidences. Early on, the family symbiosis became so strong that, in my early twenties, I decided to strike out on my own and went abroad (with the Foreign Service of the U.S. State Department), intending to stay for a couple of years, though I stayed away for eight. It really didn't make any difference. All the time I was gone, we wrote regularly and in great detail of our daily doings, and on my final return, were as close as we ever had been, though we were both married by then. Even our spouses didn't share in all of the intimacies and opinions we confided in each other. We spent time together, or spoke on the telephone every day.

Elaine's physical beauty was only surpassed by the beauty of her character, her wit, her intellectual gifts, her ability to see beauty and talent in others and to recognize and praise them. She would often, literally with her last penny, purchase a small work from an artist whom she felt needed apprecia-

tion even more than the meager sum he asked for the work. When Elaine was fifteen years old, she read an essay she had written to her high school English class. The head of the English department was standing in the back of the room, and when she finished he walked over to her and whispered, "You have a beautiful soul." How smart and right he was.

—Marjorie Luyckx

1 Citation from a letter by Mark Rothko to the editors of *Art News*, November 14, 1958. Copy in the collection of Elaine de Kooning's papers.

2 Elaine conveyed this story to me; it is corroborated by her diary entries of 1953.

3 Citation from Elaine de Kooning's notes.

4 Elaine had been feeding her diary activities into her computer, using her diary (notebooks), which she kept from the early forties until her death in 1989, to record details and factual data. In those notebooks she entered conversations, opinions (her own and others') on exhibitions, theater productions, movies, books she and Bill were reading, as well as the myriad day-to-day events that shaped their marriage and their lives over the years. She did not make entries in the computer in chronological, nor in any other kind of order, but would pull the memories randomly from her head, recording them as one thought led to another, but was far from completing the history she wanted to publish when her final illness precluded the realization of that plan. For the past several years, I have been preparing these computer records and notebooks (over two hundred of them) for publication.

Essay

Elaine de Kooning belongs at the center of the great American art movement—Abstract Expressionism—as it emerged in New York in the 1940s and 1950s and galvanized international culture. As an artist, a writer, and the wife of painter Willem de Kooning, himself a seminal figure of the movement, she lived at the source. She became not only its interpreter, she became its very voice.

Historically, the stature of Elaine de Kooning is similar to that of George Sand, the daring nineteenth-century French writer and feminist who helped create the cultural climate of her day and whose love affairs, with Frédéric Chopin and other artists, were legendary. Elaine also recalls Frida Kahlo, the brilliant and heroic Mexican painter and wife of the great Mexican muralist Diego Rivera. Through their work and their lives, all three artists—all glamorous and brilliant women—were the mediums through which their time expressed itself.

Elaine de Kooning found her artistic roots, both as a painter and as a writer, in the New York School of the forties and fifties. A complex woman with wide-ranging relationships, she was noted for her intelligence, wit, charisma, and beauty. The poet Frank O'Hara called her "the White Goddess: she knew everything . . . and we all adored (and adore) her."[1] John Canaday, in a *New York Times* article, referred to her as Abstract Expressionism's "mascot, sybil, and recording secretary."[2]

"E de K," as she signed her paintings, entered the New York art world in the late thirties when the artists were simply a group of friends who had gotten to know each other through the art projects of the WPA during the Depression. They saw each other downtown, in the area below 14th Street and around Washington Square, since they tended to live in the same neighborhoods. They met in cafeterias where they could sit for hours over a cup of coffee and talk art and ideas.

At Bickford's and Stewart's cafeterias on Fourth Avenue near 8th Street they could count on getting together in an easy, haphazard social environment that involved no planning, but supplied an offhand gait of random routine and fortuitous accident. The cafeterias allowed for freedom of asso-

ciation, both in people and ideas, and spontaneity in the talk and the thought that marked their exchanges. Those who were not in military service during World War II continued to meet there, and were joined later by the others who returned from the war. The postwar spirit in New York, as in the rest of America, was ebullient.

Several of the artists—such as Willem de Kooning, Arshile Gorky, Landis Lewitin, Aristodimos Kaldis, and Hans Hofmann—were from Europe and were deeply conscious in a New World of newness, rawness, the fast obsolescence of things and ideas—throw it out, start over, make it new, make it

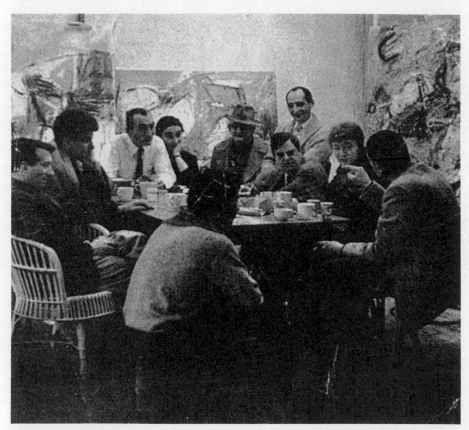

Photograph published in *Life* magazine with the following caption: "Stronghold of abstract expressionism is New York City's Tenth Street where artists congregate in studios and galleries to talk over their ideas. This group gathered for coffee in the studio of Milton Resnick *(in white shirt, rear)* whose seething, heavily textured paintings lean against the wall." Members of the group, from left to right: Jimmy Rosati, Giorgio Spaventi, Milton Resnick, Pat Passloff, Earl Kerkam (wearing a hat), Ludwig Sander, Angelo Ippolito, Elaine de Kooning. The two figures with their backs to the camera are unidentified. Photo by James Burke. *Life* magazine © Time Warner.

up as you go along—where "ugliness" and chaos, traditionally considered negative influences, could become positive forces of inspiration. The climate was one of exhilaration, experimentation, and readiness for the unexpected. Improvization became the new aesthetic. Jazz had already given it a unique American place.

The improvisatory character of New York itself made an environment where everything and anything was possible; where a cigarette butt next to a crack in the sidewalk had as much reality as a part of city life as the omnipresent spire of the Empire State Building; where there were no trees or air or natural scenery; where you felt your back was up against the wall and the only place to look was inside yourself.

New York, furthermore, was the place that people from the rest of the country and people from the world spilled into, hoping to realize their dreams, willing to put up with its harshness and risks. New York was people, the contagion of human energy; it was about artists living close to each other, the continuity of communication, the camaraderie of a high-pitched time of creative excitement.

Up and down East Tenth Street, in particular, one could see more artists running in and out of each other's studios than at any other time before or since. They included painters Esteban Vicente, Milton Resnick, Willem de Kooning, sculptors Giorgio Spaventa, Phillip Pavia, to name a few. Artists' cooperative galleries, such as the Tanager, made history, if not money. As things began to look up, the artists graduated from coffee in the cafeterias to booze at the Cedar Bar. At the newly formed Artists' Club, shepherded by Phillip Pavia, they met like religion every Friday night for panel discussions, to be lectured at, to talk, to gossip, to argue, to dance, having talked, lectured, argued, gossiped, and danced the other six days.[3]

They met to think it all out together, although they agreed it did not have one look—it had the look of its individual makers. Arshile Gorky did not look like Bill de Kooning, who did not look like Mark Rothko, who did not look like Franz Kline, who did not look like Barnett Newman, who did not look like Jackson Pollock, who did not look like Clyfford Still, who did not look like Robert Motherwell—all of whom were the major painters of what would be called Abstract Expressionism, Action Painting, or the New York School.

They also agreed that theirs was a transvisual movement, that they wanted to get beyond the surface to the authentic, to paint the forces of the unconscious at the same time as they gave full presence to the nature of paint, how it was applied at that moment in the life of the artist and what it did as a material in the process of painting, including the "accident" of the drip.

Essentially, Abstract Expressionism was America's last great spiritual move-

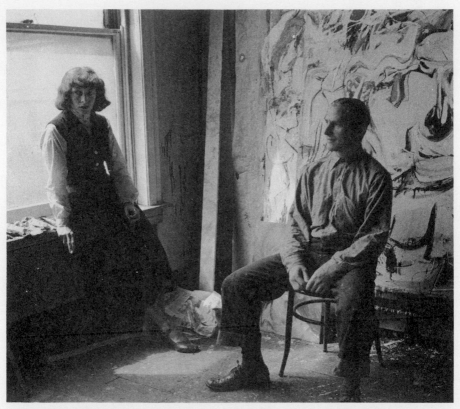

Elaine and Willem de Kooning in the latter's studio on Fourth Avenue, c. 1948-49

ment as it expressed itself in art. It aimed to transcend the visible and reach the visionary, to make the unseeable seen, to paint the unpaintable and the so-far unpainted. It was grounded in the relationship between the body of the artist and the canvas, the object of the act of art, between the spontaneous gesture and the completed painting. In his essay "The Tradition of the New," the group's best known critic, Harold Rosenberg, described the new vision. For these artists, the canvas now appeared "as an arena in which to act rather than as a space in which to reproduce, redesign, analyze, or 'express' an object, actual or imagined. What was to go on the canvas was not a picture but an event." This, Rosenberg wrote, was "Action Painting."

In 1952, when Rosenberg's landmark essay appeared in *Art News*, you could see all the exhibitions there were to be seen on a lunch hour and still have time for lunch. The American artist had little expectation of recognition and success, at that time still the province of Picasso, Paris, and the dead. Europeans and others of the culture elite still considered New York

just a dirty, vulgar city and the New York artist hopeless. Willem and Elaine de Kooning were members of the New York band of the hopeless. Bill had arrived as a stowaway from Rotterdam in 1926. What happened afterward, as Elaine said, was beyond their wildest dreams.

She was born Elaine Marie Catherine to Marie and Charles Fried on March 12, 1918, in Sheepshead Bay, Brooklyn, the first of four children—Marjorie, Conrad, and Peter, each about a year apart. It was a close-knit family, but Elaine's relationship with her sister, Marjorie, was especially close.

In 1938, at age twenty, Elaine Fried arrived in Manhattan from Brooklyn to live and study art. From age five, when her mother began to take her once a week to the Metropolitan Museum of Art, she had yearned to become a painter. She attended Erasmus High School where, she said, "all the bright Brooklyn kids went," where she shone both in mathematics and writing. But art was her love and she drew voraciously, particularly on the family farm in upstate New York.

On graduation from high school, Elaine entered Hunter College, where she planned to major in mathematics, but she dropped out after a few weeks in order to enroll in both the Leonardo da Vinci Art School and the American Artists School, the two institutions popular among young artists at the time. Bob Jonas, director of the Leonardo da Vinci Art School, introduced her to Willem de Kooning as the painter he considered the most gifted.

Alluring and vivacious, Elaine was the object of romantic attention from all quarters. Her first liaison was with the painter Milton Resnick, but it was not long before Bill de Kooning made his presence felt. Elaine was soon attracted not only by his fervent pursuit of her but by the sheer force of his artistic power. In addition, he was strikingly handsome. When he offered to become her teacher and invited her to paint in his own studio, she was thrilled. It was no surprise to anyone when they became lovers.

The two of them had it all—brains, beauty, youth, health, energy, drive. Bill's blonde aquiline head, intense blue eyes, and suggestive smile, along with the magnetism of a man obsessed by creative struggle, made him deeply attractive to women, and their pursuit of him met no resistance. In fact, the pursued was also the pursuer. He told me the two great loves of his life were painting and women. He described to me how, in the early days, he used to sit in the cafeterias, over his cup of coffee, just watching the women, too shy to say hello, making up scenes about this one and that one.

During one of our many conversations over the years, Elaine described two strong influences on her: her husband's and that of the couple's close friend Arshile Gorky. "I was already deep into being an artist [in the war years]." she said. "I regarded Bill as a master. He was up there on Mount Olympus. He and Arshile Gorky were tremendous guides to me. They

worked abstractly as well as with so-called figurative imagery. Their reverence and knowledge of their materials, their constant attention to art of the past and to everything around them simultaneously, established for me that whole level of consciousness as the way an artist should be."[4]

Living a bohemian life in Manhattan, Elaine Fried was the belle of the ball. Nevertheless, she loved her family and was a loyal participant in its traditions. Every Sunday without fail, she went home to gather with her family and the friends they invited to the house. It was not long before she brought Bill to Sheepshead Bay for the ritual Sunday dinner. Although her mother, whom Elaine adored, was uncertain of whether Bill was worthy of her daughter, Bill persisted and in 1943 they were married. His peers already recognized Bill as an outstanding artist. They were an extraordinary couple and everyone around them knew it.

In 1947 Elaine accompanied her husband to Black Mountain College in North Carolina, the short-lived but influential experimental art school directed by Josef Albers. There she met and became friends with John Cage and Merce Cunningham, and deepened her friendship with others who would become leading thinkers and artists—among them, Buckminster Fuller, Franz Kline, Esteban Vicente, and Jack Tworkov.

At Black Mountain, Elaine painted a series of oils on brown wrapping paper, remarkable biomorphic abstractions that were forgotten until recently when they were shown at the Joan Washburn Gallery. While they clearly showed the influence of both Bill de Kooning and Arshile Gorky, as well as the European Surrealists Joan Miró and Hans Arp, they also had the "E de K" mark of fierce scrutiny and fresh insight that was to characterize her work for the next forty years.

Elaine drew and painted incessantly, doing both abstractions as well as still lifes, cityscapes, and portraits, famous now for the ones she did of her young husband, Bill. These were followed in 1949–1956 by the "faceless men" paintings, a series distinguished for the recognizability of their subjects, marked by characteristic body stance that Elaine captured. Throughout the years, she continued to paint portraits of both the famous and the unknown. They reflected her wide circle of friends and admirers, including the critic Harold Rosenberg, the *Art News* editor Tom Hess, the poets Frank O'Hara and John Ashbery, the artists Aristodimos Kaldis and Fairfield Porter, and her most famous subject, President John F. Kennedy.

In 1948, Elaine began writing for *Art News*, the leading art magazine of the day. In this, she was encouraged by the poet Edwin Denby, dance critic for the *New York Herald Tribune*, and by Tom Hess, himself an outstanding writer on Abstract Expressionism. In her many articles for *Art News* and other magazines, she became one of the foremost voices of the New York

School. She was, in fact, the first in the new American art world of the fifties to take on the unique role of the artist-critic, one that is now in wide practice.

Until Fairfield Porter joined her at *Art News* in 1955, Elaine was the only artist writing art criticism for publication. It was all new. The creative activity in New York City was at a white heat. As a writer, she brought her instinct for the culture, her perception and learning, her love of the language, and her innate hunger for ideas to her generation of artists and readers. Of the roughly one hundred articles Elaine wrote between 1948 and 1988, the year before her death, twenty-eight are included in this volume. As an Abstract Expressionist painter herself, she wrote from inside the group, sharing the special friendship and confidence of the artists in each other, having access to their studios, and learning the thoughts and techniques artists reserve only for each other. As the wife of Willem de Kooning, the artist many consider to be the greatest of our time, she lived in the very core of the New York School of the fifties and was clued into its thinking at its source.

The selection in this volume of Elaine's written essays and taped discussions with her colleagues shows the very spirit of an American time as it continues in the present. Not only does the list of artists about whom Elaine wrote—and as seen in this book—read like a Who's Who of the fifties and sixties, but her pieces are as valuable and lively today as they were yesterday. Indeed they have even greater impact, their wit and truth having been enlarged through time, making them perhaps even more pertinent now in the nineties, a time in search of authentic values.

"You really can't have Whitman's open road run through the parlor without changing the look of things," she said in one of the most perceptive critical essays ever written on the work of Stuart Davis.

In "Hans Hofmann Paints a Picture," she brings us one of the primary artists of Abstract Expressionism in vivid cinematic reality, as she does the vastly under-recognized Earl Kerkam in another essay.

In "A Cahier Leaf: Prejudices, Preferences, and Preoccupations," she laughs in various places at critics and artists: "May we be preserved from painting in English. . . . Flat painting is a great bore. Also it doesn't exist, it just thinks it does. . . . A finished painting is—or should be—a reminder of what not to do again."

On the subject of red: ". . . if red is blood or wine or a rose or a box of matches or a muleta or earth, if red is smeared or dripped or dragged or glazed or spattered or troweled on, it makes all the difference in the world to red. Red can be tormented or serene or ecclesiastical. Red can be anything it wants. Likewise yellow, blue, green, black, etc. Every color has a

million ideas about itself—but fortunately desire has veto power, otherwise nothing would ever get painted."[5]

In "Pure Paints a Picture," her burlesque of the most extreme abstractionist (whom many have identified with Ad Reinhardt), her fictional character Pure explains his aesthetic: "'A painting must have no color,' explains Pure; therefore his shelves are lined with tubes of color that he never touches. . . . 'Furthermore,' he says, 'the more pure your art is the more you can give less. . . .'"

Among her most lyrical writings is her heartfelt account of Gorky's untimely death in "Gorky: Painter of His Own Legend." Still, it does not repress the wit of her observations, which she mixes with her sense of the tragedy: "Tense, unsmiling, and convivial, Gorky's passage through life, like his passage through museums, was not self-effacing. Like many a good artist before him, he regarded himself with a warm biographical interest which led him to fabricate or embellish incidents of his personal history, shuffle a few dates on his paintings. . . . A biography, as Arshile saw it, like a beard or a moustache, was something convenient to hide behind. . . ."

Her watershed essay, "Franz Kline: Painter of His Own Life," a mixture of comic observation, deep knowledge, and absolute intuition, describes the artist's relationship to his materials. It illuminates the mystique of Kline's powerful stroke and authentic spontaneity: "He bought housepainter's brushes and enamels in a hardware store since artists' brushes didn't come in large enough sizes and artist's colors were much too expensive in terms of the quantities he needed and, more important, they were the wrong consistency—not fluid enough for his needs. His image was immediately conditioned by the properties of the enamel—the drag on the brush caused by quick drying, the coarse and uneven textures that record the speed and the weight of the stroke, the predictable thickening of the whites and shifts from mat to shiny in the blacks. No matter how simplified his imagery, it was never facile (like that of some of his followers on both sides of the Atlantic). Part of its tension, for the first few years, comes from his fight with intractable materials. . . . It was Kline's unique gift to be able to translate the character and the speed of a one-inch flick of the wrist to a brushstroke magnified a hundred times. . . ."

Elaine de Kooning was the critic whose criticism I most valued in my own work as art writer. She would encourage me to "open the doors of seeing," pointing out that it was more important to see what was there as a positive act than to make negative comments on what was not there. It was a principle she herself had followed during her own years as an art writer, in the spirit of her mother, Marie, who told her, "I am superior only to the people who think they're superior to me."

I first saw Elaine in 1951 on Eighth Street. It was a spring evening and I was drawn to the figure of a young woman in black with a black lace shawl over her red-blonde hair, with large, flashing eyes, luminous white skin, and bright red lips, walking rapidly toward me. Her eyes lit with distance in anticipation of the place toward which she hurried. She did not see me as she passed, eager, avid, radiating the energy of her excitement. She was so striking as she rushed on to her adventure, probably a party where she would dance, drink, and laugh, enjoying herself in her distinctly gifted way. I was so new to the art world that I did not yet know who she was. The friend I was with saw me staring and said, "That must be Elaine de Kooning." The last time I saw her was in the hospital, a few days before she died.

Over the years, Elaine and I got to know each other during winters in the city and summers in East Hampton. Summer was the signal for exodus from New York, with many artists going there or to Provincetown or similar watering holes. Elaine and Bill spent their first summer in East Hampton in 1952 as the houseguests of Leo Castelli and Ileana Sonnabend, the New York art dealers, then married to each other. Also sharing the extraordinary household that summer was John Graham, the White Russian emigré painter, married to Ileana's mother. Graham and the de Koonings became fast friends, all of them returning to the Castelli household the following summer. In the early artists' baseball games, now charity events in East Hampton but started in this period simply for fun, Elaine was a memorable baseman, scoring home runs galore by hook or crook, mostly by crook. Her teammates included the sculptor Wilfred Zogbaum and the painters Joan Mitchell, James Brooks, Charlotte Park, John Little, Larry Rivers, and Howard Kanovitz, among others.

In 1954, the de Koonings rented what was known as the "Red House" in Bridgehampton, sharing it with Kline and the painter Ludwig Sander. It was the house where Willem painted outhouse toilet seats as decorations for the great croquet party of that summer. Elaine made crepe paper flowers, attached them to the trees, and sprayed them with perfume. Years later the forgotten toilet seats, acquired by an East End art lover, were put up for sale as paintings, raising a brouhaha over their artistic and monetary value.

The subject of the wife-as-artist came up many times over the years, not an easy one to resolve. Elaine relished the genius of her husband, supported his efforts, and did her best to promote his art long before it was generally recognized, as did her friend Lee Krasner for her husband, Jackson Pollock. Neither did Elaine hide her own aspirations as a painter, although she discovered, much to her chagrin, that the dealers, curators, collectors, and writers who sought out Willem were not interested in the artist's wife. As a matter of fact, being the wife of the most admired artist in America did not

help her own career, and she did not receive real recognition for her own achievements until a few years before she died.

Although her relationship to Bill went through many changes over the more than fifty years they knew each other, Elaine always acknowledged Bill as her greatest influence and her original teacher. When asked, "How does it feel to be an artist yourself and to have to work in the shadow of your husband?" she replied, "I don't work in his shadow. I work in his light." On the other hand, there is no question that, as de Kooning's wife, she could share in his fame, but as an artist in her own right she had her own struggle to achieve serious recognition.

And when the time came for someone to rescue Bill from his alcoholism, it was Elaine who was able to step in and make his sobriety stick, although others had tried and failed. Bill owes his life to Elaine. But in day-to-day life there was not the slightest chance that, as a wife, she would put on an apron, cook, and serve. If he said, "I'm hungry," she said, "So am I." Between the roles of traditional artist's wife and artist, she chose the latter. Early in their marriage, Bill turned to Elaine and said, "We live like a couple of bachelor roommates. What we need is a wife."

Elise Asher, the painter and wife of Stanley Kunitz, the poet, tells of meeting Elaine and Lee Krasner together one day on the street in 1951 when she, herself, had just arrived in New York. "They seemed so knowing, so strong, so in it and of it, so absolutely sure, so central and in the center, I was overwhelmed and couldn't say a word in front of these powerful women."

The de Koonings spent some twenty years, from 1957 until 1977, living apart, each involved in private affairs. Bill's daughter, Lisa, was born to Joan Ward in 1956. In 1957, Elaine left New York to teach at the University of New Mexico. It was the first of many guest teaching positions throughout the country, work that meant she was in the New York she so loved only intermittently, depending on her schedule. Nevertheless, Elaine continued to keep in touch with Bill, maintaining her studio in the same building as his on Twelfth Street and Broadway, as well as a weekend house near his in East Hampton. In 1974, she moved her entire studio from New York to another house on Alewives Brook Road where she painted and took care of art world business both for herself and Bill, and provided hospitality to her many friends, students, and admirers who came to visit from all over. In 1977, she returned to live with Bill at the house and studio he had built in 1964 on Woodbine Drive in the Springs, a part of East Hampton. Although they maintained separate houses and working places, his studio was only a five-minute drive away from hers, and she joined him at Woodbine Drive every night.

In the thirty-by-fifty-six-foot studio she added to her Alewives Brook Road house in 1978, with its seventeen-foot-high ceiling and north sky-

light wall, paintings leaned against every available wall and easel; stainless steel tables were covered with paintbrushes, buckets, rags, and jars, and the Nine Lives cat food tins and Bumblebee tuna fish cans in which she mixed her colors. The room that bridged the house and studio served as the office, with its chairs, couch, round table, desk covered with piles of papers, books, magazines, announcements, lists of things to do, letters, clippings, drawings, sketches, and large calendar with notations for every day of the month. The house was shaded by the same foliage seen in many of her paintings. She used to say, "I found this house with surroundings that look like a continuation of my painting."

A true New Yorker, Elaine functioned best in a many-faceted environment. What for others would have been fragmentation and chaos, for her was the source of creative thinking, the place where she was centered. Elaine's impulse was to include everything, even if it meant working in a turmoil of contradictions. "For this, you need the temperament for chaos," she said. The idea was to keep everything going at the same time, not eliminate anything, keep open, give all ideas that happen a chance to come through to self-illumination.

She was able to work surrounded by people and phone calls, a large and close family including six nephews and two nieces, five dogs, four cats, and a retinue of other people's children who adopted her. On a not unusual day she could fly up to Stamford, Connecticut, to have lunch with Minna Daniel,[6] John Cage, Merce Cunningham, and John Ashbery, and get back by 6 P.M. in time for her old friend Ibram Lassaw's opening at Guild Hall, then go on to a dinner party. On the other hand, she frequently cut herself off by shutting the studio door, not answering the phone, and working on her art in seclusion.

Her "Inadvertent Collection" of over a thousand artworks was accumulated over the last fifty years (the first one having been a trade with Milton Resnick in 1939), and consists of birthday gifts to her, as well as her own purchases to help friends and strangers who attracted her precise and joyous eye. By nature, she was not a collector. One day she was surprised to discover how many works of art had somehow found their way into her keeping. They had been given to her either in tribute or gratitude for the help she had given a young artist. In many cases she had purchased the work to help a friend who either needed the moral encouragement or the money and usually both.

To watch Elaine de Kooning paint was to see muscle-memory at work, the act of painting stamped into her body rhythms and stance, her arm and head gestures. I once said to her, "You make it up as you go along. You must trust yourself." She said, "Trust is the key word. When I do something I didn't expect or consciously intend to be doing, it's not accident. I have to

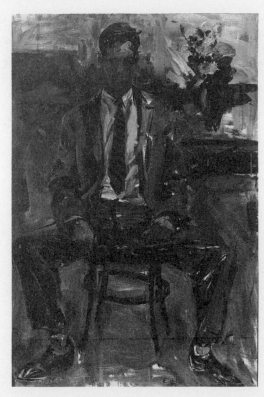

Elaine de Kooning,
Fairfield Porter, 1954,
oil on canvas,
49 x 31⅞". Courtesy of the Estate
of Elaine de Kooning.

recognize what's going on." She described her version of Action Painting. "When I start, I don't know what's going to happen. I begin by resisting what I think I already know, so that I can find out what I know that I didn't know I knew. It's mysterious. I want something there that's more than just the visual." At another time, to the question of how she made her decisions during the act of painting, she said, "When you're dancing, you don't stop to think: now I'll take this step, now that. You allow it to flow."

A serial painter, Elaine worked on her seated portraits of faceless men for seven years (1949–1956), her bullfight series for six years (1957–1963), her basketball and baseball series during the 1960s, paintings of the red Japanese maple tree in East Hampton painter Hedda Sterne's garden, Greek and Italian landscapes, and the theme of Bacchus for seven years (1976–1983) before becoming consumed by her cave series, inspired by Lascaux and begun in 1983. Throughout, she continued to make portraits, of which her series on President John F. Kennedy was commissioned by the White House in 1962. Her last portraits were of her beloved friend and former student Aladar Marberger, the late director of the Fischbach Gallery.

In 1957 she went to Albuquerque to teach at the University of New Mexico, and began the epic six-year series of bullfight paintings in ink

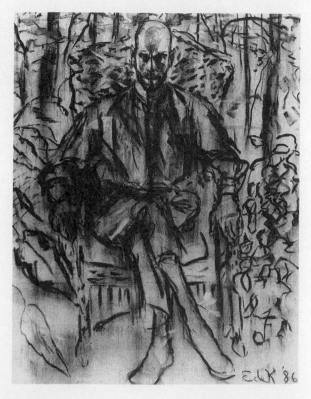

Elaine de Kooning,
Aladar #2, 1986,
charcoal on canvas,
60 x 46". Courtesy of the
Marberger Collection.

washes, watercolors, lithographs, and oils, her canvases ranging in size from ten inches to ten feet. Still among her most brilliant works, they are vivid, densely stroked, charged with the spirit of Abstract Expressionism and the landscape. She alternated throughout her work between the horizontal sweep and the vertical reach, the visible and the invisible, the emerging and the disappearing. The vertical aspiration of the basketball series was followed by the bull charging the horizon of the landscape or the arena of the bull ring, the image sweeping across the earth. Later, inspired by a nineteenth-century sculpture of Bacchus that she saw in the Luxembourg Gardens of Paris, she created a Baroque configuration, building and balancing it to its apex; it was followed with the final overall resolution of vertical and horizontal themes as they came together in the cave paintings, encompassing, as they did, first and last knowledge, the beginning and end of art and humanity, a subject that absorbed her in her last years. Ultimately, however, the subject is the same: thinking about painting and painting about thinking—the highest, most mysterious, and aesthetic human activity, moving to the rhythms of the painting, with the painting a demonstrable sign, a souvenir of the process, its metaphor. Elaine de Kooning made painting her surrogate universe of light and speculation.

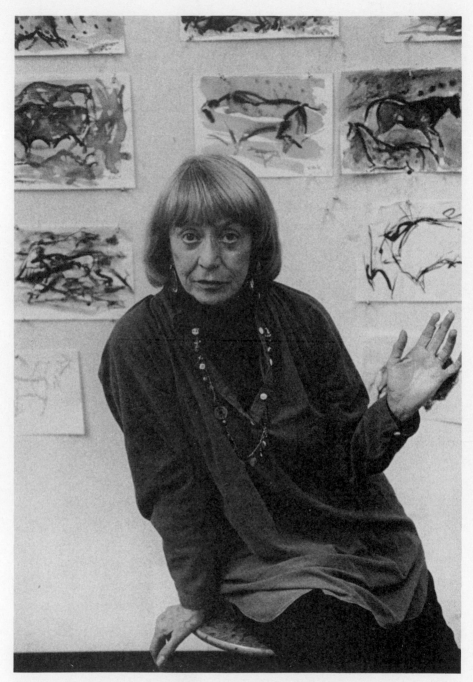

Elaine de Kooning in front of some of her many cave paintings, c. 1984.

In 1983 Elaine went to see the cave paintings in the Pyrenees Mountains of France, made some 25,000 years ago in the Dordogne Valley. Lascaux, outside the town of Les Eyzies, was the height of the experience, with its vivid polychrome paintings and engravings of the animals that inhabited the Cro-Magnon world. There, inside the pitted and dripping limestone walls—their contours and textures, accidents and attritions of the geological environment, joined with the energies and mysteries of the Paleolithic imagination—she encountered her own ties to art's beginnings, the striking parallels between the working methods of the earliest artists with that of her own way of painting, and the root nature of Abstract Expressionism. It was a galvanizing experience, further charged by the panoramic scale and pictographic complexity of the walls themselves. That summer, directly on her return to her studio in East Hampton, she began a new series, her cave paintings, that would occupy her for the rest of her life.

In the Paleolithic sensibility Elaine found the same stunning urgency that she had in Abstract Expressionism, whose roots she affirmed in her own work, in the same improvisational processes and techniques, in the same spontaneous energies, impulses, and actions. In the nonillusionistic relation of Paleolithic art to the surface on which it is inscribed, she found it close in spirit to twentieth-century art. "In a way, cave art is closer to what's happening today," she said, "in the immediacy of the application than, let's say Renaissance art where you feel, 'Well, that was then.' You don't say, 'That was then' with the caves. You say, 'That's now.' It has more to do with graffiti than with anything in between.

"I felt a tremendous identification with those Paleolithic artists," she said. "I found myself deep in the caves imagining that I was one of them, looking for surfaces smooth enough to paint on, noticing chunks of yellow clay on the ground that would be perfect to draw with. How alive their animals must have looked to them in the flickering dim light of their torches. And I loved their high-handed way with scale, juxtaposing huge and tiny creatures, with fragmented images—and always, always in profile.

"Prehistoric art was secret—hidden way deep as though they didn't want you to find it. The first two caves we visited—Niaux and Bedheilac—were vast cathedral spaces and we had to walk, it seemed for miles, before we arrived at the first images. The cave walls with their splotches of red and ochre or gleaming white calcium deposits, their rolling turbulent forms and intricate cracks and crevices seemed to be teeming with animals before I saw my first actual prehistoric drawing. When I did see it, a crude and powerful bison, I was overwhelmed by its unexpected immediacy."

The cave paintings and the way Elaine de Kooning perceived them were directly connected to her own history. As a child, on her family farm in

upstate New York, she began the avid study of animals she continued through her last years, making countless pencil, pen, and watercolor sketches of cows and bulls at rest and in motion, early drawings already showing her facility and concentration. On her travels in this country and in Europe, Japan, and China, she always went to the zoos with her sketch pad, inks, and brushes.

In 1985, I accompanied her to the caves in the Spanish Pyrenees, the most spectacular being Altamira with its incredibly sophisticated renderings of bulls and bison. There, again, she reconfirmed her initial experience at Lascaux and the smaller surrounding caves. We saw what the first human-ized species had seen millenia before. In the same darkness that closed in on the flickering light, in searching out in the dim light for the meaning of where we were, we could see all kinds of imaginary forms in the bulges and cracks of the stratified limestone. Study a crack long enough, said Leonardo, and you will see the world. We could imagine the first Cro-Magnon artist seeing his imaginary animals emerging in the dark from the cracks, con-tours, spaces, and then, through a leap of visual genius, conceiving the idea of adding color and line to the contours. Groping to consciousness in the course of humanization, the artist made art.

The geological formations and textures of the cave walls were Elaine's equivalent for her ground of flying color, drips, washes, and strokes, animal forms and drawings rising out of its contours. They gave the affirmation to her own way of working, and became a culmination, a coming together from her whole life, of her ways of working, of action painting, with its ambiguities, erasures, interplay of contour, surface, line, slash, smudge, dot, and drip. They triggered her new series of cave paintings, a combination of abstract painting and figurative drawing, as she perceived the cave walls themselves to be, with their abstract and random textures and colors, imagery emerging out of the surface action. Elaine's encounters with the caves was on as contemporary a level as her encounter with all great art.

Combing broad brushwork with concise strokes, deep forms with power-ful contours, volumes in some, transparencies in others, Elaine put every-thing in flux. The backgrounds do not describe the contours, rather they are more like terms and phrasings that twist a kind of harmonics with disso-nance. A line or a flurry of marks relate to the action of the form or to the form within the form as in many areas where she doubles the imagery echoing the caves. Forms and images, almost hidden, emerge with lines that seem to float. The drawings, whether embedded under the strokes or applied over, are essentialized with only the minimal lines of sure, swift def-inition. Always present is the ambiguity and interplay between painting and drawing, surface and contour, stroke and line, color and light, transparency and opacity. Her art is a performance. How she did it is what it is about.

Going to Altamira with Elaine was like no other travel experience. One of my most lasting memories of the trip was that it was better in general to do things with Elaine, to share experiences. You knew more about what had happened when you were with her. You got more ideas about whatever you saw and did. You laughed more. Everything was more real, everything was funnier. Elaine was a genius at life, accepting every one of its conflicting opportunities, juggling all chances, reckless with the love of it all and its high risk, contagious in her enthusiasm.

Elaine's first one-woman New York exhibition had been held at the celebrated Stable Gallery in 1954 followed by others at the Tibor de Nagy Gallery, then under the directorship of John Bernard Myers, the Graham Gallery, and the Gruenebaum Gallery. She had over fifty solo and group exhibitions in this country and throughout the world during the course of her prolific career. Although she was always considered gifted and charismatic, she began to receive wide recognition as a painter only after she reached the age of sixty. In 1987 and 1988, her cave paintings were given some ten one-woman shows, in cities such as New York, Los Angeles, Baltimore, Miami, and Berlin.

A popular teacher, with students following her to New York and East Hampton, Elaine taught at the University of New Mexico in Albuquerque between 1957 and 1962, when she returned to the East Coast to accept the White House commission to paint a portrait of President John F. Kennedy. In the years following, she accepted teaching positions at no less than fifteen universities, including Carnegie Mellon in Pittsburgh, Rice in Houston, the universities of Pennsylvania and Georgia, Yale University Graduate School, Pratt Institute, and the New York Studio School, established by the painter and teacher Mercedes Matter.

Her awards include honorary degrees of doctor of fine arts from art schools and universities nationwide, among them the University of Maryland, Adelphi, and Moore College of Arts. As a teacher, she held the esteemed position of Lamar Dodd Visiting Professor of Art at the University of Georgia; the Milton and Sally Avery Chair at Bard College in Annandale-on-Hudson, New York; and the Mellon Chairs at both Cooper Union in New York and the Carnegie Mellon Institute in Pittsburgh.

Elaine's last exhibition while she was alive opened in November 1988, at the Fischbach Gallery, showing her cave series and featuring *High Wall*. It was the long-awaited show arranged by Aladar Marberger, director of the gallery, who had tragically died of AIDS the previous month.

A heroic work considered by many to be her masterpiece, *High Wall* is a triptych nine feet high and nearly twenty feet wide on which she had worked for a year, completing it in the summer of 1988. With its churning, dappled, vertical flow of strokes and drips, it demonstrated her own lifelong

engagement as a painter with Abstract Expressionism and the insistent surfacing image. Color and contour became a part of each other engulfed in a radiant tonal sweep with open transparent areas and forms disappearing into the background. Elaine de Kooning was returning to the spontaneity and flow of her original watercolor sketches at Lascaux. It is as if she worked through all the phases of the last five years since she started the cave series to return to her beginnings.

In the winter of 1987, Elaine went to China with Courtney Sale of East Hampton, producer of the film on the work of Willem de Kooning for which Elaine was consultant and commentator. That trip resulted in a fresh outflow of Sumi paintings done with the black inks and brushes of China. Although probably the smallest, simplest, and most modest of her late works, they most clearly showed aspects of her thinking common to both her painting and writing. They revealed the true spirituality of her quest, one at the heart of Abstract Expressionism. The most austere, spare, and essentialized of her drawing/paintings, and created with no color other than the monochromatic variations in hue of the black Sumi inks, they distill what she had been working for. Embedded in layered washes on absorptive papers and in the interplay between the washes and direct strokes, the unseen emerges into an ambiguous visibility that is always on the edge of disappearing again. The Sumi paintings exist between shadow and light, among the weightless line, the radiance of water, and the dense light of the black, gray, and white tonalities. They are pure nuances of the spirit.

Elaine de Kooning's art and writing were always reflections on art, the nature of art, and human beginnings. She led her cave investigations like an explorer feeling out her own obsessive engagement with the nature of art; her writing was an extention of this exploration. For Elaine, everything was always new, never resolved, always being unmade and made, as if it had never been made before. She did not accumulate experience and learn what to expect. With a phenomenal memory for everything that had happened—and much had happened—she accumulated stories, wonderful stories. Life was a constant surprise.

In July of 1988, in order to check the last details of an article I was writing on Elaine's cave paintings for the December issue of *Art in America*, I went to see her at her studio in East Hampton. We talked for hours, with the customary interruptions: the telephone ringing, the dogs barking, people coming and going.

From time to time, she picked up a brush to work again on the *High Wall* triptych. Then she spread out all her new Sumi paintings, their liquid shadows becoming more mysterious in the failing light, the bull as always embedded as the powerful unconscious image.

At the end of the day I went with her to her husband Bill's studio where she went each night to join him for dinner and to sleep. As we opened the door, we saw him standing in the kitchen sponging the counters as he always did to keep things neat. He saw her and smiled. She raised her arms and went toward him, arms stretched out. They embraced and he pursed his lips to kiss her on the lips. She giggled and he began to laugh. They both stood there looking at each other and laughing. He no longer needed to remember what it was about. They had come so far and to this place in an amazing life. At its end, at that moment and for always, there was laughter.

Elaine de Kooning's art and her life were the same journey, made up of stops and starts, turnings around and returns to beginnings, until the beginnings of that particular place, that particular space, that particular canvas, were exhausted and she was forced to finish the journey by continuing it from another point. She began the painting again and again and ended it more than once, if she could. In that struggle were the dynamics of her way of working. It was not a sure, consecutive process. Rather, it was a series of sallyings forth and interruptions, like life. The only dilemma was how to let it go.

In her many-faceted life as artist, critic, woman, and great artist's wife, Elaine was open, allowing her multiple selves—juxtaposed, opposed, complementary—their full gamut of possibilities. Her uniquely fresh vision was based on an optimism that never stopped expecting the next miracle, and then the next.

It seems fitting that the final work of art Elaine was engaged in, when the beginning of the end arrived, was a book of lithographs for the Old Testament's Book of Genesis. And when the end came, on February 1, 1989, Elaine de Kooning embarked on a new journey of becoming. Her death marks the end of an era, the beginning of the legend.

—Rose Slivka

Notes

All quotations by Elaine de Kooning are taken from taped conversations with the author.

[1] Frank O'Hara, "A Memoir by Frank O'Hara," in *Larry Rivers*, by Sam Hunter (New York, Harry N. Abrams, Inc., 1969), 52.

[2] John Canaday, "Two Ways To Do It," *The New York Times*, April 28, 1963, II, 13.

3 The Artists' Club included painters Mark Rothko, Earl Kerkam, Georgio Cavallon, Esteban Vicente, Joan Mitchell, Larry Rivers, Howard Kanovitz, Franz Kline, Milton Resnick, Jackson Pollock, Lee Krasner, Paul Brach, Miriam Shapiro, Kyle Morris, Mercedes Matter, Pat Passloff, Mary Abbott, Perl Fine, Maurice Berisov, Herman Cherry, Grace Hartigan, Adolf Gottlieb, Louis Schanker, Warren Brandt, James Brooks, Nicholas Carone, Philip Guston, Robert Motherwell, Ray Parker, Conrad Marca-Relli, Matsumi Kanemitsu, Paul Jenkins; and of course Bill and Elaine de Kooning; sculptors Ibram Lassaw, David Smith, Peter Agostini, Wilfred Zogbaum, Marisol Escobar, Dorothy Dehner, David Slivka, Fred Farr, Gabe Kohn; the critic and philospher Harold Rosenberg; publisher Barney Rosset; the dealers Leo Castelli and John Myers; poet Frank O'Hara—to name only some of its members.

4 Elaine met Gorky through Bill around 1939. She said "I was already deep into being an artist" to me in 1982, when I taped our discussions about this period and subsequently wrote articles on it for *Arts* and *Art in America*.

5 From "Statement," *It Is*, Autumn 1958. See page 176 in this volume.

6 Minna Daniel and Elaine became friends when Elaine first began to work with Edwin Denby on ballet criticism. Minna had been the editor of *Modern Music*, in which all the young avant-garde composers had been published. Elaine and Minna's friendship continued until the end of Elaine's life; Minna is now still active in her nineties.

Portfolio of Photographs

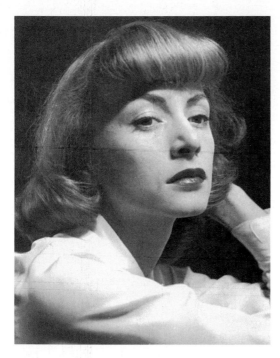

Elaine de Kooning, 1940s.

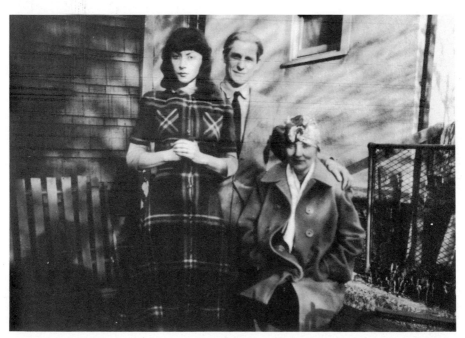

Elaine and Willem de Kooning with Elaine's mother,
Marie Fried, early 1940s.

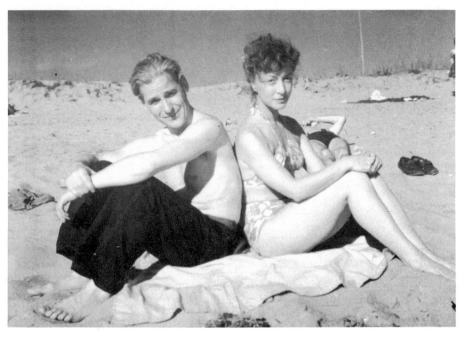

Elaine and Willem de Kooning at Provincetown, Mass., early 1940s.

Elaine de Kooning, c. 1946.

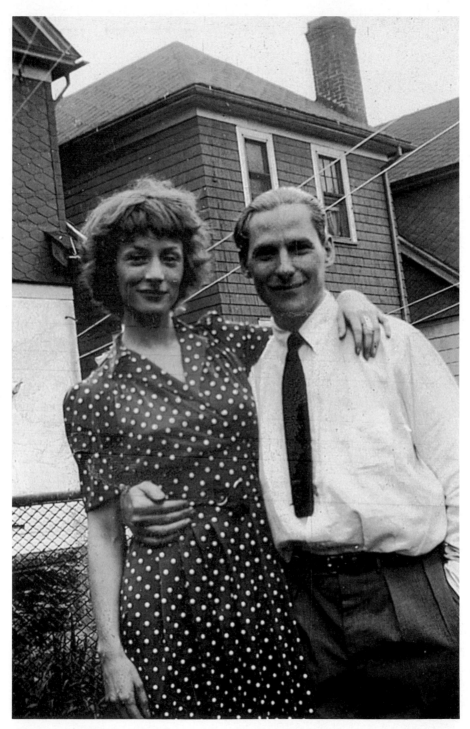

Elaine and Willem de Kooning, 1942.

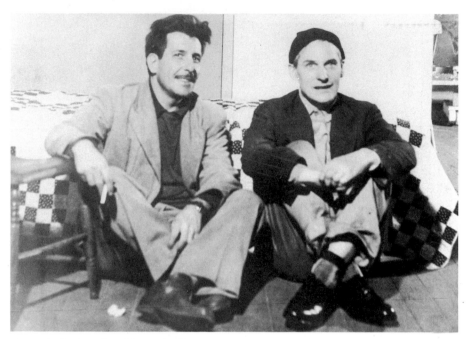

Franz Kline and Willem de Kooning, 1950 or 1951.

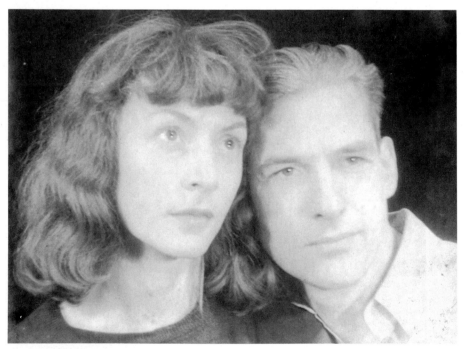

Elaine and Willem de Kooning, 1944.

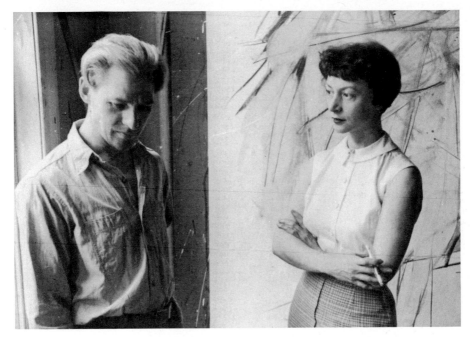

Elaine and Willem de Kooning, 1950. Photograph by Rudolph Burckhardt.
Reprinted with the permission of the photographer.

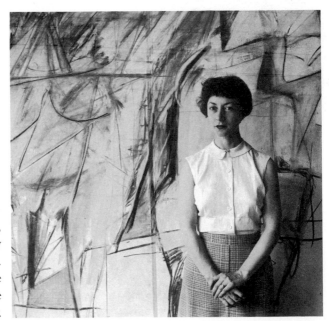

Elaine de Kooning,
1950. Photograph by
Rudolph Burckhardt.
Reprinted with the
permission of the
photographer.

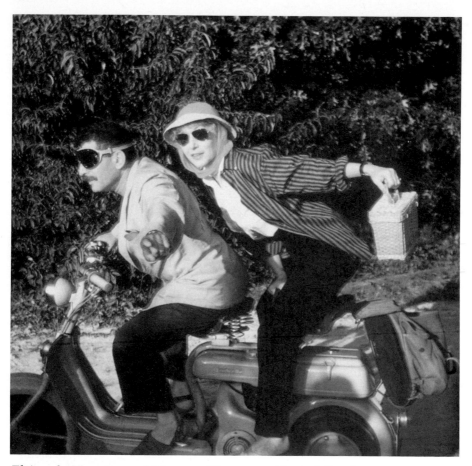

Elaine de Kooning and Herman Cherry on Cherry's Lambretta.
Photograph taken c. 1950, perhaps at Woodstock.

Opposite: Elaine de Kooning, New Mexico, 1957.

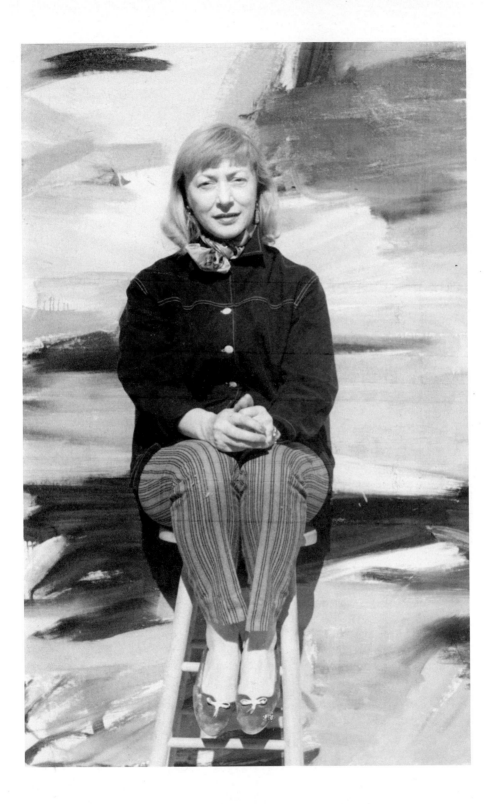

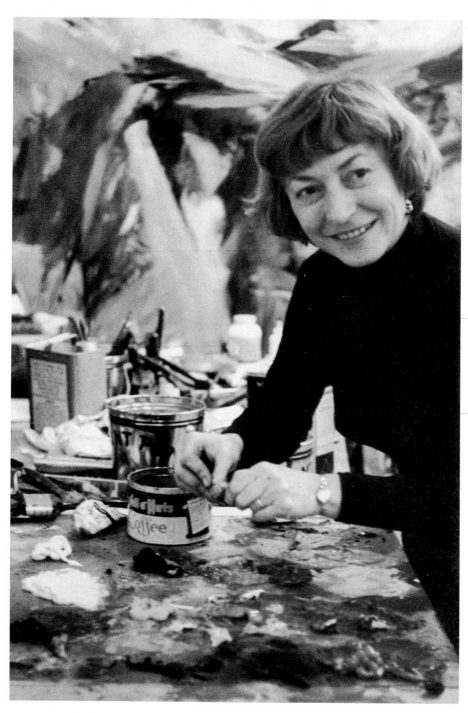

Elaine de Kooning, 1960. Photograph by Rudolph Burckhardt.
Reprinted with the permission of the photographer.

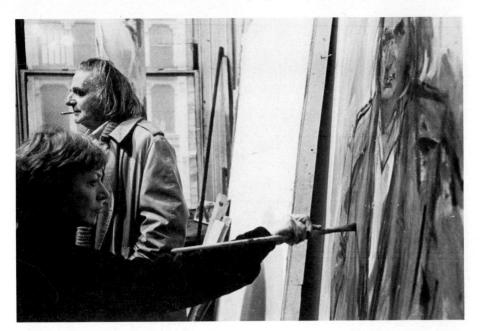

Elaine de Kooning painting a portrait of Aristodimos Kaldis, early 1960s.

Following pages:
Left: Frank O'Hara posing for Elaine de Kooning as she
paints his portrait, 1963.
Right: Elaine de Kooning, *Portrait of Frank O'Hara,* 1963, oil on canvas,
93 x 42". Collection Ariel Follett O'Hara and J. Philip O'Hara.

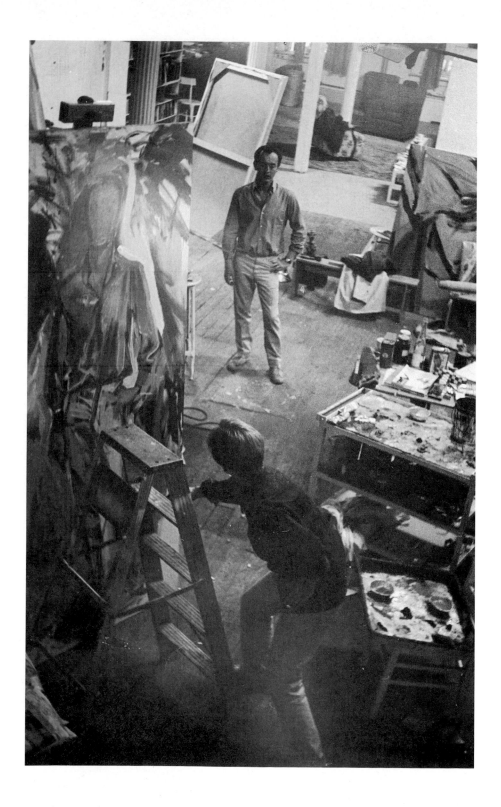

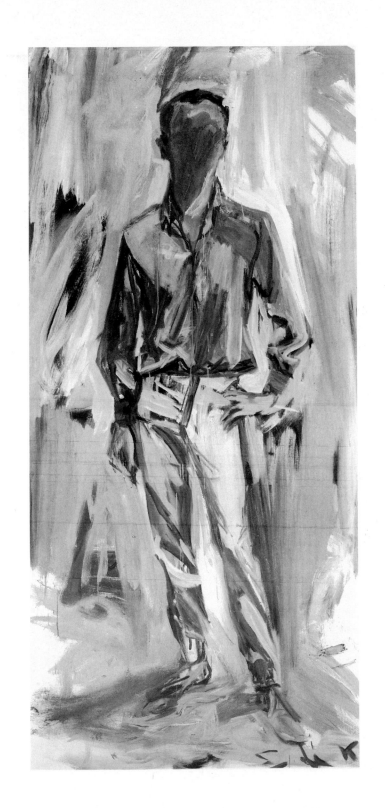

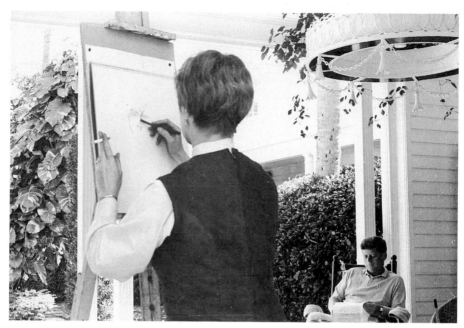

President John F. Kennedy and Elaine de Kooning as she sketches one of her many portraits of him, 1963.

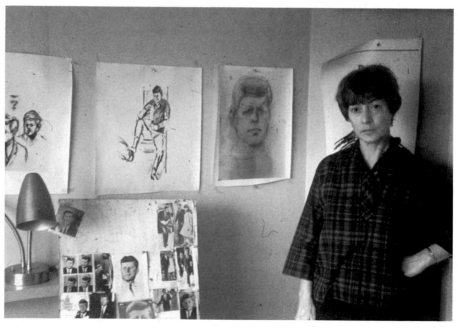

Elaine de Kooning with some of her sketches of Kennedy, 1964.

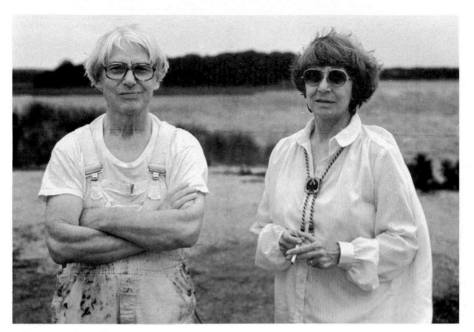

Elaine and Willem de Kooning, c. 1980.

Elaine and Willem de Kooning, 1982.

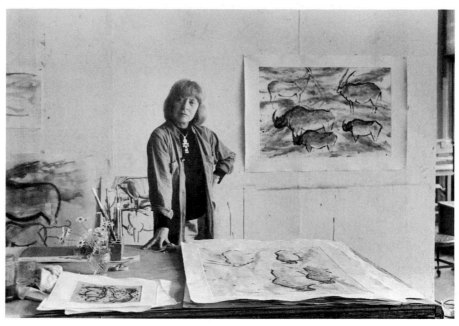

Elaine de Kooning at Crown Point Press, May, 1985.

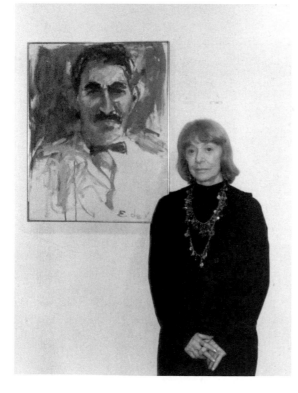

Elaine de Kooning with
one of her portraits of
Harold Rosenberg, c. 1985.

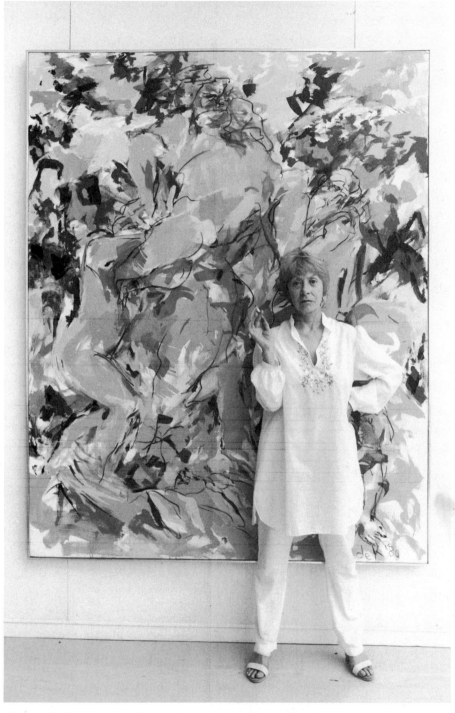

Elaine de Kooning in front of a painting in her Bacchus, series. 1985.

A Cahier Leaf

PREJUDICES, PREFERENCES, AND PREOCCUPATIONS

(1958)

May we be preserved from painting in English.

Flat painting is a great bore. Also, it doesn't exist. It just thinks it does.

We are—or we want to be—what we love.

A finished painting is—or should be—a reminder of what not to do again.

A painting without black is like food without salt. If you're fond of sweets, this may present no problem.

Horizontal paintings are naturalistic—landscapes, battles or orgies.

Vertical paintings are humane and/or architectural.

A seated man can be a gyroscope. If a man appears or disappears in paint, it doesn't make much difference.

Every painting has an axis, whether it admits it or not.

There is a bottom and top to men, buildings and paintings. And two sides. The sky is above and the earth below all.

Nature has no top or bottom.

For myself, I'm at home in vertical, (or Gothic) air, rising, falling or spinning—it makes no difference as long as something is happening.

Quiet or horizontal or "over-all" painting makes me nervous. I'm bothered by a lack of emphasis. An only child wouldn't have this problem.

However, immobility has its definite gesture as action has its ambiguity. Lucidity, clarity, definition must sometimes be sacrificed to action.

I'm willing to make the sacrifice. I'd rather be on the move than right.

The action of drawing is climactic. Action, when it is uniform, becomes texture and therefore self-denying: witness any mob scene.

One is therefore forced to choose between cleverness and scale:

Choices: The motion of paint through a motionless scene.

The motion of paint through an animated scene.

The motion of drawing through a quiet scene and quiet paint.

Other Choices: Hot or cool colors: Painters start out with Yellow and Orange and Red and end up with blue, green, brown, ochre or grey.

Anyone who starts out with blue, green, brown, ochre or grey, I don't want to meet. We all have our problems. However, black solves all problems. Ask Franz. Ask his mother.

Pin up boys

MANTEGNA	for his knowledge of drawing as crevices
MICHELANGELO	for his ability to rock and roll
RUBENS	for his talent for being rich and his knowledge that an eye is wet
REMBRANDT	for his love of flesh and his deep understanding of knees
WATTEAU	for his suicidal acuteness
EL GRECO	for his being a convincing hypocrite
DELACROIX	for the ideas not the facts of his painting
GIACOMETTI	for hacking scale to pieces and not caring about being crumby
BRANCUSI	for being an autocrat and not caring about being blunt
RENOIR	for not caring
VAN GOGH	for caring
MATISSE	for his gratitude for being alive
CEZANNE	for being King Lear
DE KOONING	for being alive
MONDRIAN	for wanting to paint The Family Out of Existence
PICASSO	for being a great colorist
JACKSON POLLOCK	for rocking the boat
GORKY	for knowing so much
PETER AGOSTINI	for knowing how to draw a horse
REUBEN NAKIAN	for knowing how to finish a bull
BARNEY NEWMAN	for his knowing that there are two sides to every painting
REINHARDT	for his originability under difficult circumstances
LEWITIN	for having the right color and the right word
RUDY BURCKHARDT	for understanding grey
LEGER	for being a successful woman hater
GABRIEL KOHN	for making sculpture that looks damp
BOB GOODNOUGH	for his inconsistency

Editorial Note: We have reprinted Elaine de Kooning's essays as they originally appeared in print. When the author describes illustrated works, which we have not included, we have added an asterisk in the left margin to alert the reader, and included the name of the painting (when known) in brackets.

Edwin Dickinson
Paints a Picture

(1949)

There are certain paintings whose style and expression are peculiarly dependent on a slow development, on the remnants of constant change. They cannot be made in a week, a month or even in years. One of these is the picture that has been on Edwin Dickinson's easel in his New York studio since 1943. Still unfinished and unnamed, it is tentatively called *The Ruin*, although the artist himself refers to it as a "study for a composition."

Portrait of the painter

Astonishingly little known and unappreciated, at fifty-seven Edwin Dickinson must be considered one of America's first painters. Son of a clergyman, he was brought up in Sheldrake, N.Y., where he painted the "wood interiors," glens and rock formations that keep recurring in his work. During the summers of 1910-13, spent in Provincetown studying under Charles W. Hawthorne, whom he regards as his most important teacher, he acquired his taste for Cape Cod, making it his home until 1944 when he moved to New York City. The cold-green gorse and scrub pine, lavender flowers and bleached stretches of sand and sky peculiar to the Cape seaside supply a key to his palette, and the highly variable atmosphere that simultaneously sharpens some contours and blurs others could have affected his concept of drawing.

Thoroughly an artist, Dickinson, from the beginning (he was making complicated drawings of battle formations at the age of eight) seemed able to hoard all his experiences until he found a way to put them on canvas. He decided as a student that he would not be interested in commercial art so he "learned telegraphy as a meal-ticket," spending two years at sea with the Navy during the first World War as a radio operator, and, later, working on a scientific schooner. Although he made no sketches during this period he evoked his vivid impressions of the sea and ships in pictures of the 1930's like *Stranded Brig*, with its complex interplay of fog and rock formations.

He also finds subject matter in his "side-interests" which last, Dickinson says, about ten years: the Civil War (he was given 175 volumes on the subject by the State of Rhode Island); fossil and coin collecting; and

arctic exploration. But his utilization of these themes is never illustrative. His *Mass for the Tegethoff*, 1923-4—an Austrian ship lost in the Polar regions in 1876—or *Amundsen and McKenna*, 1925, a study of a ship's deck in a storm, commemorating the finding of the Northwest Passage, are abstractly rendered in broad areas of light and dark with the human figure a barely discernible unit. Literary content carries much of the force of these pictures. Joyce, incidentally, is the only author who directly inspired him; he has made three pictures on themes taken from *Ulysses,* but Dickinson never composes in terms of subject. Intervals of size, color and value; the relative positions and shapes of objects; the depth of the scene; the balance of horizontal and vertical are determined beforehand—in considering these factors he often stretches his canvas a year in advance—and by the time he makes his first stroke, he has a clear idea of the organization of the composition.

Building the ruin

The Ruin encompasses Dickinson's past techniques and attitudes; inaugurates new ones. This is the first time he has evolved the structure of the underlying drawing as a preliminary step to painting. Worked in only two colors—brown *rouge*, a French pigment slightly rosier than our earth-red, and a few gradually disappearing areas of greenish-blue—the values are extraordinarily varied and luminous. Not intended as an underpainting, however, the final monotoned "drawing" will be a point of departure.

The picture, as it stands now, has undergone numerous changes, offering a parallel in its development to that of an actual ruin. It has its own history of invention, destruction and rebuilding. Battlements, towers, pillars, staircases have been erected and then partially or completely destroyed. Figures in different positions and apparel have appeared and retired (in the latest version, there is a ghostly life-size figure visible in the central arch and, set forward, a *Winged Victory*, twice life-size, which give scale to the scene). The central column, now placed with daring ambiguity so that, at first glance, the arches far behind seem to rise from its capital, has often, as Dickinson puts it, "waltzed back and forth." At one time, in the vertical strip on the left, rough, natural cliffs were contrasted with the rigid lines of the ruin; at another, a village appeared in the distance around a temple at the top of a hill; and at present, foliage rises up over a staircase. And in all of this reworking is part of the magic of this picture. An external scene presented with what appears to be the driest objectivity acquires a mystical character. Evoking Albert Ryder or the late Arnold Friedman, Dickinson's abstract method is rooted in an intense view of nature.

Paper, palette, pigment

Unlike most artists, Dickinson doesn't work from sketches. His initial plan and its development are completely worked out on canvas. His occasional drawings or his spare and fluent pencil portraits are in themselves finished works, and except for these and some etchings and watercolors made before 1920, he works in oil only.

His methods, tools and materials are fairly constant. Indoors and out, he always paints standing, with his palette—he owns sixteen, most of them glossy, pressed-wood boards—attached to his easel, which he tilts forward to avoid glare. For his small pictures, he selects his colors on the spot. For his large ones—some as high as 8 feet requiring the use of a ladder—he decides on the exact color and value range beforehand and mixes his pigment in large batches—enough to last hundreds of working hours if necessary— then storing it under water, or, recently, tubing it. "Long-winded," he carries each picture to its conclusion, with as many consecutive sittings as possible before beginning another. Time is taken out for an occasional portrait commission, often executed from photographs; his teaching jobs at the Art Students League, Cooper Union and the Brooklyn Museum school; and for his summer vacations.

If a picture is not completed to his satisfaction, it is painted away: preceding *The Ruin* on the canvas was a big French stone house of 1820 with a feudal keep attached by a bridge of sighs which he worked on for a year; and before that, a self-portrait—one of twenty-eight, half of which are destroyed. A careful craftsman, he retains his ground and keeps his impasto thin, even when he spends years on a picture, by scraping off the areas he wants to change with a jackknife instead of effacing them with another coat of paint. A master of off-tones and narrow ranges—Matisse, paradoxically, is the colorist he most admires—he achieves his rich greys with a full palette, laying on his paint freely and opaquely. He never scumbles or glazes with his medium of 4/5 linseed oil, 1/5 turpentine; and often mixes his colors right on the canvas with his hands or palette knives. Most of the sixteen-odd brushes he uses in a day's work are flat, but his favorites are some rounded, soft-haired Foinet brushes with which he can lay down the curious, undefined smears of color as characteristic of his finished work as his signature scratched in wet paint.

In his application of pigment one can discover the artists most important to his development, those whose compositions are dependent on the high visibility of the brushstroke: Velázquez, Veronese, Delacroix and, particularly, Cézanne. But throughout his career, an interest in sweeping forms, supernatural lighting, displaced perspectives and even in the occasional use of huge, heavy folds of cloth, as in some early monumental portraits, reveals

El Greco as the most persistent influence. A copy he made at the Metropolitan five years ago of the *View of Toledo* hangs in his living room in New York, and, recalling a trip he made to Spain in 1920, he says, "When I saw the *Burial of Count Orgaz*, I knew where my aspirations lay."

In front of nature

Although his style has changed since his first appearance in the Armory Show and, the same year on invitation from the French government, at the Luxembourg, one finds, looking back over his work, that it can be divided by the relation of the observed to the imaginary into three distinct groups.

In the first are the small land- or seascapes painted from nature, usually in one day—a pace he mastered as a student under his first teacher, William M. Chase, at the Art Students League, and to which he returns in the summer when he leaves New York to work in Wellfleet, Mass. Without any literary or "mood" content, these are, he says "straight representation." An important part of creation here lies in the element of choice, but once the scene is decided upon—he uses a cardboard finder; puts it aside when he has established the basic design on canvas—he says, "I take it as it comes." Here his approach is as close to automatic as this insistently conscious artist ever comes. Squinting as he works, to eliminate detail, he presents his subjects in terms of mobile, dissolving planes, always in precise reference to the actual scene. Some are so casually true in proportion and tone that, in small reproduction, they might pass for snapshots; but most of these outdoor scenes are reduced to abstract directions rather than recognizable, stationary forms. Comparing the painting of [a] clump of trees with a photograph of the site taken later (one tree has since been chopped down; others grown taller, and the fence is new), one is struck, despite the lack of naturalistic definition, by the accurate slant of the terrain and shift of the foliage, but would not discover the heifer in the foreground.

Modification and elaboration

More elaborate in expression are the heroic canvases in the second group. Also painted from life but modified and rearranged, these compositions are strung on complex frameworks of multiple perspective. The contempt for conventional angles of vision that prompted him, as an art student, to climb trees and paint scenes from above is still evident in the unusual placement of the eye-level, most often high and sometimes, daringly, out of the picture. Working on a level with the scene of his picture, he accomplishes this apparent manipulation of naturalistic perspective by painting a section at a time, standing close to the object or model he is working from; making the necessary revisions in size with uncanny exactness. In his

Self-Portrait [1949], an erudite double-play on perspective with the drawing of a cube behind his head projected in angular perspective, he established the eye-level at the bottom of the picture by painting from mirrors tilted back to show part of the skylight.

His New York and Wellfleet studios are stored with the still-life paraphernalia—kettles, fossils, plaster-casts, books, musical instruments—that recur with unstressed symbolism in these works; and an element of fantasy, more allegorical than surrealist, is often introduced in the juxtapositions. The dreamlike quality of his subject matter is heightened by his technique of changing the focus of vision: one gets the sense of looking over a scene through binoculars adjusted at different focal lengths as some sections are rendered with magic-realist detail; others blurred or obliterated in the surface action of the pigment. But each detail is placed in bold relation to the large design.

Allegory and imagination

In the third group are the compositions painted completely from imagination—undetailed, indirectly lighted and remote in view. Here scale becomes a dominant formal interest as immense, unearthly vistas unfold on canvas. In *The Ruin*—similar in topographical character to the sprawling Roman ruins at Arles, which Dickinson visited several times on his trips through Europe—the solution is spectacularly complex. Scale is ingeniously conveyed through the wide angle of vision; directions change abruptly from the staircase on the left which catapults you down into a valley up across the expanse of marble to the arches whose undersides are visible.

In such scenes, the poetic content is an important part of the expression, but here, as in his other work, by a curious reversal of the usual creative method, he does not start out with a fixed subject which he then describes or abstracts in paint, but rather he finds his subject through his method of composing. All of his past techniques; his lifelong obsession with perspective; his sense of history, archaeology, architecture, poetry and nature seemed to lead him naturally to *The Ruin* as a theater of operations. *The Ruin*, as he presents it, is a dispassionate record of constantly changing possibilities in time, in place, in style and in design. The process of painting has not yet begun, but in describing some of the possibilities as he uses or rejects them, part of the fabulous complexity of his purpose and of his method is revealed.

With the same compulsion that goaded Leonardo to substantiate his aesthetic with scientific logic, Dickinson supplies his abstract shapes with historical reasons which, in turn, suggest other possibilities in design. Each compartment of a few square inches, in this artist's conception of the flat

surface of the canvas, can represent a solid form or a defined distance answerable to any of the countless vanishing points. Establishing, as a point of departure, a floor-plan from which his structures rise, he proceeds to place it in time.

The Ruin's inner history

He begins with a "Roman ruin in Syria, built 40 A.D." Here consistency in style is not observed: the architecture is a "concoction of corrupted Corinthian, Doric and Ionic" forms. The quality of free play within an implied style is symbolized in the invention, glorious and impracticable, of the spiral column, with its marble steps (they could not, in actuality, be inserted) winding up to the sky. In 1600, the artist continues, a silo with a covered shaftway leading up to it was added (in the present version, an early temple has taken its place). Then he allows for further variations, "made according to the disposition of the drawing," on the architectural plan: "In 1900 the ruin was bought up by a well-to-do Frenchman [remotely patterned on Paul Chadenne, the scholarly architect of the Galerie Lafayette] who landscaped it and built a pool." Here again the artist retains his freedom through the intricacy of his conception: the water is placed at five different levels, which are adjusted according to the form he wants reflected.

Many of the physical changes in the ruin can be observed by comparing the three states of the picture. In the first, with the remains of the natural rock visible on the left, several shapes, like the oval base of the fountain, are worked out only as abstract forms, while others which are more completely realized details, like the silo, were later removed. In the 1945 version, the retaining wall of the pool has been straightened; flights of stairs have been added, a cornice has fallen into the pool; the reflection of an arch appears in the water; the areas for the staircase on the left are blocked in. In the 1949 version, a branch picks up the direction—with a completely different meaning, in the three-dimensional space—left by the shaftway: two small, teardrop-shaped natural pools appear in the parapet along the bottom margin; a small staircase has been inserted to the left of the temple; and faintly visible in the arch to the right of the *Winged Victory*—now also reflected in water—is a pillar propped up against the wall. These and numerous other changes are always vitally active in the total, three-dimensional scheme.

The light at present comes from one source. Shadows are accurately placed and shaped, but he accomplishes his design here by determining the form that casts them and the surface on which they fall—whether regular, like a series of steps, or irregular, like an arbitrarily shattered pillar. And supplying still another three-dimensional pattern are the birds scattered through the air.

All of these separate, unpredictable forms are strictly accounted for within his plan of perspective. Distances and degrees of convergence are computed with a yardstick and dividers, but occasionally, reverting to a more direct method, he constructs a simple, three-dimensional model of an arch or a tower out of a flat piece of cardboard, nails it on the wall, and paints by eye.

Originally the scene had only one center of vision, directly in front of the fountain, but as the composition developed, "to prevent one-sidedness," he added other station points along the horizon. Thus *The Ruin* is seen more or less as if one were strolling past it. This use of multiple station points flattens the painting by diminishing the angles at which architectural parts recede. But even here, if the design demands, he takes liberties: the temple canting to the left, slightly out of perspective, was built over soft earth, Dickinson explains.

And so there is an answer for every abstract shape and, eventually, a shape for every personal experience as a great artist reconciles poetry with perspective.

Hans Hofmann
Paints a Picture

(1950)

"Making a picture is almost a physical struggle," says Hans Hofmann, whose prodigious nervous energy is communicated in the expanding dimensions and exuberant colors of his abstractions. Working with astonishing speed, never sitting down, constantly in motion between his palette and his easel, applying his paint with broad, lunging gestures, Hofmann often finishes a painting in a few hours. The rooms of his sprawling, bright-walled house in Provincetown, where he takes his school every summer, his apartment and his studio in downtown New York, all are filled with his paintings of the past ten or fifteen years along with a number of French primitives and some recent Dubuffets bought in Paris when Hofmann had his show there last year. He likes to be surrounded by his own work because "a strong picture constantly suggests new ideas; shows up the weakness of others." "If you can't keep looking at a picture," the artist continues, "it should be destroyed." Finished pictures that don't stand this test are returned to his easel. . . .When Hofmann is dissatisfied with a painting, he doesn't "patch up" the corner or color that bothers him, but goes over the entire composition. "A picture must be finished in one sweep," he says, and this partly accounts for the violent immediacy of his works, whether they have taken hours or months to create.

One of the most influential art teachers of today, the buoyant, seventy-year-old painter has had a career, since he founded his school in Munich in 1915, divided between his classes and his own painting. In 1930, Hofmann was persuaded by his many American students to leave his native land to teach at the University of California. Then, four years later, he opened the school in New York that has attracted students in large numbers from all over the country. Here, Hofmann spends two strenuous days a week (he has morning, afternoon and evening classes) lecturing or criticizing.

Any discussion of Hofmann's technique must revolve around his theories. "Technique is always the consequence of the dominating concept; with the change of concept, technique will change." Perhaps because of the elasticity of his theories, his students' work ranges from strict non-objectivity to close representation. But Hofmann does not encourage the latter.

"Objective renderings are too often minimized: the human figure becomes a doll; a landscape a marionette set," he says. Although his teachings are based on abstract principles, Hofmann always has his students work directly from life—as he does himself, with the exception of some "automatic" paintings. One window in his studio or one still-life can supply the forms —sometimes recognizable, usually not—for an indefinite number of pictures. (The still-life he set up for [*Fruit Bowl, No. I*] has so far been the subject of five other paintings.) "An artist must look to nature for the essence of space—but appearance must be thoroughly understood. Space was never a static, inert thing, but alive, and its life can be felt in the rhythm in which everything in a visual ensemble exists."

An accidental grouping of furniture might thus serve as an inspiration, but the first creative step in the making of this picture was the careful disposition of objects on a table. (An important part of his teaching technique is involved with the actual construction—often in themselves cubist—of the still-lifes he puts before his classes.) Hofmann can, in arranging a still-life, present an object not in terms of its own shape but as a "space-maker." Thus, in this still-life a white bowl, three apples, an ashtray, a small pitcher and a jar of show-card color lose their conventional solidity as the distances between them—activated here by a "backdrop" of silver wrapping paper and the shaft of cellophane in the vase—become more prominent and suggestive than the objects themselves. Beginning with a "visual ensemble," Hofmann, in a sense, finds his subject only when the picture is finished. Sometimes general environment is reflected—the pictures painted in Provincetown are "full of sunlight"; sometimes, a mood—"A shape can be sad or gay; a line, delirious." The work-in-progress wasn't named until Hofmann had made a series and discovered at last that the fruit bowl, radically changing its form from one version to another, seemed to be the dramatic center in each: hence, the expository title *Fruit Bowl: Transubstantiation, No. I, II, III, IV, V,* etc.

Although his attitudes and methods have changed often, Hofmann has always been preoccupied with scale and likes to work on large canvases, explaining that "you can't use your biceps on a small picture." But, recalling his first visit to the Metropolitan, where, after walking through the museum he found a tiny Ryder "one of the greatest pictures on exhibit," he adds, "an artist should be able to show his capacity for monumental expression in a smaller picture." Thus, as a discipline, he spends some time every week making sketches on paper or pressed wood boards. For these, a large sheet of cardboard placed on a chest serves as his desk (this is the only time that Hofmann works sitting down). After decades of experience, he "no longer has the patience to work with pen, pencil or crayons" and he always draws

with a brush, making quantities of temperas—often twenty or thirty in an hour. These sketches are not made as preliminaries to a painting but purely as "exercises." For more concentrated work on a particular problem, however, he finds tempera an inelastic medium and uses oil.

[Three] black-and-white oil sketches from the still-life demonstrate his search for the possible depth of his subject on a two-dimensional surface. In the first, he takes the largest area, and the objects are consequently smaller in relation to the rectangle; in the second, jutting forward in a close-up, the bowl looms large in the composition; in the third, which is the simplest in pattern and closest to the painting, the relative distances have settled in a range between the first two sketches. But the only important motif carried from these sketches through the development of the painting is the subtle vertical split, slightly left of the center of the composition; otherwise the painting, even to the proportions of the canvas, is completely independent of them.

Hofmann has evolved no rules for the making of a picture. On the contrary, always on guard against intellectualism and virtuosity, he says: "At the time of making a picture, I want not to know what I'm doing; a picture should be made with feeling, not with knowing. The possibilities of the medium must be sensed. Anything can serve as a medium—kerosene, benzine, turpentine, linseed oil, beeswax . . . even beer," he adds jokingly. He usually works with a full palette, but for *Fruit Bowl, No. 1* he used only four colors—white, red, blue and yellow—bringing in one more, crimson, when the picture was almost finished. Revealing his taste for extremes in impastos, he states that he "may use a hundred tubes for one picture, or one tube for a hundred pictures; lots of medium or none at all." During the making of a picture, he gets covered with paint and spatters everything around, but he is scrupulous about clean materials. A can of turpentine and a huge roll of gauze are always handy for cleaning his brushes and palettes at the end of a session. While working, however, he very rarely stops for this purpose. Lavish with his materials, he keeps his studio well-stocked with "all instruments possible for the making of a picture." A large assortment of palettes (panes of glass, pressed-wood boards, tabletops), palette knives, jars full of brushes, boxes of tubed colors, rolls of canvas, bristol boards are all neatly arranged, ready for immediate use. He usually paints on heavy duck—originally for the sake of economy, but now because he finds it holds up better than linen against his battering technique. He prepares the raw canvas himself with flat white to close the pores, then a gesso ground, which he maintains is the only ground that does not turn yellow. (Its one disadvantage is that these pictures cannot be rolled because they would crack.) Although he likes his pigment applied generously (Hofmann is often amused by his students'

"starving palettes"), he tries to keep areas of canvas uncovered throughout the development of a picture as its texture and color are important foils for the variety of his impastos and tones. (In the final version of *Fruit Bowl, No. I* for instance, the cone of paper, the area around the dots in the cellophane and occasional edges of planes are still raw canvas.) "If I lose my ground, I have overshot my aim," he says, and in this case he restates forms with white paint (he uses Permalba) to find his bearings again. White is the most important color, the artist finds, "since it is the most neutral and the finest shades always take a definite relation to it." By "pure color," a term Hofmann constantly employs, he does not mean color as it comes out of the tube. Any mixture, he maintains, can be pure; it is in their relationship—as, for instance, the juxtaposition of tones to create the illusion of light—that colors may become dirty.

"Painting to me means forming with color," Hofmann states. His first stroke of color is very important since it may be visible in the final version of the picture, and so, for *Fruit Bowl, No. I,* Hofmann spent considerable time studying the still-life before picking up his brush. (The artist, who has been putting himself on the spot for decades by demonstrating before his pupils—often with seventy people in the classroom—was able to paint while the photographer was present, but ordinarily allows no one in his studio except his wife, Miz.

His beginnings vary. This time he picked up a small soft-haired brush, dipped it in turpentine, then in blue and yellow paint, and rapidly established the "architecture" of the still-life with fine, fluid lines in a drawing on canvas that actually evokes a blueprint. The diagonals were found in the large planes of the silver paper propped up behind the still-life and in the cylinder lying on the table; horizontal and vertical directions, in the tabletop, the cardboard pillar underneath, and the large board behind. Junctions of light and dark were caught as dots at the corners of the lines. But Hofmann doesn't always begin a picture with contours; as often he starts out by applying flat areas of paint, as in the second step here.

Using a bunched-up piece of gauze about ten inches square, he next picked up some yellow paint, then white and a bit of red, and smeared them around on his palette to get an evenly mixed tone, which he then rubbed thinly on the right side of the picture where, next to the white canvas, it assumes a darker, brownish hue. Then, with another piece of gauze, he rubbed a related mixture of yellow, white and green on the left side, establishing a "background" which immediately pushed the entire still-life construction forward. ("The picture must achieve a three-dimensional effect, distinct from illusion, by means of the creative process.") In the same way, other forms were rapidly colored in: a large, rough trapezoid of blue

was smeared on; then using the same piece of gauze, he picked up some yellow and rubbed the resultant streaky green on another form. So far, he had kept his color within the original contours, which he reiterated from time to time with a small brush. But his method of applying pigment is never arbitrary—canvas was allowed to show through in one area; covered with long, carefully directed strokes in another; and in the simple act of "filling in," the position and scale of the planes became radically altered.

But then, suddenly, the artist broke away from his original drawing, utilizing more specific forms as he picked up the left contour of the white bowl, and the diagonal shaft of cellophane. Here, the white lights in the crumpled, transparent paper were translated into a tick-tack-toe diagram, traced on so thinly that the paint dripped down. (Hofmann often works on the floor when he uses thin paint, partly achieving his drawing in this case by carefully tilting the canvas one way or another to control the "runners.") In [this] stage, . . . the negative space of the uncovered canvas became the dominating solid form, weaving through the colored areas in a bold and final image. It is the artist's contention that "at every stage in its development, a picture should be finished" in the sense of clear relationships of color and form. Often, at this point—where forms are left as they were first stated, without modification—he will find the spontaneity has crystallized and that any further work would dilute the effect. But here he felt it necessary to "fill the picture more." Forms were put down and wiped away as the impulse of the drawing swung from side to side: a stroke shooting to the left was balanced by another to the right. He scraped off unwanted colors with a palette knife; picked up one of the paint-soaked pieces of gauze that had accumulated on his palette table, wrung it out so that it was almost dry, dragged it across the coarse-grained duck for a dry-brush effect; dipped another piece into turpentine (the only medium used for this picture) and washed on a glaze. As the composition became more complex, the impasto was laid on more thickly, sometimes heightening a color, sometimes contradicting it. The artist picked up a thick gob of deep blue paint with a large brush held in his fist like a dagger; brought it down with force on an area of raw canvas, then on a pale blue rectangle; heavy streaks of white were drawn across a fresh layer of yellow; a brushful of red was plunged into an area of green—but, incredibly, working in thick, wet paint like this, he managed to keep his colors intact and separate.

His remarkable control here is a direct result of his method of applying pigment. Using his hands, cloth, palette knives, "anything I see around," Hofmann sometimes thinks "a brush is a great limitation." Only very good ones can withstand the rough treatment he gives them—pounding them straight down into the paint or scrubbing them on the canvas so that the

bristles stick out in all directions. From his large collection, which includes dozens of house-painter's brushes, he once salvaged some Rubens brushes that were worn down to half an inch above the ferrule by cutting away part of the metal exposing another inch of good bristle. But he doesn't insist on expensive brushes, and often prefers to use a cheap, frayed one. "The choice of a brush is as important as the choice of a color in affecting the drawing," says Hofmann. There is perhaps no other living artist who can give a dab of paint the special, haphazard intensity of expression that he can; and the splotches, streaks and dots, apparently so wildly splashed on, are always under perfect control.

In the [next] stage, . . . these splotches of bright color seem, at first glance, to be zig-zagging in a free action on top of the basic geometric structure; but on closer examination, they can be found to describe the edges precisely, or fill out the corners of a new group of planes, superimposed like overlapping sheets of glass. Spotted with opaque paint, giving off flashes of colored light, the picture here attains a marvelous transparency. And a daring, spinning equilibrium is created as these planes, on the verge of toppling over, are pivoted, almost dead-center in the composition, at the lower rim of the fruit-bowl. By this time (after three hours' work), the artist was holding fifteen brushes in his left hand, and his four original colors had each multiplied into as many distinct tones. Color and drawing, feverishly animated in effect, were at their most complex. From here on, development was a matter of simplification, and the picture advanced by means of "creative destruction." Qualifying the development here was the fact that the paper behind the still-life collapsed and knocked the objects out of position so that the artist had to work only by the logic of the picture itself. (The subsequent paintings in the series were made from an altered arrangement of the same objects: the three apples were put in the fruit bowl; the jar of show-card color, the ashtray and the cylinder of paper were removed; a lemon was added.)

After an eight-hour session the following day, the composition settled into a simpler balance as whole groups of small, glittering planes were swallowed up by a deep, substantial green in massively defined rectangular forms. A brilliant, heavy yellow now covered the initial, delicately tinted "background" and light, rapid contours acquired a magnificent, somber rigidity. A long ribbon of red, flippant and final, on the left, and his signature on the right declared the picture complete—but, after beginning *Fruit Bowl, No. II,* Hofmann was impelled to return to the original version three times before he brought it—with a thick red calligraphy, the most pronounced addition—to its final stage.

"A work of art is finished from the point of view of the artist," says

Hofmann, "when feeling and perception have resulted in a spiritual synthesis." This synthesis may occur at any point, or even—as demonstrated by the different stages and "transubstantiations" of *Fruit Bowl*—during the execution. As he has written, "Every deep artist expression is a product of a conscious feeling for reality. But for the spectator, the reality that appears in Hofmann's canvases is the powerful one of paint alone.

Andrew Wyeth
Paints a Picture

(1950)

Following a shaft of light across a room, presenting with a dry and piercing accuracy the worn polish on a wooden chair, the wrinkled seams on a denim jacket or the flesh puckered around an anxious eye, Andrew Wyeth, from the start to the finish of his most recent painting in egg tempera, never worked directly from life. A master of the magic-realist technique, the thirty-three-year-old artist bases his astonishing photographic improvisations on a thorough familiarity with his subjects—most of them taken from his surroundings at Chadds Ford, Pa., where he has lived all his life. But his depictions of commonplace visual realities are always charged with a high emotional content. Without tricks of technique, sentiment or obvious symbolism, Wyeth, through his use of perspective, can make a prosperous farmhouse kitchen or a rolling pasture as bleak and haunting as a train whistle in the night. But in this picture, pointedly sacrificing the surrealists' conventional nostalgia of converging lines—with only the slight deviation from horizontal of the cross-beam to remind the spectator of continuing space—he finds the same drama of loneliness, curiously without pathos, in this close-up, straight-on view. An overpowering sense of desolation is here conveyed in the clarity and economy of representation.

Son of the late N. C. Wyeth, who was widely known for his illustrations of children's books—*Robin Hood, Treasure Island*, etc.—Andrew, along with his two sisters, studied under his father at Chadds Ford, where they formed a small art colony of their own. His sister Carolyn, now married to an engineer, paints and holds classes in the house that belonged to their father. Andrew, his pretty wife, Betsy, and their two boys, six-year-old Nicholas and three-year-old Jamie, live in the amply proportioned school-house where his sister Henriette and her painter-husband, Peter Hurd, used to have their studios before they left, in 1940, to live in New Mexico.

Although young Wyeth worked mainly in oils under his father, he soon discovered his preference for water-solvent pigments, making a precocious first appearance in 1937 with a show of watercolors of the Maine seacoast (where he and his family still spend their summers), and shortly after, he began experimenting with tempera (all his shows have since been divided between the two mediums).

Before he can plan a tempera, Wyeth has to find a subject he feels strongly about. Often while working on a picture (he paints about four temperas a year), he will get an idea for another and jot down some sketches to record it, but he never works on more than one at a time, and when he is finished, the subject is exhausted for him and he never returns to it again (he can't bear to look at the finished picture for months, and usually destroys the preliminary sketches). But sometimes after finishing a picture, he has no particular idea for another. In this case, he waits for weeks or even months (during such a period working every day from life on his freely brushed watercolors) until a subject "hits" him. . . .

Driving home one day last September, Wyeth saw a Negro, Ben Loper, whom he had known since he was a child, standing before a shack. The artist stopped to talk with him for awhile and then drove off. But something about the man's face in the afternoon light—the shape of his head silhouetted against the field behind—kept haunting him vaguely as a possibility for a painting, and a couple of days later he returned and knocked at the door of the shack. Receiving an invitation to come in, he opened the door on the scene that directly inspired his painting: Ben Loper, sitting alone in the murky room, leaned forward, and a beam of sunlight settling for a moment in a blazing yellow triangle around one eye. Then Loper stood up and the vision was dispelled. The artist never again saw that clot of light on his sitter's face, but in it he had found the spiritual focus of his subject. The reconstruction, bit by bit, of this remembered impression, with all the complex meanings the artist eventually realized in the image of "sunlight striking upon a skull," was his main preoccupation for the next five months—although the painting, which was finished in January, was only eleven weeks in actual execution. It was a month before Loper, who works at a greenhouse nearby, would consent to pose on his weekends, and another month before Wyeth accumulated enough sketches to begin work.

In his sketches, Wyeth carefully selects the elements to go into the painting, explaining that "it's not what you put in but what you leave out that counts." Thus, the stove, the uneven finish of the wall—anything in the actual scene that does not directly express his idea about the subject—is eliminated from the beginning. With a particular gesso panel in mind (27 by 17½ inches), he made his first sketch from Loper, slightly smaller than life-size, with his favorite pencil an ordinary No. 2, indicating tones on part of the jacket with an ebony pencil. Here hands and shoulders (used in the painting for a while) are broadly drawn and hairline is barely observed as he stresses the structure of flesh over the cheekbones and around the eyes, and finds the asymmetry of the eyebrows that gives the face its apprehensive expression. Immediately aware of a cramped area, he extends the back rail

of a chair in the detail set like a picture on the wall. (At this time, Wyeth was going to have the figure much larger in the composition, so the drawing ends right under the hands.)

Next he turns to the limp sweater hanging on the back of the chair, achieving his tones in the manner of sixteenth-century German engravings, with fine lines that follow the folds of the material (a technique Wyeth was using in drawings when he was thirteen years old). These initial sketches supply much of the actual construction of detail used in the final tempera (compare the button on the sweater, the ribs of the chair), but the general structure of the composition is dealt with in the rough sketches which he makes from memory. The chair is brought around closer to full-face in the next study and he conceives a design carved in the back rail, which in the painting has faded to a suggestion of wood-grain. Then at two o'clock one morning, he suddenly remembered the beam of light falling on the eye, and quickly made a sketch emphasizing the motif of the shadow cutting across the face. (Except for rare occasions like this, Wyeth works by daylight only.) Here the head seemed to be the right size, and Wyeth decided to make the figure smaller in the composition.

Without any further preparation, he then made a charcoal drawing on the gesso panel, copying the face, which he had squared off, by eye; placing the figure daringly to the left: roughly delineating the garments as he remembered seeing them on the wall. Now the content of the picture became more defined. On the following Saturday, while Wyeth was making sketches, a boy who was "not all there" paid Loper a visit. During the space of an hour, the boy went to the door, opened it and looked out about twenty times before Wyeth finally broke down and asked him what he was looking for, and the boy's irrelevant answer later became the title of the picture: *A Crow Flew By*. It seemed to express to the artist the nature of the bare wall with the hanging coats as "symbols of a man's whole life lined up."

Except for the tattered baseball shirt on the left, none of these sketches were used, and the artist invented the garments hanging from the wooden pegs. "I know the Negroes here in Chadds Ford. I've grown up with them and played with them as a boy and I now the kind of things they have in their homes." Thus the dark-green corduroy jacket is "like those worn by the Negro band in the neighborhood on Armistice Day" and "the one graceful note in the picture" is a piece of silk on the next peg that "his wife or somebody may have left there." For the jacket, he made sketches in his studio, taking the forms for the painting from the pencil sketch. The other, more loosely rendered in watercolor (he uses a cold-pressed Watman paper, AMC, here) was one of the few color notations made for this picture. When he gets interested in the color of a particular object, Wyeth prefers to

work directly from it. (He borrowed Loper's denim jacket to hang in his studio while he painted; and now at work on a picture of a seventeen-year-old boy riding a bicycle that is profusely decorated with some brightly colored fox-tails and figurines, he prevailed upon his model to part with much of this paraphernalia for the duration of the painting.) In the past he used to become increasingly precise in his successive sketches, developing a complete plan intricately detailed in a dry-brush watercolor, but he has abandoned this practice, realizing that his temperas were, in this case, simply copies of the final sketch.

Tacking all of his sketches on a board or spreading them around his feet on the floor, the artist again returned to the charcoal drawing on the gesso panel (he uses Frederick Weber Renaissance panels mounted on Masonite), shifting his forms back and forth, selecting and eliminating. Included among these work-sketches was a large drawing made years before of Bill, Ben Loper's brother, who used to spin tales for Wyeth. From this drawing, the artist took the contour of the head, and as the portrait developed in tempera, it became, the artist said, "a composite image of all the Negroes I've known." When the large masses were established in a loose contour drawing, he brushed away the charcoal, leaving faint traces of the drawing which he then refined with pen and ink (he never uses pencil on a gesso panel because it has an oily base). From this stage on, the changes in the drawing were accomplished with the brush.

After trying out many methods in the past decade, he finds elaborate formulas for tempera painting are usually "a lot of hokum" and that most books on the subject complicate matters so, "that you feel you have to be a chemist to start on a picture." His present technique is of the simplest, and apparently fool-proof: he never has any trouble with paint drying too fast or too slowly; his pigment never cracks or flakes off; and his clear luminous colors are permanent. The yolk of one egg (not necessarily stale) which he places in a small, white pan with a bit of distilled water (Purock) is sufficient medium for a day's work. (He used to add a drop of vinegar to the egg as a preservative, but discovered that this was apt to cause a "blush" on certain tones after a few months.) The thinned yolk is then lifted out with a spatula and mixed in the small indentations of his aluminum palette with equal amounts of pigment. (He keeps the pigments he is using on a picture— eight for the work-in-progress—covered with about half-an-inch of distilled water in jars on his palette table so that he won't have to wait while they dissolve when mixed with the egg.) More distilled water is kept ready in the second small pan to be added in minute proportions to the yolk or the mixed pigment to maintain the right consistency during the day. The egg causes a slight surface gloss which dries away after a year or so, leaving

the mat absorbent surface characteristic of pure tempera painting. (Wyeth used to give his finished pictures a coating of varnish, both as a protective measure and to heighten the "clarity and richness of tones," but he no longer does this because of the almost inescapable element of "cheapness" he felt it brought.)

"If you find a good pigment, it's a good idea to get a lot of it before the deposit is exhausted," says the artist, who has discovered that even the most reputable firms can't always maintain a color exactly consistent from year to year. Thus he acquires his dried pigments in large quantities (he bought out the entire stock of twelve different colors in two-gallon cans from a small company that went bankrupt), preferring none in particular of the different European and American makes he uses. "I have enough pigment to last the rest of my life, but," the artist adds, "you have to keep searching for new colors." Peter Hurd often came across unusual colors on his travels and sent them to Wyeth—the splendid yellow-ocher that forms the basic tone of this painting came from a deposit Hurd discovered on his ranch in New Mexico. Jars of dried pigment, some of it still unsifted and full of pebbles, are stored away in cabinets in his studio, but before he uses them, Wyeth has them tested for strength and permanency at the Hercules Powder Company Laboratories in nearby Wilmington.

His temperas—completely different in style and method from the sweeping, almost abstract watercolors which he often makes in half an hour—are always tightly worked. Holding his brush like a pencil, resting the heel of his hand on the board, he makes his strokes with finger movements. But although he works minutely over details, he wants them to carry across a room, and so he often walks back and forth from his easel while painting (unlike most tempera artists he never works at a desk). From the beginning to the end of the picture, he worked mainly with one very fine brush of camel's hair, less than half-an-inch long (No. 1 Delta's Jewel 5000), which he splayed so that it left four clearly defined strokes, each the width of a pen-line. Occasionally he used a larger brush, dry, to blend away the separate strokes; or, with lots of water, to lay on a wash of thin paint before building up his tones with the Delta 5000.

Painstakingly applying his paint in tiny strokes hatched in all directions, Wyeth began filling in the wall, working up to the pen-lines, leaving the hanging garments and the seated figure as blank areas. Mixing his different colors—ocher, cadmium-yellow-pale and -deep, black and burnt umber—both on the palette and the picture, the artist spent three weeks painting the wall before he was satisfied to go on. The wall alone brilliantly conveys a sense of three dimensions in its suggestion of air, as the basic ocher was overlaid with silvery tones, like floating particles of dust. "You can almost

tell," says the artist, "when you get the tone you want. Then you work out from there." Beginning with the coat on the left, working from the center outward toward the contour, the artist finished it thoroughly before going on to the next garment, arriving at the figure last. As each of the blank areas was filled in, he would return to the wall, subtly adjusting the surrounding tones, working back and forth on both sides of the outline. This technique demands a very clear preconception of the composition, and although the artist made many alterations from day to day, they were usually within the object he was working on. He rarely moves large masses. "If I begin changing around—'placing' things—then I know I'm through," the artist admits. "You can always paint something away. It's harder to add." But although he sticks closely to his original plan, contours are never stiff, but acquire a remarkable mobility in the variations of light along the edges of each object.

Although muted in tone ("I wanted everything to look dusty") much of the effect of the picture is carried in the peculiarly atmospheric color. A golden glow, rising from the ocher wall, suffuses the painting, reaching its highest pitch in the flesh around the lighted eye; subsiding to an ivory tone in the shirt on the left; imparting a dream-like insubstantiality to the body of the sitter as it comes forward in his vest. Keyed to this ocher are the dry, pale blue of the denim jacket; the warm, perversely elegant grey of the trousers; the oyster-white of the undershirt; and the intense gleams of pure white on the piece of silk. Unmixed white or black are employed only as accents, never as colors in themselves. When the artist wants white over a large area, he leaves the panel bare: in the baseball shirt, for instance, shadows were lightly rubbed on in ocher with a damp cloth (he used very little brushwork in this section of the picture), but for the rest of the garment he left the panel uncovered. And throughout the painting, although each object had its "local" color based on one pigment—terre verte for the corduroy, French grey for the trousers, burnt umber for the towel hanging under the corduroy hat—each is composed of several colors (except for the pure cadmium-red of the jacket lining). Sometimes they are mixed together while wet on the palette or picture, but more often the new color is applied in sparse, barely visible brushstrokes over the dry impasto, altering the tone by the close juxtaposition of the separate strokes almost in the manner of the Impressionists. In this way, the artist will sometimes work for a week with only one or two colors which are concentrated in one area but scattered over the rest of the picture, creating a unified tonality.

As the painting approached the finish, he began to alter sections in relation to the whole. The hands seemed inexpressive, so the artist returned to his model once again to make the eloquent study utilizing the poignant

upward thrust of the thumbs, the set of the fingernails and the distended veins for the final version. When all of the colors and forms were defined completely, the jacket seemed "too perfect" so the artist rubbed some of the color away with a damp cloth before reworking it with his brush to achieve the present moldy aspect. Then he polished tones and contours; the skin was stretched tight and shiny over the temples as highlights were sharpened; flecks of light picked out separate hairs on the side of the head; the jawline was pulled taut; folds and holes in the cloth were accented. And details—the gaping fold at the crook of the left elbow, the dangling lily-shaped cuff of the corduroy jacket, the dent in the hat, the eight buttons distributed over the three coats—acquire a hypnotic presence as each seems to be at the center of a complex play of tensions. The eye, like a stone dropped in a puddle, starts a series of subtly suggested circles—the smallest described by the eyebrow and the shadow next to the nose; the next one, more faintly, by the hairline and the top contours of the vest; then the crown of the head and the outer fold of the collar; and finally a powerful arc sweeps through the inner contour of the sleeve of the hanging jacket, around over to the hat, and then back to the arms. Opposed to this rhythm are the rigid diagonal forces which cut through the garments, figure and wall, sometimes as lines, sometimes as casual deepening of tone. And in the total, almost photographic aspect, the static scene is given its motions and counter-motions by the architectural structure which was defined by every careful stroke of Andrew Wyeth's brush.

Albers Paints a Picture

(1950)

Holding a tube of pigment in one hand and a palette-knife in the other, Josef Albers finished his *Homage to the Square* in five hours. Evenly painted in grey, black and white, the severe, anonymous construction of this picture does not seem to demand a virtuoso touch, and the artist insists that "someone else could have executed it." But the aseptic, almost militant simplicity of each of Albers' designs is the result of a long series of rejections— an arduous and complicated exercise of the element of choice. It is not surprising, therefore, that the artist tends to describe his technique in terms of what he renounces: "no smock, no skylight, no studio, no palette, no easel, no brushes, no medium, no canvas." (He works on a table in any room handy, and can keep a white linen suit immaculate throughout a painting session.) And, continuing to list his rejections in terms of style, he says "no variation in texture or '*matière*,' no personal handwriting, no stylization, no tricks, no 'twinkling of the eyes.' I want," he concludes, "to make my work as neutral as possible." And so each single color and form in his work is clearly circumscribed, measurable and describable (the artist lists them in his spectacularly tiny handwriting on the back of each board). But the complex moral issues and attitudes toward society—the puritanical conviction—that a susceptible observer might find in the total effect of any one of his pictures, could not be so easily accounted for. This extra dimension is precisely intended; as Albers says: "The concern of the artist is with the discrepancy between physical fact and psychological effect."

Eminently articulate, the fresh-complexioned, sixty-two-year-old artist has been making himself clear (and entertaining) to students of art, architecture and industrial design ever since he held his first classes in the Bauhaus workshop in 1923. After ten years at the world-influential German school and laboratory, where he married a student of one of his fellow-professors, Albers came to North Carolina, staying there for seventeen years to form the avant-garde art policy of Black Mountain College. Here he gave his unorthodox and far-reaching classes in design, while his wife, Anni, who is celebrated for her elegant tapestries and fabric designs, taught weaving. Recently appointed chairman of a new Department of Design at Yale

University, Albers, unlike many other artists, has always managed his duplex career of teaching and painting without infringement either way. Rather, each seems to be an integral part of the other: his own paintings make brilliant demonstrations of his verbal theories, while his theories constantly expand with his discoveries in design and color.

Exactly the opposite in method and approach from Mondrian, with whom his name is often inaccurately coupled, Albers does not arrive at his strict, geometric forms through sensibility—by inching a contour back and forth until it settles in place. Rather, his is a completely intellectual attack. With an almost oppressive consciousness of every aspect of his art ("not to be aware is a weakness for an artist," he says), Albers confines himself to "actual, mathematical relationships." As Mondrian strove until he found the utmost rigidity of a plane or straightness of an edge, Albers—a master of optical illusion—will try to make a ruled line look bent or a flat color seem modeled. As his opaque reds, blues, yellows or greens approach each other, they to shift in tone, lightening or deepening, becoming warmer or cooler, creating effects of overlapping films of color that have more in common with Turner's shimmering, transparent hues then they do with the Dutch master's unyielding primaries. And, finally, as Mondrian worked for months over one painting, Albers always makes his directly, never changing a color or form once it is put down. But although the physical execution takes only one night, the real evolution of a composition by this artist is through a long, tortuous series of sketches.

Working mainly by night, he begins searching for a theme, making small, freehand pencil drawings, playing with different geometric configurations. He manages to find such a staggering variety and expressiveness here that he is never lured away from his straight lines and symmetrical designs. "For me," says Albers, "a triangle has a face. A square, a circle—any elemental form—has features and therefore a 'look.' They act and provoke our reactions, just as complex forms, such as human or other faces and figures do. That many don't see this is unfortunate—but does not prove the contrary. Many are willing to see features in dress or furniture. Fewer are able to accept that every visible form and color has meaning." (Although he received a thorough academic training at the Royal Art School in Berlin and later at the Art Academy in Munich, Albers, with the years, became less and less interested in representational art. More related to his concept of the making of a picture was his Westphalian family tradition of craftsmen—blacksmiths on his mother's side, carpenters and tinkers on his father's.)

Right from this first step, through each stage, Albers finds himself confronted with thousands of possibilities. The lines that form his brittle diagrams are diminished here, lengthened there, made finer or heavier, juggled

to yield up a constantly increasing number of relationships. Teasing a problem for more and more solutions, Albers admits that he "hates to leave butter on the plate." When he finds some themes that interest him—for *Homage to the Square*, a group of progressively smaller squares, asymmetrically set on the horizontal axis, but symmetrically on the vertical one; and for the series of designs called *Transformations of a Scheme*, an arrangement of overlapping squares tilted against the rectangle of the panel—he discards a mass of sketches and begins to refine the few he has settled on.

From now on, the diagrams are more carefully controlled. He uses a ruler, working on graph paper, measuring his lines and angles exactly, balancing unit relationships. At this stage, he uses tracing paper over the graph paper, lifting forms from one drawing after another, constantly altering proportions and adjusting combinations; sometimes effecting a change with his soap eraser, but more often making a completely new plan. He will pick out a basic motif, using a pin to mark it off on five or six sheets of paper at one time, and then introduce counter-movements in the different variants. "After your first sketches," says the artist, "you must either enlarge or reduce." So the drawings in this group range from postage-stamp size to double that of the final work.

He goes no further than this preparation for the shiny-surfaced laminated plastics which comprise about half of his output every year. When he has decided on the final sketch . . . he makes a plan (actual size) on tracing paper, indicating the precise gauge measurements of the lines, which are then engraved, to reveal the white core of the board, on a pantograph machine by a company in New Jersey (Insulation Fabricators). The hard surface of the plate permits the drilling of very fine lines—down to .015 of an inch. When the finished engraving is returned to him, he sometimes wants to make further adjustments. He may find an area "too full," in which case he will reduce a set of lines by filling them in with black ink, but more often changes are in the nature of amplification. He will decide that certain shapes should be emphasized, which can be done either by making the outlines heavier or by making the enclosed areas grey and mat (this is accomplished by sand-blasting) in contrast to the smooth black finish of the rest of the panel. In these engravings, straight lines, describing static, geometric forms, fall into designs of the coldest orderliness—and yet the artist, with his genius for emphasis, avoids the immobility one would expect, achieving an unaccountable liveliness of expression as his forms seem to march from one plane to another (Albers sees them as "making grimaces"), giving a vivid sense of temporal—as well as spatial—rhythm.

But, for his paintings, this stage is just the point of departure for the next series of sketches in oil. He has made his format more specific: the

number of squares is more or less fixed at four, two of which are to be the same color but divided by an inscribed pencil line. These are made on blotting paper so that the surplus oil is absorbed (Albers finds that "tubed colors nowadays have too much oil"), leaving only enough to bind the color and produce the mat finish he generally prefers. And, as with his line drawings, he makes innumerable variants "to see what fish are in the net." Although he begins these with ruled lines, the pigment is applied rather quickly (he may make thirty in a week) and the edges are often unintentionally wavering. At this point, his main interest is the balance of masses of color next to one another. Using twenty different shades of grey ("all I could find"), several blacks and whites and some twenty other colors, the artist [makes] all of these sketches rarely if ever mixing his pigments. "All mixing is a subtractive measure," he maintains, "costing some loss of color and light." Although he works by night "because most pictures are looked at under artificial light," he occasionally breaks this routine since "certain colors demand cold daylight."

An authority on optical effects of colorants, Albers does not agree with the "harmony laws of various color systems which hold that only certain colors related in certain ways fit well together." (Among the theoreticians, he likes Ostwald and Chevreul—the latter for stressing contrasts over harmonies, and also Goethe, for his exhaustive studies on the science of color.) Interested in employing "color-discords" rather than harmonies, Albers feels that any group of colors can have an exciting relationship. "That seems simple enough," the artist continues, "but since the effect depends on the quantity, placement, shape, recurrence, ground, reflectability, etc., it remains a struggle, as color is the most relative medium in art, and it takes a trained eye to see the possibilities of correspondence among any given tones." In each of his sketches, he fixes proportions and area subdivisions before applying his pigment, explaining "I want color and form to have contradictory functions." Thus, working with one format, but varying the color in the different versions, he can alter the relation in depth of his fixed forms, making one rectangle become a hole in the surface of the larger one enclosing it, jut forward or even assume the identical plane; or he can make a shape expand or contract, from version to version, on the flat surface of the picture.

When the artist feels he has exhausted the possibilities here, he is ready to begin another selection. Spreading them out on the floor, he studies his sketches for hours, from up-close as well as from a distance (often using a reducing glass to qualify their effect), rejecting some immediately, and finally choosing some fifteen or twenty from a group triple that many. Then, taking this smaller group, he begins to experiment further, cutting out masks to lay over them, painting on the masks to try out other effects,

employing sheets of cellophane, as a time- and material-saving device, to paint on. (He is able to scrape the pigment from the cellophane and use it over again indefinitely). He also cuts up some of the sketches, removing a "border" or a center from one to place it over another.

Now, with one painting in mind, he decides on a range of colors— white, black and grey—for the first version of *Homage to the Square* (for subsequent versions—there are ten in the making—he returns to these sketches to pick out other combinations). Dispensing with the inscribed pencil line of the previous studies, he makes his final, and largest, preliminary sketches. In enlarging from one sketch to another, he finds that fixed relations of color and form alter with changes in size of the entire design. Therefore, he can't simply square off a sketch he likes and blow it up, but has to change a tone here or a proportion there to achieve the effect of the original. In all but one of the four, he has settled on a black center surrounded by grey, then white; but even here he continues to find a range in the play of tones. He has experimented with different greys . . . in the outer two sketches, sooty and deep in tone; in the others, closer to the center of the scale. The greys also vary in warmth, ranging from yellowish to bluish shades. When the artist made his ultimate selection from these, he said: "The picture is finished. All the problems are solved. Nothing remains but the execution."

In executing his pictures, he works exclusively on Masonite because he likes the "wall resistance" of boards, saying "canvas runs away from me." Preparing several boards at a time, he gives them three or four coats of Luminol casein, mixing the casein paste with linseed oil, turpentine and damar varnish "to make a fine soup." (If he used straight casein, his paintings might eventually flake off because he employs no medium while working.) Quick-drying, and still water-solvent despite the addition of oil, several coats of this mixture can be applied in one day, leaving the panels smooth, hard and ready for use in a couple of days. After giving the back of the board an oil coat so that it won't warp, he takes his first step—the ruling of the lines with a 7H pencil.

Conceiving of the area of the picture as one hundred units (the unit, in this case, being 3¼ inches square), he allowed sixteen units for the black area, forty-eight for the grey, and thirty-six for the white, so that a cross section of the composition would reveal the following proportions: divided horizontally—1 to 2 to 4 to 2 to 1; and divided vertically (rising from the bottom)— to ½ to 1 to 4 to 3 to 1½.

In painting, he starts from the lines, working slowly with equal strokes and equal quantities of pigment toward the center of a form. He often has to scrape off the burr at the edges of a color in his sketches, but this is not necessary here because he uses his paint thin—"just enough to cover." "It's

a durable technique," he remarks, "only one coat of paint. Black, of course, loses its blackness but it acquires a 'nobler skin.'" The artist finds that different makes of black "paste" differently: "the butteriness is different." For *Homage to the Square*, he discovered a three-year-old tube that had dried out a bit. "The pigment had become stickier, harder to manipulate"—a factor Albers found useful in qualifying the surface of the central square. But he never modulates a color by his application of pigment. His impastos are kept as uniform as possible, with the barely visible tufts—"the marks of the tool"—left by his palette knife, the only variation he allows. He does not believe in juxtaposing different textures to alter the drawing or tones. "Every color, every form should speak with its own voice," says the artist, who further expresses his disapproval of the use of texture by describing a varying impasto as "too painterly." However, he finds the contrast between mat and shiny surfaces very important—and a point to be considered when he selects his pigments. For the white areas in his painting, he prefers Permalba because "it's hard," but sometimes he uses Delux Dupont Superwhite Enamel, a flat paint which "stays white."

When a painting is finished, Albers designs a frame, taking into careful consideration its width and formation (he prefers beveled edges), and the color and texture of the wood—sometimes leaving it natural, sometimes polishing it or painting it himself. Occasionally he uses a strip of metal, and sometimes he just "backs" the picture so that it can be hung without a frame.

Although, throughout the development of each of his paintings, Albers' methods might seem to have more in common with the techniques of science than those of art, he disavows the attitudes of the former, stating "science aims at solving the problems of life, whereas art depends on unsolved problems." Thus, he considers each finished painting a variant rather than a final solution, leaving the way open for endless experiment. And the endless experiment that went before *Homage to the Square*—the interminable weighing of positions, proportions and tones, the constant comparison and selection, the amplification and condensation—stubbornly haunts this picture as three squares, reversing their offices and assuming different depths and sizes, seem to continue the flux that led to their creation. From the ruled lines which are, at last, peculiarly gentle and tentative, to the opaque colors lying next to one another in a delicate translucent atmosphere, an unadmitted sensibility stamps each aspect of this art, denying its first impersonal impact and maintaining, finally, that no one of his quiet pictures could have been painted by anyone but Josef Albers himself.

Gorky: Painter of
His Own Legend

(1951)

"**H**ere is an art entirely new," wrote André Breton in 1945, "here is the terminal of a most noble evolution, a most patient and rugged development which has been Gorky's for the past twenty years." Considered a Johnny-come-lately by some of Arshile Gorky's early admirers, Breton, however, was one of the first to give this artist a just appraisal in print. Even now, although the Whitney Museum has elected to give Gorky a retrospective exhibition covering two decades of his work, and although there is a growing group that considers him to be one of the greatest painters who ever picked up a brush in the Western Hemisphere (Clement Greenberg wrote in *The Nation* last year: "We have had to catch up with Gorky and learn taste from him . . . I now find Gorky a better painter than Ryder, Eakins, Homer, Cole, Allston, Whistler or any American artist of the past one can mention"), still Gorky has by no means been accepted by the larger public that waits for "time to tell." But aside from such inertia, some of the treatment this artist received at the hands of critics and fellow painters seems actually unfair. The artist, who was almost naïvely outspoken, often made very unflattering remarks about the work of others, many of whom were not above taking a personal and retaliatory view, and undoubtedly his reputation suffered from just such a simple cause.

Badgered throughout his career by accusations that he worked in the style of other painters, Gorky's borrowings were always highly deliberate. He never entertained the provincial (but popular) concept that originality in art is measured in terms of rejection of tradition. Untroubled by the fact that all serious artists are indebted to others—El Greco to Tintoretto, Ingres to David, Cézanne to Poussin—Gorky picked freely (and without covering up his tracks) from multiple sources.

Leonardo wrote in his *Treatise on the Art of Painting*: "Great love springs from great knowledge of the beloved object, and if you little know it, you will be able to love it only little or not at all." And maybe it works just as well the other way around; but, either way, Gorky proved in his work both his great love and his great knowledge of the various attitudes toward space in Western painting from Uccello to Picasso.

Paradoxically, the most obvious influences in his work—Picasso, Braque, Léger, Miró, Kandinsky—were not the most important: Gorky spent more time in the Metropolitan and the Frick than he did at the Museum of Modern Art. He had "key" works: corners of tapestries, pieces of archaic Greek sculpture, to which he returned over and over again. People who didn't meet him until years later remember the tall, black-bearded man coming up to them and launching into unsolicited explanations if they happened to linger before an El Greco, a Raphael or a Bosch that he felt possessive about.

Self-taught, he revealed from the beginning an extraordinary virtuosity, evident in some early, small pencil copies of details from Ingres, Poussin or Rembrandt in which he would twist the design as he worked, finishing abstract shapes he saw suggested in shadows or folds of material. Even in later years, forms in his abstractions were often directly inspired by these highly organized representations of reality. He would cut up prints and, turning the isolated fragments upside down, work from them as from a still-life. In the same way, his own few representational paintings were purified and formalized until nothing remained but clear, flat shapes and colors. Thus, the superb *Portrait of the Artist and His Mother* (a theme, taken from a small snap, of which he made several versions over a period of fifteen years) directly presages the style of the abstract *Garden in Sochi* of 1940.

Eclectic in techniques as well as concepts, Gorky, who wanted to be able to do everything, was constantly analyzing other artists' methods—in and out of museums. A painter who was his assistant on a government-sponsored mural project tells how Gorky, after visiting Ozenfant in his studio, rushed back to his own easel, and, picking up some brushes similar to Ozenfant's, immediately began to experiment with that artist's method of applying paint.

Tense, unsmiling and convivial, Gorky's passage through life, like his passage through museums, was not self-effacing. Like many a good artist before him, he regarded himself with a warm biographical interest which led him to fabricate or embellish incidents of his personal history, shuffle a few dates on his paintings (he was always investigating how old Raphael, Ingres and Cézanne were when they made certain important pictures), sign his name to a couple of essays he never wrote and, if no one tripped him up, pass off as his own a nice, bold line or two from the very few poems he read. A biography, as Arshile saw it, like a beard or a mustache, was something convenient to hide behind. Thus, from various accounts, all his own, he was born in three different countries in three different years (Tiflis, Russia, 1904, was, for some reason, his favorite choice). He was fond of telling his friends that he didn't speak until he was six years old. Before then he spoke only with the birds, he said. And unabashed by the most skeptical reactions (or, more likely, unaware of them), Gorky went on unfolding tale after tale of his childhood, of extraor-

dinary peasants, customs, events and conversations. But the lyrical imagination and intense visual cast of these descriptions were real. "About 194 feet away from our house," he once said, "on the road to the spring, my father had a little garden with a few apple trees which had retired from giving fruit. There was a ground constantly in shade, where grew incalculable amounts of wild carrots, and porcupines had made their nests. There was a blue rock, half-buried in the black earth with a few patches of moss placed here and there like fallen clouds. But from where came all the shadows in constant battle like the lancers of Paolo Uccello's painting?" And seeing him work (Gorky loved having a spectator or two while he painted) in his huge studio off Union Square park, where his easel, painting table, art materials and book shelves were all crowded next to the one window that faced north; or seeing him at parties chanting his own accompaniment (when Gorky said he "liked the song of one person," everyone knew whom he meant) to his slow, intricately paced Caucasian dances, even his least susceptible friends had to admit there was something fabulous about the man, his origins and his art. And as the facts are sifted from the fictions, his cherished childhood in the mountains of Northern Armenia remains as exotic, if less tranquil, than the ones he invented.

Wostanig Adoyen, born of an Armenian father and a Georgian mother in Hayotz Dzore, a village on Lake Van in Turkish Armenia, gave up his wonderful name when he came to America at the age of sixteen for the loaded and prophetic one of Arshile Gorky ("Gorky" means bitterness in Russian, he liked to explain, and "Arshile," Achilles). From the age of three, when his father left home to escape military service, the young artist (he made drawings constantly from an early age) had to contend with hardships which he gracefully omitted in his elaborate accounts of his past. A few years later, his mother took him and his three sisters to the city of Van, where he attended an American missionary school. This quiet period was ended during World War I, when they had to flee from the Turks to Russian Transcaucasia, where they settled in Privan, now capital of Soviet Armenia. Here, he attended an Armenian secondary school and, after hours, worked to help support the family. Two years after his mother's death in 1918, Arshile and his younger sister, Vartoosh, made their way to Tiflis and then followed their two older sisters to Boston, where they had been living for several years.

After five years divided vaguely between Boston and Providence and between factories and museums—where he made copies from pictures of American presidents to earn a living—Gorky came to New York, and, in 1925, entered the Grand Central School of Art as a student. Edmund Greacen, head of the school, soon appointed him a teacher in the sketch class, and from then until 1936, when he got on the Federal Art Project, Gorky supported himself by teaching and by selling an occasional drawing

or painting. (One of his private pupils and first patrons was Ethel Schwabacher, who wrote the warm, thorough and beautiful account of his life and art for the catalogue of the present show [the 1951 retrospective at the Whitney Museum], and is now writing a book on the artist.) By 1930, when he moved into his Union Square studio which he kept the rest of his life, Gorky—with his ironic, purring voice and studied accent, his melancholy brown eyes, his big, black mustache and his long, stooped figure—had become a well-known character, about whom legends were already being made. From then on, although he never had really smooth going, he managed to paint uninterruptedly. In 1941, he married Agnes Magruder; in 1943 his daughter Maro was born, and two years later came another child, Natasha. In 1945, Julien Levy became his dealer and he was formally recognized by the surrealists (a fact from which he derived much satisfaction) in the person of André Breton. But then, the next year, began the series of catastrophes that ended with his death in 1948.

"In January 1946, a fire reduced Gorky's Connecticut studio to ashes, destroying about thirty of his paintings, half of them done in the previous nine months," writes Ethel Schwabacher. "Not a book or a canvas was saved. One month later, Gorky was stricken with cancer and subjected to a drastic operation. . . . For Gorky, valuing health as a peasant does, this operation was a traumatic experience, an attack on the integrity of his ego, a fatal impairment of his physical completeness." In July, 1948, his neck was broken in an automobile accident, leaving his painting arm temporarily paralyzed and, three weeks later, Gorky, after warning almost everyone he met of his intention, committed suicide by hanging.

"He sought his own self all his life," wrote Antonin Artaud of Van Gogh, "with a strange energy and determination. And he did not commit suicide in a fit of madness, in the terror of being unsuccessful, but on the contrary, he had just succeeded and had just discovered who he was and what he was. But . . . there are days when the heart feels the impasse so terribly that it is stricken as if by a sunstroke with the idea that it can no longer go on."

Tireless, fastidious and intolerant, Gorky reduced personal tragedy—his own or anyone else's—to the level of discomfort or irrelevancy, and in the light of his lack of sympathy, any misfortune lost its magnitude. Thus his friends, not wanting to see the artist after his operation for fear he had been chastened, rejoiced, when they met him, at the first dirty crack. His energy was unimpaired, and in his last years he painted a large number of his most important pictures.

Gorky's first love was Cézanne, and often through the years he would set up his easel in Central Park and, after frightening away intrusive onlookers with a fierce scowl, make the little landscapes that demonstrate, in the softly

clumped brushstrokes and hacked-out edges, a profound understanding of that master. But several deviations hint at his own later style. He never took a large vista, but preferred to find all his distances in the branches of one tree or in one cluster of weeds, and even in *Still-life with Skull*, made in the mid-'twenties, the young artist had begun to find the shapes—as in the folds of the cloth to the right of the skull—that he later formalized into his visceral-floral imagery.

Around 1927, Gorky came under the influence of the cubists, and during the next five years made a series of gracefully designed still-lifes, mainly like Braque, using the conventional cubist paraphernalia. But here, too, blunt, mobile shapes of his own poked up their heads, lusty, original though somewhat illogical in the flat, cubist compositions. Often during these years, he found himself without money to buy paint, and so he made quantities of large pen-and-ink drawings, experimenting, endlessly with a variety of cross-hatchings to find brilliant tones in black, white and grey. Working with washable ink, he would sponge down the finished compositions to blur the edges and grey the paper. Always prodigal of time and effort, once when he had finished one of these drawings, the artist, eager to get his final effect, precipitously rubbed a soaking sponge over it, smearing two weeks' work into a black mass before he realized that he had used ordinary ink. Horrified at first, he shrugged his shoulders characteristically and said, "Oh well, I didn't like it anyway," and immediately began on another.

In 1935, the artist, for the first time, found a steady income from his work on the Federal Art Project. He used to astonish his fellow painters by the large amount of his salary that he spent on art materials and books. Squeezing out whole tubes on his palette for an hour's work, Gorky would begin to paint with a fierce extravagance that in itself made his work stand out against the skimpy, scumbled impastos characteristic of the social-realist art of the period. He would work on these paintings for years, scraping them with a razor blade at the end of each day's work, not in order to remove the paint, but to smooth it down for the stony surfaces that were an obsession with him at that time. Changing the colors of more or less fixed shapes, he would lay on coat after coat of pigment until the edges rolled up like rugs next to the shimmering black bands that physically divided them, like valleys. Painted in large areas of white and blazing pastel tones (one can trace the characteristic, heraldic lavenders and tans or golds back through his work to this period), these large compositions, with their fixed, airless spaces and compressed scale, reveal a passionate interest in Picasso and Léger. But by 1938, the geometric forms began to take on a perverse animation and shapes, almost unbearably weighted with pigment, seemed to shiver and sway, about to tear loose from their moorings for an impossible flight.

His murals—the first one consisting of ten large panels on the theme of aviation and, later, the two large compositions for the Aviation Building at the New York World's Fair—supplied a new direction for the artist (all his murals, including those made for Ben Marden's "Riviera" night club, seem to have been lost or destroyed). An intensive investigation of the isolated parts of an airplane led to a fantastic vocabulary of shapes, based on rudders, wings, instrument panels, searchlights and propellers, that kept cropping up in easel pictures of this period.

Then, in 1940, abandoning his spectacular, heavy impasto and closely packed spaces, he released these shapes in thin, clear colors, letting them fly freely over the surface of the canvas. In *Garden in Sochi*, the rollicking motion of the winsomely curved forms recall Miró, but the impasto—tight, smooth and opaque—and the construction of the composition, are completely different. The forms do not pass before the background, as in Miró, but rather are seen through apertures in the larger surfaces around them—and, actually, Gorky found the contours of his shapes here, not by painting them directly, but by cutting them with the surrounding color, a reverse method of drawing carried to brilliant conclusions in later works. At this time, breaking away from the still-life-and-interior scale of the cubists, he had put himself on the track of the opulent dream-landscapes of his greatest work.

After a few weeks in Connecticut in the summer of 1941, the artist managed to spend more and more time each year in the country—an environment which profoundly influenced his art. With twenty years of concentrated painting in the city behind him, Gorky, at last, could turn to his immediate surroundings for inspiration He responded to this first experience with a series of exuberant canvases worked in amorphic, loose washes of brilliant color, culminating in such gentle, grand and uninvolved works as *Waterfall*. In the summer of 1943, he made quantities of pencil and crayon drawings from which most of his later paintings were made. Sitting outside day after day, he found in the contours of weeds and foliage, a fantastic terrain, pitted with bright craters of color which he let swim isolated on the white paper while a labyrinthine pencil line, never stopping, created dizzy, tilted perspectives that catapulted the horizons to the top of the page. Then he focused more minutely, staring down into the hearts of flowers to come up with magnified stamens and pistils, aggressive as weapons, with petals like arching claws, leaves like pointed teeth and stems like spears, in an increasingly refined and sadistic imagery.

After a summer of drawing, Gorky would return to his studio to paint from his sketches which he followed closely, squaring them off and enlarging them—often leaving large areas of the white canvas bare, as he had the paper. His early years of arduously packing shapes in, working from both

sides of the contours, enabled him now to lay down a brush-line with one whipping stroke that cut into the space of the canvas, creating massive forms and astonishing shifts of volume. After a series of paintings in which color appeared only as bright gashes on the white surfaces, he began to cover his canvases again. In *The Leaf of an Artichoke Is an Owl,* transparent washes collide, creating sliding, viscous contours in a swirling, molten image of earth. But in other paintings of the same year, like *The Liver Is the Cock's Comb,* forms are more precisely defined and there are sharper value contrasts. Scattering his light and dark tones over a composition or, as he worded it, "spotting" them, he could alter the effect of the drawing unbelievably.

Keenly aware of horizontal and vertical impulses (he often liked to arrange his compositions on a cross-shape), no matter how he directed his forms, they float upward with an extraordinary buoyancy. Poignantly graceful, Gorky's gardens at first flutter with a light and witty loquacity, but, in an overpowering flux of successive and simultaneous images, forms change, as you look, into a cruel and opulent sexual imagery. Accents of bright color suddenly lose their meaning as flowers and become crevices, imparting a strange, voluptuous meaning to the surrounding pale, thinly washed surfaces; or plant forms change into human organs and a riotous pageant is transformed into a desolate landscape strewn with viscera. The general erotic content of his later work is suggested in some of the titles: *Soft Night, Betrothal, The Unattainable, Agony, Charred Beloved*—and all but one were made from the artist's sketches from nature.

Like Van Gogh, who, in 1890, made one of his greatest pictures, *Lazarus,* directly after an etching by Rembrandt, so Gorky, in 1945, patterned one of his masterpieces, *Diary of a Seducer,* on a print of Jacques Louis David's *Mars Disarmed by Venus.* This magnificent composition is built around the long torso of the reclining female nude (that Ingres borrowed and purified still further in the grisaille *Odalisque,* which Gorky adored). The massive forms on the horizon in the Gorky are brought up close, like the figures on the couch that stretches across the horizon in the David. Here, following the "negative" shapes—such as shadows or the areas between the different figures—Gorky finds fantastic metaphors for flesh. And one can further trace his transfigurations as a helmet becomes a vague deepening of tones in the background; Cupid's quiver turns into the delicate minaret rising from the foreground; or the sole of Venus' foot becomes an obscure little glow on a pale grey surface. And then, as you look from one painting to the other, watching the interplay, the David begins to change (a good artist may influence the past as much as it influences him) and we feel a new rhythm reverberating through it, as an echo of the work that came into being over a hundred years after.

Always interested in "the colors in the shade" (even his brightest hues have this quality), Gorky made several other grisaille paintings after the *Diary* (which was painted in yellowish, sooty greys, with touches of red and rust), and some large, faint charcoal drawings with tiny flickering accents of bright color. But in 1948, in his *Dark Green Painting* (unnamed by the artist) and in *Golden Brown Painting*, his colors—heavy, warm and curiously forbidding—create a sense of distances hollowed out of huge interiors not seen before in this artist's work. And then, looking at the anguished, faceless figures of Gorky's last untitled painting, stripped of every trace of the supernatural elegance by which we recognize his work, seeing the wild lunge in a totally different direction, the people who are aware of his greatness might feel they should be permitted some grief over the fact that he was stopped in the middle of a leap. But again, Artaud could pull them up short—"I do not call upon the Great Weeper to tell me with what supreme masterpieces painting might have been enriched. . . ." The artist had time enough to place himself in his epoch. But for his friends, who every now and then walk past Union Square park and catch themselves looking for his long stride and dour face, the least convincing fact that Arshile Gorky ever wove about himself is the one of his death.

Kerkam
Paints a Picture

(1951)

"**M**an is the most intricate thing an artist can find to paint," says Earl Kerkam. Defending his strictly limited choice of subjects (perhaps a bit flippantly) on the grounds of personal experience, he continues: "If I were a farmer, I'd do landscapes." Well known for his graceful still-lifes and serene, classical figures, the fifty-six-year-old painter—who looks and cracks wise like a character out of Damon Runyon's Broadway sagas—would certainly not fit the popular concept of what an artist should be. But that very fact, combined with the palatable lyricism of his work, might account for the generous share of publicity that Kerkam has received in the past fifteen years.

Largely self-taught, he started out as a commercial artist, beginning to earn his living when he was fourteen years old ("time of Mae Murray") making theater signs, a field he was led to naturally since his mother was on the stage. His formal training was acquired in snatches between jobs—a couple of months at the Art Students League and the Pennsylvania Academy of Fine Arts—or in his spare hours when he had "an easy job," like the time he was press representative for the St. Denis Theatre in Montreal and could spend his mornings at the Institute of Art there. These studies were interrupted when the first World War came and: "it was either the Canadian or the American army, so I came back to the U. S. where they took one look at me and decided my pen was mightier than my sword and I ended up making cartoons for the tank corps magazine. The old *New York World* ran a series of my cartoons, *Barrack Sports,* at the time and after the war my editors wanted me to bring my army characters into civilian life, but I wasn't much of a success," Kerkam says. "I found show business more exciting and it paid better so I made posters for Warner Brothers. Had to work on a very big scale; sometimes designed displays six stories high, like the big whale for *Moby Dick.* Movie only lasted a week. Didn't want a whole whale to go to waste. Next week they had a picture about a zeppelin, so I painted out the eye, cut off the tail, hung a basket under it and it served fine." But it was the artist's inventiveness in designing with large, flat areas of color that got him his first patron. Jules Mastbaum, president of a small movie company, who had endowed Philadelphia with a Rodin Museum, paid for the artist's first trip to Paris.

"I really went there to find out what people meant when they talked about modern art. I used to go to Picasso shows. Didn't understand them at all," he recalls, "so I thought Picasso was a faker. Then I met a painter in Paris, student of Hofmann, name of Jensen, who pointed out the way that Picasso constructed—so you could say that indirectly I got my first insight into modern drawing from Hofmann. During the first two years in Paris, I made sketches from the nude and at the end of each day I had enough drawings for a one man show. After another year I had my first exhibition. I had to pay twenty-five dollars for it and it was worth just that, so I decided I had to get some more money to do some more studying." Another year with Warner Brothers in Atlantic City supplied the backing for his return trip to Paris where he again concentrated on drawing. Then in 1932 he came back to America to stay, and after several years on the Federal Art Project has managed to support himself "the hard way" by the sale of his pictures. Working only from nature, he is as definite and uncomplicated about his methods and materials as he is about the abstract principles of his art. He paints in oil only ("never made a watercolor or a gouache in my life," he announces somewhat proudly), taking anywhere from a few hours to a few months on a picture. In the past, he would keep returning to the canvases lying around his studio, maintaining that "a picture isn't finished until it's framed and hanging in someone else's place." But recently he has begun to feel that he does his best work in one uninterrupted session. For his drawings, he long ago decided that pastel was "too final" a medium. Never using pastel as pastel—"If I want to work with more than one color I'd rather use oil"—he makes quantities of monotones, generally sanguine, smudging in his modeling with the side of the crayon and picking out his fluid contours with a black ink line. A piece of bamboo whittled down to a point and then slit to hold the ink ("a trick I learned from Lewitin in Paris") produces the unpredictable, irregular line—"You have to fight to get it down on paper"— that tears with such perverse speed around his quietly posed figures.

For his male figures, he works from a mirror (he has been the model for hundreds of his own paintings), but, severely anonymous, they are never self-portraits. And for his female figures, he almost invariably hires a model. "Friends are no good," he asserts, "they don't hold still." (Anita Gibson, the friend who posed for the work illustrated here was, he admits, an exception.) But although he insists on immobility, he periodically instructs his model to make slight alterations in the pose. Thus, at no point in the development of a painting is there much of a resemblance to the particular model he is using. In fact, to avoid even an accidental resemblance, he prefers to use two or three models for one picture. Interested in an "impersonal image of the human figure," he looks at his subject in terms of position, bulk and pat-

terns of light and dark, ignoring what is exceptional, particular or detailed. Searching for the most generalized aspects, he keeps the poses as simple as possible, mostly single figures standing with the arms at the sides.

His attitude toward a studio is undemanding. "Just so long as the light is cool and even—I can't work where there's a bit of sun—any room will do." (He has been working in space borrowed from the studio of a painter-friend, Franz Kline, since he had to give up his own studio a few months ago.) He always works by daylight because his colors are strictly related to nature ("when I want a blue background, I take the blue from something in the room"). Artificial light "seems to take the life out of the colors around." Kerkam's color is an important element in his pictures from the beginning. "I usually start on a yellow ground. It gives a general warmth and helps to hold the picture together. I probably got that," he adds with parenthetical modesty, "from Bonnard." Always interested in warm, blond color, he decided several years ago that his paintings were becoming too light in tone or, as he describes it, "I was whistling too softly." His recent work is characterized by pronounced value contrasts. Composing with masses of light and dark, defining the edges of a form by the juxtaposition of contrasting colors, he tries to keep the dark or "shadow" side of the figure warm and the light side cool. He tends to use raw sienna for "transparent shadows," but often a spectacular scarlet will appear instead. "I've explored chiaroscuro to the nth degree. In fact," he blandly continues, "I've almost spoiled my paintings with it." Thus in his recent work, he places much more stress on separate strokes of bright color which take on an energy independent of the patterns of light and dark as they shoot past or slice the edges of his solid forms.

Conceiving his subjects sculpturally, as solids before empty space (he talks of "building" a figure or a still-life), Kerkam is one of the few modern painters who is not squeamish about using the term "background" to describe the area around his subject. "The structural form of the model is my concern," he says, "and I want the background to stay 'back there.' If I filled it with shapes as important as the model, it would come forward." But never academically treated, the space in which Kerkam's figures exist is painted with the same broad strokes and intense, lyrical colors as the subjects themselves.

Preparation for painting is a simple matter: a few minutes to pose the model, a few more to take his brushes and pigments out of his paintbox and scatter them over his palette table and to place his easel at the right distance (about 8 feet) from the model, and then, wearing his street clothes complete with hat (baring his head and shedding his jacket only when he uses himself as a model) Kerkam is ready to start on a picture.

In the manner of his sanguine drawing, he makes a charcoal sketch, roughly blocking in the size and position of the figure on his canvas, which

is mounted on board so that he "can battle with it" (he doesn't stretch his canvas until the picture is finished because he often finds it necessary to cut it down). In the case of this figure, he completed this first sketch from a five-year-old drawing before he called in the model. Placing a small table on a stool to make a stand for her to lean on, he then had her assume a slightly different pose based directly on that of a standing figure in another painting, interested, even at this stage, in varying the gesture of his subject. Working very swiftly, the artist then cut down the size of the figure, narrowing and straightening the body from its original crouching position, squaring the shoulder-line and pushing the neck back, lashing out long contours with the tip of the charcoal and using the side to delineate shadows and to indicate the horizontal direction of the bricks in the fireplace (a motif he abandoned almost immediately). After drawing awhile, he decided the light on his subject was too uniform so he closed the blinds on one of the windows, thus producing sharper contrasts of light and dark. Also the busy construction of the table and chair began to bother him and he draped a bedspread over it. When he was ready to begin painting (after half an hour or so), he flicked off the excess charcoal with the end of a rag. Then, picking up a mixture of light red and raw sienna with a very fine sable brush, he began, as he had in his sketch, at the top of the canvas and, working his way downward through the multiple charcoal contours, he defined the figure with a single, continuous line. Then returning to the head ("I always paint the nose and forehead before the rest because that's the way a face is built"), the artist began to lay in the receding planes. A shadow under the nose was dabbed on with a brilliant red. Unmixed raw sienna made a deep tone on the temple, and white was added to it for the lower part of the face. Next he took a half-inch bristle-brush and combined several colors haphazardly to make a "dirty purple" for the hair. Continuing with this brush, which he held in his fist up close to the ferrule, he moved down the figure following the shadows with choppy, short strokes, constantly instructing the model to lift her head, lower her arm, pull back her shoulders, etc. Making these minor alterations in the pose, he thus utilized actual contours to build an imaginary figure, drawing one side of an arm for instance, and then changing its position slightly before drawing the other.

When the shadow structure was established, he began to work on the lighter areas, combining lemon yellow, white and a little sienna for a flesh tone which cascaded in vertical strokes down the center of the canvas. Then making a "concoction of almost everything on the palette" (this turned out to be a grey-green), he laid in the background, constantly muttering derogatory little descriptions of his tools and materials as he went along—"This goddam brush doesn't hold paint—This yellow has too much oil in

it"—etc. Taking a still wider brush, he indicated folds in the striped cloth with a deep grey, scattering a few strokes of each new color throughout the canvas. So far (after three hours) the strokes were all dry-brushed, but now he began to thin out his pigment with a mixture (half-and-half) of linseed oil and turpentine, unifying large areas with long, wet strokes of color. Every now and then he would pick up a piece of charcoal and scratch it through wet paint to leave lines that were, if not painted away, automatically fixed by the medium when the paint dried. Or, for a similar effect, he would use a fine brush to define the edge of a form with black paint. These black accents were, however, usually swallowed up again, greying the colors that covered them. . . .When the canvas was completely covered, the artist again began to work with short strokes and unmixed pigment—using it in thick gobs now, giving an unexpected weight to the pale, yellowish whites of the face and figure. Scarcely looking at his palette when he chooses his pigments, casual about cleaning his brushes when he changes over to a different color, Kerkam produces subtly gleaming tones at the end of one day's work that seem to be the result of weeks or months of careful adjustment and experiment.

Painting without the model on the second day, referring instead to the ruddy figure that inspired the pose, the artist reduced the body to formalized, sculptural masses of extraordinary weight and density. Planes were made clearer and more complex as the opaque tone of the forehead continued down the bridge of the nose, twisting intricately against the arabesque of the eyebrows and the arching shadow of the nose; or the left arm was pushed forward making the rib-cage smaller. And the spatial structure became more compact as the background, woven with criss-crossing strokes, pressed the shoulders down and closed in on the massive arms, which took an almost archaic bulk in relation to the narrowed torso. Then, as the tension of the composition increased, the literary element found in the taut, strained expression of the face and body gave way to the fawn-like placidity, impersonal almost to the point of blankness, that is characteristic of his female figures. Abstraction takes the form of idealization as a nude or a clothed figure comes close to being the same thing in this artist's work and garments seem to melt into flesh or a naked body is portrayed without any surface detail.

Up to now, the development of this picture—in the contracting contours and tightening brushstrokes—was not so much by a refinement as by a peculiar compression of form, and the figure finally had the density of a slab of granite. But despite the looming bulk and rigidity of the drawing, the picture presented an image of gentleness and even fragility, which effect resided in a rich, romantic tonality. The blue-grey background was flecked with short strokes of rust, ocher and grey. The lavender, in a heavy band under the left arm, subsided into a pale, cold pink in the shadows of the green cloth. And as

the colors of the surrounding space advanced over the figure—the rust of the background falling on the purplish brown hair, or the ocher notes mottling the central column of pale yellow—the painting shimmered with the warm, interior light that made Kerkam his reputation as a colorist.

At one time, not so long ago, the picture would, at this stage, have been finished. But since his last exhibition a year ago, the artist has been working in a new vein. Dissatisfied with a certain static quality; feeling he had lost or muffled the articulation of joints—the arms to the torso, the neck to the shoulders, the artist began to work on the picture again with just these sections in mind, taking off his shirt and using himself as a model. But here, as so often happens in the making of art, the picture took the lead and the painter followed, the alteration of each form starting a sequence of others. With the lowering of the arm, the weight of the trunk was shifted over to the left leg, twisting the figure almost full-face. And then, as the artist continued, working with the broad strokes of the earlier stages, muscles were reduced to flying segments and the figure took on an unmistakably masculine cast which extended up into the face as the artist's own rough features began to appear in the baroque strokes. After an hour of feverish painting, the original figure was obliterated, and after another hour, finding his colors had become muddied, Kerkam put this canvas aside and began on a fresh board of the same size.

Using the previous painting as a starting point, he followed the composition closely, even to the bold looping forms in the background. Again using himself as a model, elongating his own stocky frame in dripping washes of color, Kerkam found himself working in a style that seems to contradict the step-by-step development of this picture, and of all his previous techniques, as he slapped on thin, radiant pinks, blues, yellows and greys that recall Tiepolo's palette, to arrive in a few hours at the superb figure that is a direct culmination of thirty years' study of the human body. When Kerkam is finished with a figure, all we know of it is that it is a woman or a man. Shorn of specific character, mood or emotion; expressing no period, environment or position in a daily existence, these paintings of solitary people present, in modest and eloquent terms, the barest actuality of human substance.

David Smith
Makes a Sculpture

(1951)

Hot-forging a piece of metal with a trip-hammer, flame-cutting with an acetylene torch or welding his forms together, David Smith says "the change from one machine to another means no more than changing brushes to a painter or chisels to a carver. . . . Michelangelo spoke about the noise and the marble dust in our profession, but I finish the day looking more like a grease-ball than a miller."

The huge cylinders, tanks and boxes of metal scrap; the racks filled with bars of iron and steel-plate; the motor-driven tools with rubber hoses, discs and meters; the large negatively charged steel table on which he executes much of his work; the forging bed nearby; and the big Ford engine that supplies the current for welding and drowns out WQXR on his little radio in the corner, all help to give his working quarters near Bolton Landing, in the Adirondacks, the aspect of a small, erratic but thriving foundry. Here, since 1941, when he built the long room that serves as his studio, poured the concrete floor and topped the structure with a full row of north sky-lights set at a thirty-degree angle, Smith has turned out some twenty odd pieces of sculpture a year. With an oil stove at either end, the studio is usable through zero weather, and Smith's winter work-clothes—heavy ski shoes, hunter's-red wool jacket and blue jeans, like those sported by lumbermen in the district—are a further protection against low temperatures. Calling his shop the Terminal Iron Works, after a Brooklyn waterfront company owned by two Irishmen, Blackburn and Buckborn, who gave him working-space in their shop for his sculpture in the thirties, Smith feels that this name more closely defines his "beginning and method" than to call it a "studio." "Since 1933," he says, "I have modeled in wax for single bronze castings; I have carved marble and wood; but most of my works have been steel, which is my most fluent medium."

Born in 1906 in a "Sherwood Anderson town" in Indiana where he lived until he was eighteen, Smith left home to go to Ohio University, but quit after a short period and went to work in the Studebaker factory in South Bend, where he got his "first taste of metal-working." But it was not until seven years later, in 1933, when he borrowed a set of welding equip-

ment from a garage, that he began the metal sculpture for which he is known. Beginning his career as a painter in New York, he studied with John Sloan at the Art Students League where he met Dorothy Dehner, "a student a year ahead," who became his wife.

"You get something from everybody," says the sculptor. From Sloan, he "got revolt against established convention"; he was introduced to Cubism by Jan Matulka. A show of Gargallo at Brummer's and a piece at the Museum of Modern Art by Gonzáles, pioneer experimenter with sculpture in direct metal, interested him in the Spanish ironworking traditions. Most important, he feels, was "the intense interchange among artists on the project" and conversations with Stuart Davis, Gorky and John Graham "in the days when American abstract art was rarely shown except in artists' studios."

And now, although Smith likes his solitude, he still finds the company of artists necessary, and makes regular trips to New York "after several months of good work" to go to galleries and museums and to "run into late-up artists chewing the fat at the Sixth Avenue cafeteria, the Artists Club, the Cedar Tavern . . . then back to the hills," where he likes to "sit and dream of the city as I used to dream of the mountains when I sat on the dock in Brooklyn."

The sculptor—who worked on ships with Blackburn's crews of dock workers, and during the thirties at a locomotive works in Schenectady "where you had to lay down 120 feet of weld to earn a day's pay"—feels that his guiding techniques are not those of sculpture but of industry. "One thing I learned from working in factories," he says, "is that people who make things—whether it's automobiles, ships or locomotives—have to have a plentiful supply of materials. Art can't be made by a poor mouth, and I have to forget the cost problem on everything, because it is always more than I can afford—more than I get back from sales, most years more than I earn. For instance, 100 troy ounces of silver costs over $100; phos-copper costs $4 a pound; nickel and stainless steel electrodes cost $1.65 to $2 a pound; a sheet of stainless steel ⅛ inch thick and 4 by 8 feet costs $83, etc. I don't resent the cost of the best material or the finest tools and equipment. Every labor-saving machine, every safety device I can afford, I consider necessary." Since recently receiving his second Guggenheim Fellowship, Smith's stock is "larger than it has ever been before." Sheets of stainless steel, cold and hot rolled steel, bronze, copper and aluminum are stacked outside; lengths of strips, shapes and bar stock are racked in the basement of the house or interlaced in the joists of the roof; and stocks of bolts, nuts, taps, dies, paints, solvents, acids, protective coatings, oils, grinding wheels, polishing discs, dry pigments and waxes are stored on steel shelving in his shop.

From working all shifts on his various jobs, Smith also discovered his profound distaste for "routine-life." "Any two-thirds of the twenty-four

hours are wonderful as long as I can choose," says the sculptor, who puts in a regular twelve-hour working day which usually starts at 11:00 A.M. after a "leisurely breakfast and an hour of reading" in his large three-room, one-story house, six hundred feet from the shop. Built with similar economy and Spartan proportions, of pale grey cinderblocks, with a steel roof he welded on himself, a steel floor covered with rubber tile and huge plate-glass windows that face a magnificent stretch of mountains, this structure is plain, elegant and convenient. Here, in a small studio, working from quart bottles of colored ink, Smith makes quantities of the drawings that usually precede or accompany the development of his sculpture.

When he starts on a new work, Smith doesn't want to get involved with its dramatic meanings. "The explanation—the name—comes afterwards," he says. Looking at his recent work, *The Cathedral,* in terms of its inescapable social implications, he sees it as a "symbol of power—the state, the church or any individual's private mansion built at the expense of others." The relation between oppressor and oppressed is conceived as a relation between man and architecture. The poetic existence of the building comes to a focus in the predatory claw. The limp form on the steps under the talons, expressing "the concept of sacrifice," is "a man subjugated, alive or dead, it doesn't matter." The prominent disc in the back is a "symbol of the coin." The relic or fragment of a skeleton displayed on the "altar table" refers to a spurious "exaltation of the dead," as does the silhouette of the man hollowed out of the plaque on the left (here he uses "stitches" of metal running up the center of the figure to evoke the seams on the sacks sewn around corpses in the Middle Ages). The incised plaques suggest walls or the artworks on them and the upright bars reiterate this interior aspect as pillars, which then rise as towering spires in a construction, measuring only 3 feet high, that achieves heroic scale. But much of the content resides in the actual material used—forged steel, encrusted with pale oxides that suggest Pompeian pinks and golds.

"Possibly steel is so beautiful," the sculptor feels, "because of all the movement associated with it, its strength and functions. . . . Yet it is also brutal: the rapist, the murderer and death-dealing giants are also its offspring." Human brutality, "the race for survival," has been a predominant subject for this artist. From his predatory birds and dogs personifying greed and rapacity to his "spectres" of war swooping precipitously in fierce diagonals, Smith's sculpture in the past has been characterized by an overwhelming sense of motion, but his recent work, with the stress on the vertical and horizontal, reveals a new preoccupation with centralized balances and—particularly in the case of *The Cathedral*—with a curious climactic stillness. Evocative and complex, it expresses the termination of an event. The scene is transfixed, but motion is vividly implicit in the construction of its parts.

A flat disc seems to have rolled along its track on the cross-bar before coming to its present equilibrium; pillars with the rings around them can be seen as pistons arrested; a twisted column has reached an impasse in its logical movement downward as a drill; the scythe or scimitar supported by the column has come to the end of a predestined sweep to become the rim of a cupola; the prone form was moving erect before it was caught and pinned to the steps by the downward-pouncing claw. Finally, the separate members of a violent situation are resolved into parts of an architectural structure, as characters in Greek mythology are transfigured into symbols of their last act or emotion.

Conceiving a piece of sculpture through different levels of experience, Smith doesn't see a form as stationary but as "going places," having direction, force-lines, impetus: "Projection of an indicated form, continuance of an incompleted side, the suggestion of a solid by lines, or the vision of forms revolving at varying speeds—all such possibilities I consider and expect the viewer to contemplate. An art-form should not be platitudinous or pre-digested with no intellectual or spiritual demands on the consumer." The first impact of his sculpture on "the consumer" is, naturally, in terms of its most general associations. His works are primarily abstractions whose impetus and rhythm are a matter of "drawing" which then, secondarily, yields up the narrower action of the subject. And finally, on a third and more practical level of reference, Smith's forms suggest motion in the way that tools or parts of machinery not in use still reveal their predisposition to a specific function. It is mainly on this level that Smith consciously composes—and therefore he often finds that he can work with "ready-made" parts (he used sections of an old wagon for his first piece of metal sculpture in 1933). This interplay of form and function can follow either way. A theme will suggest a particular tool (an old hand-forged wood-bit that he had "lying around for fifteen years" became the figure with the wrung neck that he wanted for the foreground of *The Cathedral*); and conversely, a tool or piece of machinery will often suggest a theme: thus, four turnbuckles he found rusted together in an empty lot were brought home and cleaned and hung in his studio until one day, two months later, the sculptor recalls, "I recognized them as the bodies of soldiers with the hooks for heads," and immediately began work on an eloquent sculpture of four charging soldiers. Constantly on the lookout for discarded machinery, he loads his truck ("a necessity for a sculptor") with his bulky finds which are stored along with his regular stock.

Smith has "no set procedure in beginning a sculpture." Usually there are drawings—anything from sketches in pocket notebooks to the large ink drawings on sheets of linen rag. Some works start out as chalk outlines on the cement floor of his shop with cut steel forms working into the drawings; some, like *The Cathedral,* are begun and finished without sketches. There

always are, however, weeks of preparation. "I want an abundance of ideas and material so I always make many more pieces than I need. In this case, I knew more or less how the vertical structure, relating to church architecture and a forest maze, was to be arranged." So the first step was to forge a group of bars into right angles with unequal legs, the long leg in each case intended as an upright. In preparation for forging, the bars were clamped in a vise with a flame-torch trained on them and then anchored in place so that the sculptor was free to work on something else. About half of these forgings were selected for the initial grouping. Then the base was forged and a set of short, tapered bars were tack-welded around the rim as supports for the rising, angular structure. (If dissatisfied at any point in the development of a piece with the position or proportions of a form . . . he removes it by flame-cutting, a process "pretty much as easy as running a knife through butter.") For the fore-altar body, he cut down the stubby, partially forged limbs with a band-saw before welding them to the torso. And after the wood-bit was pounded into the limp, ropy line he wanted for the twisted neck, and the knob was built up with melted iron to form the head, they were attached—"like a ball and chain"—to the body which was then placed on the altar steps. When the twisted column was set on its supporting table, he began work on the hollow arm of the claw, cutting a boiler-tube in half "on the bias," and forging an elongated funnel from each of the parts. For lengths that have to tally exactly, he sometimes uses a micrometer, but more often he gauges distances by eye, testing relationships by holding the piece to be added up against the forms already fixed in place, and then extending or shortening the new piece to make it fit. Searching for the proportions of the plaques, he suspended various rectangles of paper in position, and when satisfied with the measurements, he formed them from steel-plate with an oxyacetylene cutting machine. This machine burns smoothly and is most useful, he finds, on straight lines and geometric forms; and the slag it leaves on the edges can be easily hammered off or else smoothed down with a grinder. For the negative "shroud-figure" in the left-hand plaque and for the "mural" on the right, he drew his forms with soapstone and then burned the design completely through the metal with a hand-torch.

Working constantly from five sides at once (including the top view), the sculptor will change from one metal to another during the development of a piece, sometimes because of a physical problem. For the glittering wounds under the talons, he used silver which "served aesthetically" and, thinner than water in its melted state, has a penetrating quality that makes it an excellent soldering agent for fine joints that are not under a strain. Also selected for their brilliance were the stainless steel rivets that plug up the holes or support the encircling bands of the uprights.

After all his forms were temporarily tack-welded into position and the sculptor felt he had no more adjustments to make, final arc-welding completed the assembly. . . .

The last step is the surfacing. "I've no aesthetic interest in tool-marks," says Smith. "My aim in handling materials is the same as in locomotive building—to arrive at a given form in the most efficient manner"; but "each method imparts its function to varying materials." And the sculptor is not necessarily interested in eradicating tool-marks either, and generally the act of beating a form into shape gives it its final surface. When he wants small, shiny spots—as on certain seams in *The Cathedral*—he uses a die-grinder with tungsten-carbide burrs, and although he sometimes works with so fine a burr that he needs a magnifying glass (on his medals, for instance), he rarely tries for a high polish, preferring a surface that expresses the crude nature of the metal. Using color in various ways this past year, he applied subdued metallic tones in even, mat coats with a spray gun to some works, or smeared rust solvent mixed with large quantities of powdered pigment on others—like the huge, red *Fish* recently shown at the Whitney Museum—achieving brilliant, streaky, raw washes; but for the subtle, blonde tones of *The Cathedral,* his method was more tentative. Dissolving splotches of rust, Smith coated the different metals of the piece with a phosphoric acid, mixing small amounts of cadmium powder with it to produce deposits which varied from the golden patina on the steps to the mottled, whitish-pink of the twisted column, all falling into a unified range of shimmering, elusive tones.

Finished, *The Cathedral* seems to expand through its own atmospheric haze as an historical edifice, bigger than life, undetailed and unapproachable, taking on as part of itself the surrounding air and countryside. This extraordinary sense of "landscape" in the coloring is reiterated formally in the powerful, horizontal lines that cut through the piece, giving it a curious effect of transparency as each of the elements seems to indicate a receding plane. And with the irregular placement of the six short legs or "corners" that support the "walls" of this sculpture, a sense of deep interior distance is created on the shallow base (the depth is only 17⅛ inches at the bottom step) as the first level of horizontals, including the two tables, seems always to fall at eye-level, no matter from which angle the piece is viewed. And thus, Smith has magically achieved his aim—to create a sculpture that is, in his own words, at once "scene and symbol."

Dymaxion Artist

(1952)

Editorial Note: *This essay was written on the occasion of the exhibition of Fuller's geodesic dome then on view at the Museum of Modern Art, New York.*

R. Buckminster Fuller is a phenomenon four years older than the twentieth century, and the century so far seems to be having trouble catching his lead. Occupying a fast-moving point in space somewhere between the tetrahedron and the sphere, Fuller now shoots into the public line of vision again, this time with his geodesic dome.

Although he has been involved over the last twenty-five years with questions of shelter, and is widely known for his radical and highly rational "Dymaxion" houses which were hailed upon their construction in various architectural journals, Fuller is not, in the conventional sense, an architect— in that no line or proportion or material of his houses is arrived at in aesthetic terms. But the spare beauty of his structures has always been recognized by his admirers—including the many artists who have been following his development closely over the last two decades. The recognition of this beauty, however, and the resemblance contemporary painting and sculpture often has to his structures, is a matter of the universal visual conditioning supplied by earlier artists—Cubists, Purists, Neo-Plasticists, Constructivists, and, in small part, the architecture of the functionalists. As a spectator or creator, the artist, after all, is concerned mainly with appearance. Thus Frank Lloyd Wright can maintain that "a house should have *the look* of a shelter." But Fuller, keeping close to the facts of his mechanics, wouldn't mind—would, no doubt, be delighted—if his houses had *the look* of flying saucers, provided they offered the all-inclusive efficiency that is his primary consideration. "Let's have a house go up in the form of good geometry," he suggests, and it is exactly here—in this good geometry made visible—that the beauty of his constructions is to be found.

A building, in Fuller's concept, is both a mechanical and a technological problem, not an aesthetic one and "the pound is the yardstick by which success and failure are measured." He employs the dome-shape because it gives maximum strength for each pound of structure, as it permits use of

materials in tension, allowing for a reduction in weight by as much as ninety-eight percent. And, constantly thinking in terms of manufacture and packaging as well as structure, computing the value of a house in terms of "schedule of performance—per pound, per dollar, per man-hour," he maintains that "if all people are to get high-quality shelter, that shelter must be industrially produced in enormous quantities." Able to meet these terms the geodesic dome outstrips any other framework of comparable size. Its properties seem magical: constructed of a discontinuous three-way grid which stresses its members equally and acts almost as a membrane in absorbing and distributing loads (Fuller describes this action as "the chemistry of tension"), the dome can be built in several layers and then trussed together to span great distances without disproportionate increases in framing weight. Lending itself to a variety of uses—railroad stations, airplane hangars, grain roofs, theaters, gyms, factories, department stores or housing for any number of people from a family to an army—the dome can be erected easily and quickly by unskilled labor; supports itself while being built; is completely demountable and reusable; and the aluminum struts that make up the triangulated grid of the framework can be turned out by any machine-shop.

With the machine-shop as an ever-present factor, all of Fuller's inventions have been conceived in terms of portability. Perhaps best known for his die-stamped metal bathrooms which incorporated walls, ceiling, floor and the three units in four sections; his three-wheeled Dymaxion cars; and his centrally pivoted Dymaxion houses, Fuller feels that the techniques of ship and airplane construction should be applied to the building of homes with much saving of weight and, consequently, money. (The term Dymaxion that he applies to many of his ventures is simply a personal trade-name for a philosophy which "aims to harness on a non-profit basis the maximum technological resources for the greatest number of people.") His Wichita House—not to be confused with the geodesic dome—is a proof that a luxury house, built on aeronautical principles, can be mass-produced. Built in an airplane factory with aircraft materials and tools, the house encloses more cubic feet per pound of structure than any in the world, and the entire structure could be crated and sent anywhere in the country for under a hundred dollars. When it was first publicized in 1946, some thirty-seven thousand letters flowed in from prospective purchasers, but materials were scarce and the initial expense of tooling-up an industry was prohibitive, so it was not put into production.

Breaking into print periodically since 1927 when he appeared with his first Dymaxion house, a hexagon hung on cables, Fuller as a celebrity generates an enormous amount of affection, outgoing and incoming. He is

regarded by a large public with the peculiar, dry devotion America usually reserves for her ballplayers, and his nickname, "Bucky," is immediately adopted by everyone who meets him or reads about him with the undemanding familiarity that sports fans display for their champions. And in turn, Bucky, who, one suspects, does not differentiate much between individuals, regards "the human family" with the same strong, disinterested love that he has for the tetrahedron or the ball-bearing. But the bantering warmth for Fuller as a personality that characterizes most of the articles written about him has tended, while enumerating his achievements, to cover up their practical meaning and cloud their social importance. Thus lists of his inventions are usually presented as the profuse, spectacular and disconnected products of a fabulous twentieth-century Leonardo: good news-value for the science fiction field but too revolutionary to be utilized now. The general suspicion of radical ideas simply because they are new— and particularly if there are too many of them coming from one source— may in part explain why his projects have not yet been put into mass production despite their possibilities. Of course the careless (i.e., private) use of terms like "the human family" is certainly not going to be reassuring to potential backers who might regard other factors as more pertinent to a sound investment. But the fact is that his enthusiasts among professionals and laymen are increasing in numbers almost from week to week. His researches are beginning to get the kind of excited but careful consideration that will lead to action as trade magazines are examining his plans in reverent detail and speculating about the potential consequences of his dome, and figures like U.S. Steel's Foster Gunnison are claiming that he is "the unquestioned genius of the entire field of prefabricated construction." (Fuller however, makes a difference between the industrially produced house of his dreams and the contemporary prefabricated house which he sees as a compromise in technological terms, since it is actually just a conventional structure utilizing more machine-made transportable units than other houses, but falling far short of full factory production.)

Teaching and lecturing, which supply Fuller with his income at present, also supply him with valuable manpower as he travels from college to college followed, like the Pied Piper, by the young. Graduate students, who are freshly equipped to calculate the intricate measurements and build the models of endless variants of the dome, flock around him ready to give time and energy to his projects while supporting themselves. From Black Mountain College came Kenneth Snelson, an art student who built Fuller's elusive, mobile geometric constructions immediately after attending his first lecture and who is now a fellow of the Fuller Research Foundation. (The Foundation puts out booklets and works out innumerable projects, hypo-

thetical and actual.) From M.I.T. came Zane Yost, who alone constructed a geodesic dome which spans 27 feet, with twenty-two dollars worth of plywood; and Harold Horowitz, who for two years has been investigating the materials and equipment necessary to make an autonomous house (another of Fuller's key ideas) with independent power, water and sewer lines. From the North Carolina State College School of Design came twenty graduate students who constructed the model of the textile mill. And in Montreal— where aluminum and steel are available on the open market—two of Fuller's "lieutenants," both under thirty, Jeffrey Lindsay, from the Institute of Design in Chicago, and Ted Pope, from a stray lecture, are putting two variants of the dome into commercial production on a small scale. Here, the cold figures make exciting reading. The larger dome, an aluminum framework with an Orlon skin, called "Weatherbreak," will roof a cubic foot and support seven pounds with each ounce of structure. 24½ feet high and 49 feet in diameter, offering a clear floor area of 1,450 square feet, it can be erected in forty-five man-hours. This dome costs $7,000, and the smaller one, a vacation house called "Skybreak," 500 square feet in floor area, costs $800 (duty, delivery and construction included). These are higher figures than they would be if the domes were produced in any quantity, but in the near future, Lindsay and Pope plan to lease shelter by the square foot on term contracts and when the contract is over they can dismantle the dome and put it up elsewhere. "Airplane hangar space is generally quoted as high as $100 per square foot of enclosure. We can do it for one-third that, on a permanent basis."

Also members of the Fuller Research Foundation are well-known figures like the architect George Nelson, who recently designed a graceful, loose arrangement of cubic units—"glorified pup tents"—which can be placed as separate rooms in various groupings under the enclosing shell. Although the dome allows for unheard of economy and fluidity in living quarters, this aspect—as Nelson and Fuller both admit—still has to be worked out in its details. But, taken as is, for huge amounts of storage space, temporary or permanent, for any situation that requires a completely sheltered area for men, machines or material in the shortest possible amount of time, the advantages of the dome are obvious. It can be flown to inaccessible areas and it permits a strict control of temperature. Insulation, for instance, can be accomplished by building one framework inside a larger one. And again, by the device of building a larger dome over the existing one, before dismantling the first, it can be expanded, if the need for more space arises, without interrupting its function as shelter. Depending on the height needed in relation to the distance spanned, the dome can vary from a shallow, segmented arc (the form that would probably be preferred for

covering large distances) to a three-quarter sphere when verticality is desired. And the trusswork, with strength increasing in ratio to the complexity of the grid, can vary from a simple pattern like that of "Weatherbreak" to the intricate grid of short steel units that make the enclosing shell of the textile mill (Fuller's chief lieutenant, a young engineer, Don Richter, took a couple of years to calculate the angles and strut-lengths of this pattern).

The textile mill mill is the most comprehensive demonstration of a possible application of the dome yet to be worked out by the Foundation. Cantilevered from a central mast, and independent of the enclosing shell, the floors here can assume shapes varied to suit the nature of the operation and the machinery assigned to them. Constructed of an openwork three-way grid, the floors act as sieves permitting services and materials to be passed through. Called a "fountain factory" (in contrast to the one-floor "pancake factory" that characterizes this industry) because the raw material is transferred to the top through the central duct and then passed down from process to process through the floors, its design is revolutionary in more than structural ways, as it allows for a complete re-processing of the different steps in the manufacture of cotton. Through the arrangement of his sieve-floor structure, Fuller makes it possible for automatic processes to be carried to ninety percent of total process.

A visionary who immediately converts his insights to practical application, Fuller is the founder of a system of mechanical-mathematical relationships which include the element of motion called "Energetic Geometry." This system—probably his greatest single contribution—supplies the basis for the miraculous trusswork of his domes. He began with "an absolute of nature," the tetrahedron, which is the geometric form enclosing the least volume with the most surface, and the sphere, which is the form that encloses the most volume with the least surface. He observed that each of these forms has a tendency to a particular motion: the tetrahedron tends to resist external pressure; the sphere tends to resist internal pressure. He liberated these two tendencies in a mechanical construction of a compound geometric form which he calls a Dymaxion. Composed of a number of "great circles" which intersect each other to form spherical triangles on the surface of a sphere, the Dymaxion permits a series of events. Its first degree of contraction is an icosohedron; then an octohedron; then tetrahedron; and finally a triangle which in this conception is a tetrahedron with zero altitude. If the Dymaxion is reduced to its most contracted form, the triangle, and then released, it will immediately spring to its most expanded form—the sphere. The Dymaxion in motion is called a "Quantum Machine" since it indicates a "more than coincidental" resemblance to

wave mechanic quanta phenomena which always end in triangulation. (The geodesic dome, incidentally, took its name from the science of geodesy which measures portions of the earth's surface by triangulation. Einstein, it is reported, was surprised, upon seeing Fuller's demonstrations, that these laws could be expounded in simple visual terms. But Fuller, like Leonardo, translates every abstract concept he deals with into physical fact.)

His stringently precise and specialized vocabulary indicates that he questioned almost everything he was ever taught from geometry to semantics. Author of several books, unique cartographer (the only patent-holder of a new method of map projection in the United States), Fuller has in the past held a variety of positions while carrying on his own researches. He was consulting editor of *Fortune*; editor of a technological survey for the Chrysler Corporation; chief mechanical engineer to the Board of Economic Warfare; and special assistant to the Deputy Administrator of the Foreign Economic Administration. Slipping easily from one category to another, described by none, Fuller sometimes terms himself a designer. But his definition of that term bears no resemblance to the commonly accepted one. His intentions and his methods obviously have nothing to do with those of the designers who pretty-up chairs, refrigerators, stoves or automobiles in "the modern style" with forms borrowed from Miró, Arp, Mondrian, Gabo, etc. Today the designer and the artist take very different positions on philosophical grounds—and Fuller's attitudes and techniques place him squarely in the camp of the artist. The term "designer" means two things to most artists, the same two things that the term "Mercenary" might have meant to a Crusader: a reformer who works for hire. (The case of the unemployed or self-employed reformer in no sense affects the issue.) The total overthrow of traditional ways of thinking implicit in Fuller's concepts has nothing to do with the compromise implicit in reform. And as for hire, Fuller, like the contemporary artist, was obliged, throughout his development, to be his own patron (except for the aid of an occasional enthusiast who was in a position to put his projects into production. Christopher Morley, who, in 1940 backed his design for the Dymaxion Deployment Unit—an adaptation of corrugated steel grain bins for emergency habitation—with the proceeds from his novel, *Kitty Foyle*; or Jack Gaty, of Beech Aircraft, who turned over the plant for the production of Fuller's Wichita House). And the third and most profound difference between a designer and an artist is one of approach. Being a reformer implies that there has to be something definite and limited to reform. Thus the designer starts out pragmatically with a specific problem which he attempts to solve. But as the designer is a reformer, the artist is an inventor—and he casts about for the problem only when he has a solution. Or, to put it another way, his solu-

tion defines the problem. Cézanne or the Cubists discovered the problems they solved only after they solved them. Mondrian explained that "the neo-plastic aesthetic . . . was founded by the creators of neoplastic after they had created the work itself." Picasso noted this fundamental aspect of being an artist when he said, "I do not seek, I find." And in the same way, Fuller's career has been a continuous series of interdependent solutions—of discoveries, of inventions—which are then applied to problems.

The role of the designer-reformer was largely propagandized by the Bauhaus whose aesthetic conceives of the artist or the designer (no distinction is made between them) as a craftsman. But as a craftsman, the work of the artist is involved only with "a background for living"—with the simple beautification of the objects that surround us in daily life. Malraux, in *The Creative Act*, gives a definition that takes in a little more territory for the artist as it suggests that there is more to art than aesthetics. "All art is a struggle against destiny, against man's awareness of all those forces outside himself that are indifferent to him or hostile; death and the tyrant earth." This definition, which involves a more ardent sense of social responsibility, comes closer to Fuller's concept than does the modest artist-craftsman theory of the Bauhaus.

In an article called *The Comprehensive Designer* (Trans/formation, 1950) and in any exposition of the meaning of his work, Fuller always begins with certain statistics: "The Human Family, now numbering two and one-quarter billion, is increasing at an annual rate of one per cent and trends toward three billion by the end of the second half of this century. Of this number, sixty-five per cent are chronically undernourished, and one-third of them are doomed to early demise due to conditions which could be altered or eliminated within the present scope of technology—specifically, that area of technology comprising the full ramification of the building arts."

Fuller has often been accused of throwing around abstractions. "The Human Family" is an abstraction; the premature death of three-quarters of a billion people is an abstraction. Except to each one of them. And except to men like Fuller, whose hard-headed genius it is to batter abstractions down to their concrete cores. Not philosophy, not science, nor engineering, nor economics, nor politics will be able, he feels, to deal with this problem, which is one of distribution. Fuller sees it simply as distribution of tonnage: "At present all the world's industrial, or surfaced, processed and reprocessed functional tonnage is in the service of one quarter of the world's population. . . ." He advocates no social upheavals, which, no matter how drastic, would fall far short. "All the politician can do regarding the problem is to take a fraction of that inadequate ration of supply from one group and apply it to another without changing the over-all ration. . . . All

that money can do is shower paper bills of digits on the conflagration. . . ." It will be industry, Fuller points out, that will solve the problem in terms of its own inescapable momentum: "The more people served by industrialization, the more efficient it becomes. . . . World per capita consumption will trend to equivalence of North America by end of century with world equivalence of standard of living." And here the Comprehensive Designer—defined as "an emerging synthesis of artist, inventor, mechanic, objective economist and evolutionary strategist"—takes his responsibility: "As first of first things, the designer must provide new and advanced standards of living for all peoples of the world." But whether the Comprehensive Designer succeeds or fails, he seems to be one of a kind.

The Modern Museum's Fifteen: Dickinson and Kiesler

(1953)

Frederick Kiesler, enlarging the positive precepts of the De Stijl group, and Edwin Dickinson, continuing the American Romantic tradition, seem, at first, to have little in common beyond the superficial facts that both are pushing sixty, are major American artists whose work is more or less unfamiliar to the art-wise public and are both in the Museum of Modern Art's "15 Americans" show.

Kiesler, who, as a young architect in Austria, was playfully tagged *Doktor Raum* because of his possessive attitude toward "space," which he made his personal property as a prefix for any project—the space-theater, -stage, -city, -house, -etc.—he happened to be working on, tops Mondrian's up to now irresistible finality with the next logical step in that militantly progressive aesthetic. Once made, it seems an inevitable step, but it took twenty-five years— and Kiesler—to make it. Thus his "clusters" or "galaxies" of paintings and sculpture are completely unexpected as they burst on the art-world with the impact of a great formal revelation. In the two-dimensional *Galaxy*, nineteen separate, small paintings are arranged in relations as carefully defined as the forms within any one of them. Each picture is complete in itself, offering a simple, autonomous balance as the eye finds a central focus in any one of them; but they are conceived as inseparable units of one composition. On the back of each unit is a diagram of the master-scheme, indicting the position of all the pictures and the exact measurements between them. They can be displayed on any wall that offers an uninterrupted expanse of 14 by 9 feet. Most of his galaxies are arranged on a strict vertical and horizontal plan, but the one in the Museum of Modern Art's exhibition, his largest so far, expands upward and outward on irregularly placed axes. The effect is staggering as colors and brushstrokes leap from one painting to another over intervals of wall space that are swallowed up in their action. This is art without secrets, open, aggressive and sudden, making its powerful radiating tensions immediately evident to the spectator, overwhelming him with the purely physical sensations of large scale, strong color and bold, plain form.

No expression could be further from the withdrawn, mysterious paintings of Edwin Dickinson. Here, an unearthly light wanders over lonely

lakes and fields, over melancholy faces, over anachronistically heavy folds of clothing, over fetish-like objects, leaving some forms untouched in dim, expansive recesses; burning intensely on others to pick up fragmentary images with a piercing, nightmarish clarity that recalls passages in Poe. The spectator penetrates these pictures slowly, peering into the darkened or bleached surfaces to experience one formal rhythm after another in a dreamlike succession of discoveries. This imagery reluctantly discloses its structure. And Dickinson himself is as reluctant to talk about his art as Kiesler—who has published numerous explanatory articles—is willing.

"The debacle of art as a necessity today," writes Kiesler rather pessimistically, "is caused by its separation from daily living, its isolation. . . . To separate sculpture and painting from the flow of our daily environment is to put them on pedestals, to shut them up in frames, thus destroying their integrative potentialities and arresting their continuity with our total mode of life." One suspects that Dickinson world be sublimely indifferent to "the integrative potentialities" of painting and that he'd doubt if they would be destroyed by a frame anyway. Standing for totally different values, each of these men, in his work, puts up a certain resistance against current trends in art, and that resistance—in both cases, paradoxically—fits in with a Renaissance state of mind. In a century when *the version* is king, when an artist's range is usually revealed in the juxtaposition of many of his pictures, Dickinson packs into a single work the time, energy and multiplicity of attitudes that other artists might put into several one man shows. Completely a painter, one painting can express his position completely. And Kiesler recalls Renaissance artists in his rebellion against the prevalent concept of a work of art as the production of a professional whose profession is determined by his medium. Painting, sculpture, architecture, stage-design—creating in all of these fields, Kiesler refuses to have his energies channelized by any one of them. Both of these artists, in the sense that they can compress a broad moral and aesthetic philosophy in a single work, are makers of masterpieces—inimitable and unmistakable statements of high facility and purpose.

In a country that places a premium on uniqueness of expression, the lack of recognition of such spectacular and original artists is rather astonishing. But the lack of public response to a great artist during his lifetime is not always the fault of the public. Kiesler, who came to America in 1926, is now showing his painting and sculpture for the first time. Vaguely known as an architect whose reputation is based mainly on his daring design for a "Floating City" in Paris in the 1925 International Exposition of Decorative Arts, Kiesler was never actually commissioned to design a building in the United States and rarely even exhibited the extraordinary models, such as his *Space-House*, 1933, or his *Endless House*, 1950, that are already widely

influencing students if not practitioners of architecture. Limiting his public appearances to occasional stage sets or designs for interiors, like that for Peggy Guggenheim's Surrealist "Art of This Century" gallery, Kiesler, a precocious leader in the center of the International Theater and Music Festival in Vienna at the age of twenty-eight, seemed to retire from active creative life on crossing the ocean a couple of years later. He has spent much of his time in New York as director of scenic design for the Juilliard School of Music, and also working in the School of Architecture at Columbia University. It was not until 1947, when he recrossed the ocean to supervise the construction of a fantastic "Hall of Superstition" in Paris, that the artist returned to his muse. At the instigation of André Breton, whose perception, in this instance, was brilliantly prophetic, Kiesler made his first piece of sculpture, a huge *Totem of Religions*, immediately revealing phenomenal gifts for this medium. In the five years since, with an energy apparently stored up over two and a half decades, the artist has produced enough painting and sculpture to fill a floor of any museum, but except for the two mammoth *Galaxies* now on view, none of this work has been publicly shown.

But America has no excuse for not recognizing Edwin Dickinson, who has been painting more or less uninterruptedly since the age of ten, and exhibiting—if not often, often enough to have been celebrated by now— during the past two decades. Any single one of his big pictures, since he hit his mature style in the late 'twenties, should establish his stature, as the *Raft of the Medusa* established that of Géricault. And although this country is notoriously slow to credit native genius (an artist like John Singleton Copley is still outrageously underrated as an international figure), one has every right to expect Dickinson to be represented in more than three American museums.

Kiesler, who is committed to the interrelation of life and art, and Dickinson, who puts as much of life into his art as it will absorb, differ from each other most essentially in their attitudes toward the relation of execution and theory. One might say that Dickinson has been painting a lifetime to present ultimately, in the bulk of his work, a defined philosophy of art. And Kiesler has been philosophizing a lifetime before arriving at the physical facts of painting and sculpture. The initial concept for his prodigious *Galaxies* was decades in the making; the execution, a matter of one afternoon for a painting, a couple of weeks for a sculpture. His long experience with architectural principles profoundly influences his treatment of both two- and three-dimensional space. Opening up with the drastic force of a prehistoric temple, his twelve-foot-high [*Galaxy*] sculpture, with its four lintels and piers, could actually serve as the skeleton of a house. The intricately contrived joints, self-explanatory in their clear articulation, are as sturdy as they look. Undoubtedly one of the deep pleasures this sculpture offers is the sense of its

substantiality. The spectator might easily be tempted—as Kiesler hopes he will—to step inside and sit down somewhere. "Sculpture should be touched not by the eye alone," he writes. "It should be enjoyed not only aesthetically but physically as well. This is a sculpture for relaxation."

In this *Galaxy*, as in the painted one, each unit is complete in itself. Dismantled and towering in a room, the separate elements have the ominous, commanding presence of primitive wood idols. Resembling huge bones or totems, they give the impression of having been painstakingly carved by hand. But Kiesler delights in disparities of method and effect. As he works on his small ovoid terra cottas for months, polishing and rubbing laboriously to alter a contour a fraction of an inch, here he whips out huge, elaborately twisted forms in a day with a band-saw. Devoted to this machine, which he finds "a real discovery," he insists on utilizing it for even the most delicate details. Uncannily anticipating his final forms, he laminates thin, flat pieces of wood together to achieve apparently impossible curves, or fits groups of irregularly shaped segments together to arrive at flat planes. These mechanical ingenuities, evident only on close examination, offer another important level on which to experience this work.

The weighty cross-bar of the base and the heavy rope looped eloquently over one of the joints were both inspired by the theme of his original *Totem*. The *Totem*—simultaneously a Christian and a pagan religious symbol, the artist suggests—was based on the principle of a primitive fire-making device, a wooden cross with a rope attached. But a motif in Kiesler's work often jumps from one medium to another. Thus, the version preceding this *Galaxy* was made as part of his 1948 stage production for Milhoud's *Le Pauvre Matelot*, and the version following it is the *Galaxy* of paintings.

Rising on the wall a foot higher than the sculpture, the grouping of the separate paintings is a witty echo of the wooden construction. A blue suggesting the sky to be seen through the open roof of the sculpture (which is intended for a site outdoors) appears in the uppermost units which together form a rough square like that of the lintels. Powerful strokes of ocher enamel skip from picture to picture in the asymmetrical cross that follows the plan of the base. And four vertical strips, the only parallel units in both *Galaxies*, become the piers. Broadly painted, with a sensuality and light-heartedness he never learned from De Stijl, this *Galaxy*—exhibiting a new principle, offering a new direction—is undeniably a revolutionary step in modern painting.

Offering nothing palpably new but his own unique talent, Edwin Dickinson, in terms of his awareness of the artistic climate about him, paints with as square a spirit of rebellion as does Kiesler. The rebellion, as manifested in his art, is directed against the rabid rejection—which is the

moral basis of much avant-garde art—of a whole area of past tradition. Dickinson stubbornly resists this pressure to reject, and continues to put anything into his painting that occurs to him, ruling out no technical possibilities, directly utilizing whole levels of non-painting experience. But his refusal to make his art on the basis of a pre-decided concept puts him in the position of following, not leading his painting. Working on a broad base of objective or traditional principles of structure, of modeling, of perspective, Dickinson can be surprised by the development of one of his own paintings in a way that avant-garde artists—taking conscious decision as a point of departure, knowing beforehand what they are trying to do—can never be surprised. And in this unfailing element of self-surprise is much of the vitality of his art. A scrupulously conscious workman, Dickinson veers away from conscious theory. Any theory (including that of progress) supplies limitations that the artist refuses to accept, yet this is painting that directly reflects its period. Any internal limitations that his style presents in personal characteristics—the cold, dreamy greys, lavenders, greens and sandy tones of his palette, the soft, smeary brushstrokes, the alternate sharpening and blurring of detail and the sudden, hallucinatory changes of perspective in his large compositions—are the result of method not theory. Rejecting progress-in-art as a philosophy, he is, nevertheless, not retrogressive in his manner of painting. The secret of his contemporaneity is precisely that he can accept modern techniques without referring to modern theory. Although his superb, small, "one-sitting" landscapes, without any naturalistic detail to hinge them to their specific sites, present clusters of planes that are visually abstract, the artist never set out to make a non-representational painting. As in the work of Hans Hofmann, nature is a private foil the artist insists on, whether or not its traces are visible in the finished work. But neither does he set out to "represent" a scene before him or one he imagines. Making one of his huge metaphysical compositions charged with a complex and overpowering symbolism, he works as strictly in terms of the plastic aspects of the painting as Mondrian did, endlessly tinkering with all the parts, wiping away whole areas of carefully defined composition, enlarging or diminishing his forms, moving planes back and forth, deepening and lightening his colors as he clings tenaciously to a painting day after day for years. Here, perspective becomes a major tool through which he arrives at the distribution of shapes over the flat surface of the canvas. And for his fabulous, unfinished composition of a ruin [*The Ruin*] on which he has been working since 1943, perspective becomes his subject matter—the total poetic content of the picture—as stone pillars and staircases, pools of water, birds, clouds and foliage swoop giddily away in response to an incredibly complicated scheme of multiple vanishing points. Stressing value—an ele-

ment as unfashionable today as perspective—rather than color, the artist also finds shapes in sharply contrasting areas of light and dark as solid forms are broken up or linked together by shifts in tone. Light becomes a means to disguise, not to describe the subject. Light falling on irregular surfaces, as this artist contrives them, offers him any shape he needs. Utilizing elusive off-tones—"colorless color" that seep through his compositions as shadow, mist or smoke, enveloping figures and objects, obliterating distances, creating planes without surface—Dickinson always achieves his forms with direct paint strokes. Looking into these incredibly rich purplish or creamy greys that seem the result of endless transparent glazes, one is startled to find that they are caught in coats of paint as forthright in application as those of Miró, as opaque in body as those of Léger.

His refusal to accept any philosophical limitations in his method of painting is carried into his choice and treatment of subject matter. Here, too, he rejects the pre-decision and the post-explanation. Compulsive and profound, this is a level of symbolism not available to any exposition but that of paint. Like the work of Arshile Gorky, which makes most other Surrealist imagery look contrived and pedantic by comparison, Dickinson's panoramas are not literary conceptions illustrated in paint. His compositions unfold in terms of visual not dramatic situations. If nude figures, elegantly and inexplicably twisted by death or sleep, lie in opulent interiors; if shadows lop off their heads and limbs; if walls melt away to reveal stormy skies, shattered tree-trunks, masts at sea or falling boulders, these effects are always based on the formal requirements of the two-dimensional spectacle the artist is creating, not on incidents he wants to suggest to the spectator. Allowing any suggestion to take hold, however, once his design is achieved, but never probing into his own intentions as they unfold on canvas, Dickinson is not a Surrealist. The narrative, colloquial temper of his symbolism is closer to that of folklore or to Gothic tales of the late eighteenth century. Like these, he deals with the exterior supernatural, not the interior "natural" territory of Surrealism. A Portuguese woman that the artist knew on Cape Cod is quietly portrayed in *Woodland Scene*. Her chin line fades into her neck and the V of her throat appears to be a pointed beard, heightening the masculine aspect given her by her rough overcoat. She seems to be sitting alone in her own room, but her pale face looms, stately and unperturbed, in the center of a holocaust. A rim of flames eats away at the shoulder line of the naked woman on her left. On the other side, a richly swathed girl lies unconscious, oddly suspended in one of the abrupt shifts of perspective the artist loves. A large lavender rose—recurring often in the work of this period—is caught at her breast which is illuminated by the fire in the smoldering underbrush. A brick wall and a plow handle, barely visi-

ble in the foreground, like the rose, keep their secret significance to themselves. And echoing the perversely placid expression of the seated figure, the polished satiny surface of the painting imparts a curious incorporeality and remoteness to the entire scene. The action of this fantasy is inextricable from that of paint. The dramatic core of the picture is not in the eloquent face of the old woman or in the haunting figure of the girl but in the magnificent hieroglyphs of their garments. Finding abstract forms wherever it falls, light is the hero of this painting as perspective is of *The Ruin*.

Venus, Eve, Leda, Diana et al.

(1953)

Editorial Note: *This essay is a review of* **The Female Form in Painting** *by Jean Cassou and Geoffrey Grigson and* **Nus d'Autrefois** *by Marcel Bovis and François St. Julien.*

When these two books were delivered one sunny afternoon in a house full of painters (mainly male), the book of photographs, *Nus d'Autrefois,* took immediate precedence over *The Female Form in Painting.* Aside from the single, pressing fact that the secondary characteristics of the female were more consistently present in the photographs (Christine Jorgensen's Renaissance counterpart could have posed, one suddenly realizes, for many of the painters), there were several logical reasons for the camera scoring over the brush in the relaxed atmosphere of this parlor. The paintings, for the most part, are almost tediously familiar. Opening with a conventional School of Memling figure (chronologically, Masolino is the earliest artist included), through Titian, Botticelli, Michelangelo, Cranach, Ingres, Courbet, Renoir to Matisse and Picasso, the book offers sixty-seven reproductions of which none is surprising (except the Picasso, which is surprising for its mediocrity when the inclusion of *Les Demoiselles d'Avignon* could have offered the fairest representation of this master on the subject). If one starts with the assumption—which both of these books do—that a nude is nude for a purpose, The Purpose is more evident in the photographs, which have a frank, libidinous cast the paintings for the most part lack— except, of course, for Rubens and the Fontainebleau School. The painted nude has, in the past, usually disguised her nakedness under the name— Venus (appearing here eleven times), Eve (five), Leda, Diana, Andromeda, Lucretia, Susanna, Vanity, Profane Love—that places her safely and impersonally out of reach in the Bible, in history, allegory or mythology. She is not just a woman. She is also the symbol of a woman, no matter how intimately (as in Rembrandt's *Bathsheba*) her particular flesh confronts us. But the nude seen through the nineteenth-century lens is invitingly anonymous and personal. Without a name, she is most intensely herself. Her aspect, absent-mindedly erotic, like that of a wife sleepily undressing after a late

party, is droll, domestic and not at all remote. Most of the photographs were obviously inspired by painters (and, as obviously, there are a few examples that work the other way around). Corot, Ingres, Courbet, Delacroix, Velásquez, Poussin, all leave their traces in the poses of the nudes and in their groupings, in the arrangement of draperies and even in the quality or the modeling, which is controlled more by retouching than by lighting. Apparently the nineteenth-century photographer went in for darkroom work to a much greater extent than the contemporary man. As details are emphasized or bleached out, and tonal contrasts modified or heightened, the figures gain a clarity of presence and purity of form that is anti-naturalistic. The spectacle seen through the eye of the lens was not accepted by these art-conscious photographers, but manipulated to fit preconceived desires. Some of these photographs are magnificently composed, and one could wish that photographers today were as aware of the painting around them. Certain photographs are included, the accompanying text (in French) suggests, not for aesthetic reasons but simply to illustrate different characteristics of this type of Victorian pornography. These examples, as might be expected, are moderate—dainty, naughty and sentimental, on a level, say, with Greuze's visions of kitchen maids or shepherdesses. Some could cause quite a bit of hilarity in the family circle: a plump, dignified lady wearing nothing but a carefully arranged pompadour, cotton stockings and buttoned-up shoes, carrying a carefully placed tray of apples; or another, similarly garbed, even plumper lady leaning against a bicycle, are extravagantly unmistakable specimens of the Second Sex.

Like *Nus d'Autrefois, The Female Form in Painting* stresses the theme before the manner in which it is handled, and thus includes studies of nudes that are below its top artistic standards (by Etty, Gros, Mengs, Pater, Domenichino, for instance) in order to make points about the various treatments of the subject. This seems an inadvisable and wasteful practice and one might wish the shortcomings of these artists were merely described in the text. However there are few enough of them and the case against the academic nude can undoubtedly be made clearer by such specific illustrations. With their object "to cut across art history for the purpose of revealing the development of a chosen theme," the authors direct one's attention to the female form before considering the art form, and the reader, being led to view these overly familiar paintings from this strictly held vantage point, can recapture some of their first impact. In juxtaposition, they yield up revelations that might be lost in another context. And it is to this book, more than the book of photographs, that one might continually return.

Jean Cassou and Geoffrey Grigson each supply a sprightly commentary. Both are ardent and opinionated and, although one might find numerous

occasions to disagree, their judgments are generally fresh and independent. But the argumentative tone tempts one to respond in kind. When M. Cassou announces flatly that Goya's *Maja Unclothed* is one of the most perfect examples of painting in the world, the reader, with as much if not more justification, may claim, "It is *not,*" and go on to the next point of contention. As he analyzes the nude in chronological, sociological, ethnological, national and aesthetic terms, this French poet-critic reveals a weakness for stale words, like "truth" and "beauty," without doing anything to revive them, and for such trite observations as "the German genius . . . does not truly apprehend the world except in war."

The atmosphere of controversy is consciously encouraged by the authors who carry their own differences of opinion into print. This seems an excellent idea, since it immediately places private attitudes in a correct perspective and liberates the book somewhat from the dogmatic tone so common to art criticism. The differences are minor and friendly ones and Mr. Grigson seems to come off on top in all of them. Either M. Cassou did not have the chance to comment on Mr. Grigson's text or else, which seems more likely, waived it—understandably, if the latter circumstance, because Mr. Grigson makes his case very thoroughly and it would be difficult to pick it apart. Unlike M. Cassou, he sticks to specific examples and it is his text that justifies the selection of paintings; so, very likely, they are all his choices. But, unfortunately, like so many critics who can respond sensitively to the art of previous centuries, he begins to go blind when things get closer to home. On the last page of the book he deals with all artists who have painted the nude since Renoir. Here Corinth, Toulouse-Lautrec, Munch and Bonnard get pretty rough treatment, and he seems to make the nude a closed book. With a Ruskinesque sentiment, "an honest object among objects is better than a lie among lies," artists are indirectly advised to stop painting The Girl and to sit back as spectators of "these images which have been given to us by five centuries of painting." But, of course, artists won't stop, and Mr. Grigson's grandson, no doubt, will be as enthusiastic about some painter of the nude in 1950 as Mr. Grigson is about Renoir.

Vicente Paints a Collage

(1953)

Collage has generally been the medium for an art of interruption, of abrupt jumps that break the initial momentum of mood, of plastic structure or of literary content. In Cubist collages, the jumps are mainly aesthetic, from one specific texture, pattern, plane or visual situation to another. In Dada collages, the jumps are from one fragment of reality to another, creating a sense of the bitter or the absurd. In Surrealism (to overemphasize the difference between these two movements), the jumps are from fantasy to reality or from fantasy to fantasy. And these juxtaposed elements, whatever they are, are usually caught midway in an attitude of surprise, like Marianne Moore's "real bird in a painted tree." For the observer, the expectation of what is to come—depending on whether he noticed the bird or the tree first—is dashed by the second sight. The interruption is perpetuated in one frozen moment. Action is caught at an impasse. Collages, to use cinematic terminology, are in most cases *stills.*

In reference to the bulk of the work in this forty-year-old medium, Esteban Vicente's collages are uncharacteristically fluid and animated. Color and forms give a sense of continuous motion, sliding into one another, exchanging positions, continuing beyond and negating the edges of the separate pieces of paper. His technique tends to obscure the fact that he is working with paper. Not only does he make no attempt to retain the character of paper in opposition to that of paint; he seems actually to be trying to disguise it both through his concept of drawing and in his treatment of the surface of the paper, which is deluged with washes of paint or scrubbed with pastel, charcoal, pen or pencil. Often, from a distance or in reproduction, his collages could be confused with his paintings. The aspirations and effects of both are identical. But because he is essentially involved with painting effects, there are several possibilities of collage that Vicente sacrifices to get where he's going.

The carefully cherished patterns and textures of the familiar collage accomplish two plastic objectives: they maintain the flat surface sacred to much modern art, and they fix the composition in a range of precisely limited scales—still-life, interior or human in reference. Vicente's irregularly

torn pieces of paper do not hold their flatness, but swoop off into deep perspectives. The surface of the paper has lost its immediacy—its two-dimensional presence—in exchange for a smoothly ambiguous large scale rare in this medium. Rejecting the close-up fragmentation of "classic" collage, Vicente chooses to see panoramas. Rejecting the possibilities of the "frozen moment," he offers, rather, an interweaving of events. The element of poetic shock—to be found in the concept of simultaneity—gives way in Vicente's work to a serenely single-minded and sequential imagery. Forms unfold in one measured procession. Unrelated to any of the specific traditions of this medium, Vicente's collages connect, rather, with painting traditions—of Expressionism, Fauvism, even Futurism. He is not interested in collage except "as a way to get somewhere else."

"Collage is a technique to arrive at a painting . . . collage is a sketch for painting . . . collage is a substitute for painting," says Vicente describing his rather unconventional attitude toward the medium. Concentrated on painting for some three decades, he backed into the collage one Sunday in Berkeley, California, in 1950, because he wanted to work and his paints and brushes had not yet arrived. He cut up a colored Sunday supplement and pasted up a composition. This first collage supplied the motif for a later painting. He has never begun one as a project in itself, but only as a kind of general relief when he is stuck on a painting or perhaps as an attempt to work out some specific area. However, "sometimes these sketches finish themselves." When this happens, the collage means much the same thing to him as one of his finished paintings. Although he spends much more of his time on his painting, collages now make up half of his annual output (about eight works in each medium). Spending months on a painting, weeks on a collage, he has developed methods so interactive that it is impossible to describe one without bringing up the other.

His present style is the result of a decade's struggle during which he did not exhibit. Through these years, he made hundreds of drawings, landscapes and portraits. Most of these works were sold or else destroyed. Vicente, however, was dissatisfied and finally abandoned working from nature, and turned to abstraction. The collages and paintings of the last three years that are stacked against the walls of his studio on New York's East Tenth Street seem to have no relation to the work done before 1950. Thus his present style seems to be another instance of the mysterious conversion described by Harold Rosenberg in his article on the American "Action Painters" [*Art News,* Dec. 1952] that swept through avant-garde art in the 'forties with all the passion of a religious movement.

Born in 1906 in Segovia, one of the provinces of old Castille, north of Madrid, near the Guadarama Mountains, Vicente decided to become an

artist when he was sixteen years old. He quit the military academy that his father and grandfather had gone to, and began to study sculpture at the School of Fine Arts in Madrid. Here he met a "very brilliant guy from Iowa named James Gilbert, very refined, could find values anywhere." Almost every artist seems to meet someone at the beginning of his career who profoundly and often inexplicably affects later decisions and attitudes, someone whose personal expression is identified with the peculiar glamour of art that hits certain people so hard that they are caught up with it for the rest of their lives. James Gilbert, the painter, was the someone for Vicente. They both quit school and began to work on their own, sharing a studio. Fascinated by Gilbert's intense preoccupation with his somber-toned landscapes, Vicente gave up sculpture after three years ("I always made the heads too small, anyway") and became a painter. "Plaster and clay seemed dead when I felt the appeal of color." He began to haunt the Prado. "It was most terrific to see the abundance of flesh of Rubens next to Greco who avoids the flesh . . . the colorless light of Velásquez and Goya." These artists all had their influence on his figure compositions. "Then I discovered that there were certain people in France—Cézanne, Matisse, Picasso." He bought little books of illustrations. He subscribed to Parisian magazines. And he began to get restless. "Madrid was El Prado . . . the past. The contemporary work was unrelated to both. I was looking for air." America had lots of air, be thought, but Gilbert persuaded him that it was the wrong kind. "America is no place for an artist," he was told, and the first words in English Gilbert taught him were how to ask for work—"commercial work." This discouraged Vicente sufficiently and he went to Paris instead, after having a show of abstractions in Madrid at the age of twenty-two. But it was difficult making a living in Paris too. He retouched photographs and worked on stage sets and did his painting at night. After spending several years in Paris, he decided "the whole thing was too commercial—too businesslike," and in 1936, he came to America to stay—and here, except for a small amount of time teaching, he has been able to devote himself to painting. He saw little thereafter of Gilbert, "who paints and paints and paints and never gives a show." But a small, superb portrait of Vicente by the painter from Iowa hangs in the apartment on Second Avenue, downtown, where Esteban lives with his wife, Teresa, a scholar who recently finished a work on Lorca. And every now and then, Gilbert leaves Chicago where he teaches at the University to come to New York and visit the Vicentes—a rare instance of the first important influence remaining a lifelong friend.

Other American artists to influence the young Vicente, more concretely, if perhaps less deeply, were Demuth, Dove, Ryder, Gorky—the first artists whose work impressed him upon his arrival in this country. But whether he

was working on the curious blunt-contoured figure compositions reminiscent of Daumier, with which he made his first reputation in this country in the late 'thirties, or on his recent abstractions that offer a direct reflection of participation in a large movement in contemporary American painting, there is always a stubborn insistence on private methods that sets Vicente's work apart, a heterodox technique—and, therefore, philosophy—within any style he chooses.

Heterodoxly, he begins a collage as he does a painting, with a charcoal drawing. His paper, like his canvas, is tacked to the ten-foot-square partition that serves as his easel. Then, working as if each step were to be the final one—since he has no preconceived ideas on how full or empty a finished work should look—he applies his colored paper, proceeding from small to large areas "so as not to block the space." Sometimes he decides a painting is finished when the canvas is not completely covered with pigment. And in the same way, the white of the original sheet of paper on which he pastes the colored pieces may be partially uncovered at the end. "The important thing is to keep the sensation of white, the open sensation of white. But," the painter continues, "this is most easily done by translating white into a color." So, generally, both his paintings and collages are covered by patches of contrasting hues that produce expansive and curiously volatile effects. This volatility results from the closeness of tone which is so uniform that, in a black-and-white photograph of one of his works, two contrasting colors will lose their boundaries and blend in one value. Seen in the changing light of an ordinary day, his colors keep shifting their relationships, becoming luminous at dusk, flat and clear at noon. Contrasting tones, he finds too graphic or static, and he prefers the wider play of light when drawing is carried by color alone. "Color to me means light," he says, rejecting the sensuality invoked when color means "surface."

The colors on his palette table are those of the sheets of paper stacked in his cabinet. Lavender, blue, grey, pink, rust, ocher and orange prevail. The shades are intermediate. Opaque, heavy, dusty, powdery, sooty, pale or deep, every color is modified by the addition of others—complementaries or white. He claims he never uses a pigment straight from the tube, but his reds and yellows often flare up with an intensity that seems improbable in a mixed color. The surface of his paper, like that of his canvas, is covered with thin, even washes that register the tracks of his brushes. Sometimes he works with construction papers, but he does not favor them because he often can't get the exact hues he wants, and also because they fade in time. He prefers to paint batches of paper in the desired colors . . . covering enough in one day to last for months. (For this he uses a Devoe lacquer.)

Pieces are torn out of these sheets and pinned in place. He constantly alters their size and shapes, tearing off strips, substituting larger or smaller

fragments, changing the position of color areas. This is done in much the same way that he paints, inching his way around the oddly tentative forms with small brushes. (He uses mostly long-haired ten-cent brushes from a hardware store, just a few good, short-haired bristle brushes.) As colors are kept close in tone, so the sizes of the separate shapes are delicately uniform. There are rarely leaps from small to large. The unit sizes remain more or less constant, and this evenness of size makes for the same sense of expansion and fluidity created by the evenness of tone.

Lines don't figure as contours, but mainly as scratches on the surface of a shape. Thus their action is textural or tonal, like that of brushstrokes, not sculptural, as in drawing. This applies only to the final stage. In the development of a painting or a collage, he keeps using charcoal to describe temporary contours which are then filled out or covered with paint or paper. Exceptional are a series of black-and-white collages which relate directly to drawings. The pieces of paper in these earliest collages were all cut out in the sharp, Futuristic edges that characterized both his painting and drawing of three years ago. But recently he prefers the evasive, fuzzy edges produced by tearing. He now uses scissors only occasionally to get slivers of color to wedge between the larger, vaguer forms, or to trim torn edges to a more precise line. In the case of this formal device, it was his painting that followed his collages rather than the other way around. Now areas of color on his canvas often resemble pieces of roughly torn paper. (Like a great many contemporary artists, he actually does pin on paper in the earlier stages of a painting to try out different shapes and colors—a time- and surface-saving device that probably stretches back to the Renaissance.)

When he is satisfied with the position of the pinned-up shapes, he pastes them in place, and then proceeds to pin and paste new areas on top of them. (For his large collages—they range from 36 by 45 to 7 by 9 inches—he employs "Foxpaste," a water paste which he mixes himself; for the smaller ones, a ready-made waterless paste does just as well.) He used to paste the paper carefully flat, but now allows the edges to rise up, buckle or curl. Thus emphasized, the edges create a subtle shift of planes even when they do not define a change in color. As he adds new areas, a piece of paper underneath may eventually be covered except for an edge. "Amazing the difference it makes whether a form is left over or directly applied," he says, but this observation, he admits, applies to painted shapes as well as pasted ones. Sometimes, after work of a week or two, the pieces of paper accumulate in thick layers; and since he dislikes heavy "impastos" in collage as in painting, he tears off the papers and starts over, just as he scrapes off paint to keep his actual impastos thin and transparent. All through the making of a collage, Vicente uses his brush freely, applying tempera, watercolor and

often oil. And over these painted surfaces may come charcoal, pencil, ink or pastel. Collage, in this Expressionist technique, is reduced to a non-ideological, purely physical process. If custom makes laws, then Vicente has quietly broken those of the collage. But art there any laws in this territory?

Collage is defined by Larousse (after reluctantly putting aside the initial, pleasant notion of "clarification of wine") as the action of pasting paper or the state of being pasted. More recently and eloquently, collage has been defined by John Myers, the hyperactive young New York dealer, as a "feel-ie." But action, state or technique, collage, as a method for arriving at a composition via paste and paper, is without a philosophical base, although it has been gratuitously identified with certain schools of painting, perhaps most closely with the Cubists. The reason for this association has less to do with the nature of collage than it does with the historical facts that it was a Cubist invention and that more Cubist artists than any others used it as a method. However they could and did accomplish the same arrangements of two-dimensional space with paint, making collages that looked like paintings and paintings that looked like collages; imitating printed fragments with pigment and painting over actual ones. Being the originators, they were naturally not concerned with purity of method.

A pure collage, then, might be a paste-up of ready-made, undoctored parts. Max Ernst, who cut up nineteenth-century illustrations and rearranged the sections in compositions whose startling effect lay in the fact that they looked as though they were directly drawn, made a point of never touching them with a pen or pencil, although it seemed impossible to achieve the junctions without "outside" aid. And, similarly, Landes Lewitin achieves his astonishing baroque compositions with forms melting imperceptibly together by simply cutting up colored magazine illustrations and pasting them together. Here again, the result seems that of a direct rendition. But how pure is a medium whose very effect of purity depends on the illusion that the composition was arrived at in another than the actual manner? Purity in this context is simply a matter of virtuosity and is therefore not a serious consideration in establishing the philosophical meaning of a work of art. The collages of Ernst and Lewitin are to be taken on grounds other than the undeniable purity of their techniques. The element of illusion in their work is not an inevitable by-product of the collage, but of the aesthetic of Surrealism.

Like the Surrealists, the Dada artists tended to leave a collage as a paste-up job of ready-made materials without imposing any painting materials. But unlike the Surrealists, and also the Cubists—both of which schools dealt heavily with trompe-l'oeil effects—the Dadaists did not generally work with or for illusion. Junctions were not disguised. Things were not

made to look like other things. Their scraps of paper were more often objects in themselves rather than the sections of reproductions or of images favored by the Surrealists. That is, they were ascertainably life-size. Using his real objects—theater tickets, post-marked envelopes, pieces of newspaper, etc.—for their actual associations, not for the optical illusions they might be forced to express, Kurt Schwitters used as the basis for his impassioned designs the authentic, if miniature, record of city-life to be found in the gutter. Of all the artists to use this medium, he is one of the few whose art could not have been made in any other way, but that is because of his dependence on the ready-made. The ready-made, however, is the raw material of Dada; it is not a prerequisite of collage.

Thus, the difference between the collages of the three schools is the difference between the schools themselves and no one of them can, on logical grounds, claim the medium for itself. Schwitters—who probably covered the most ground the most brilliantly, utilizing the Cubist concepts of form along with the content of Dada—could in addition be called the founder of the Expressionist techniques in collage. In a sense a traitor to Dada, since he dragged in his extraneous materials for formal as well as literary reasons, Schwitters was one of the first to begin painting over the junctions of paper. (The Cubists were generally pretty careful to observe the boundaries of their separate pieces of paper.) This step was picked up by several American artists. Robert Motherwell, also starting with the Cubist practice of painting on patterned paper, reached the point in some beautiful, big collages, of completely covering the paper with pigment. Misha Reznikoff tried something else in his "de-collages," ripping his compositions out of layers of colored paper previously pasted together to produce effects of great, slashing brushstrokes. Paper, in these works, was more or less reduced to a simple, paint-bearing surface. If this approach could be called a tradition, then this is the tradition with which Vicente might be related. He finds the controlled "constructivism" of the usual collage not to his taste, although, paradoxically, the artists whose work in this medium he most admires are among the nearest: Matisse, whose plain, lighthearted cut-outs or *découpages* are among the most spectacular paste-ups (although here, too, Schwitters made his mark); and Anne Ryan, whose small rectangles of cloth floating against pale walls of space are among the only collages that attain a scale comparable to Vicente's.

But most of these artists kept their space shallow and their forms parallel to the flat surface. Vicente seems to be one of the few artists working with collage who is interested in an expression of depth (excluding the instances of academic perspective often employed by the Surrealists). And it is through his management of depth that Vicente achieves his remarkable

scale and also his sense of mobility. The scale is non-human, that of a land-scape, although Vicente is no longer interested in landscape as a subject for painting. If he thinks of anything concrete when working on an abstraction, it is usually a figure. In [an] untitled collage [of 1953], the panorama seems to thrust a solid vertically through the center of the composition. But the solid is apprehended indirectly, the way one would see one's hand if pressed between the eyes. The shape is indeterminate; the substantiality guessed at. If the fingers are put in motion, the motion itself is clear while the outlines of the moving fingers are not. In the same way, one segment of Vicente's composition will seem at one moment to belong to the vague and mysteri-ous solid in the foreground; at the next, to the panorama behind. Positions are consistently ambiguous. Five white areas scattered over the surface will find a connection with one another and suggest a vast white plane seen as though through chinks in the colored areas. Then, suddenly, the white areas seem to shoot forward, becoming smaller as they assume their separate independent positions in the foreground. The same action takes place with the blue areas, with the yellow ones and with the "flesh-colored" ones. This action, involving scale as it does, is the result of the interplay of the four colors. Each of these colors has a range: the flesh color from pink to orange, the yellow deepens to ocher, the blue to purple and deep grey; but the unity of each color family is more prominent than their interior variety. The secret is that colors taken numerically produce these results. Any num-ber will do. As a student Vicente was much impressed in Madrid by a group of Goyas, each one limited to four colors, that blazed with the high, trans-parent, colorless, Spanish light he loves. The artist was a man with a beard, not a child, when he left Spain, and all of the things that he left behind keep coming back in his work. Landscape and drawing, which he pushes out of his art, push their way right back, and the hills of the *View of Toledo* here extend into the twentieth century.

Reynal Makes a Mosaic

(1953)

An original and intricate technique for the making of mosaics, developed by Jeanne Reynal over the two decades since she first began working in this medium, has made it possible for her to use as inlays materials which she finds strewn over the ground wherever she goes. Driving past a field in Nevada in 1943, she once spotted a rich supply of green jasper and gathered enough in a couple of hours for a whole mosaic. Wandering through some Hopi Indian ruins in Arizona, she came across quantities of obsidian, a black, volcanic glass used by the Indians for arrow- and spearheads, and she was able to fill a carton with enough to last for years. She found flakes of chert, a reddish, soapy-looking flint, on a visit to Mexico; pumice on a beach in California; colored pebbles at Jones Beach.

Working with these materials more or less as she finds them, she creates an art closely involved with the look of certain aspects of the earth. Unlike the painter's pigments, which are ground and mixed until all visible connection with their source vanishes, Miss Reynal's stones and minerals constantly thrust their origins upon you. Terrain is suggested not only by the rough, natural presence of her inlays, but also by her treatment of the bed of magnesite in which they are set. Sometimes her mosaics evoke a kind of no man's land where the topsoil is gone and no vegetation exists—where minerals push their way to the surface in acid-bright colors, fierce tints of clay, rock and mud baked by the sun—a brilliant, ravaged earth pitted with craters, scored with dried-up river-beds, contorted with rock formations. And yet these visions are mysteriously opulent. Her expanses of desert country somehow evade bleakness. As one peers into these landscapes, treasures are uncovered in dim recesses which unexpectedly yield the gleam of precious stones, or flat, sandy washouts suddenly catch the light and come to glittering life. This is the geography of anxiety turned to paranoiac hope—the nightmare becoming a dream of pleasure.

As in dreams, the quality of timelessness pervades. It would take centuries to change a contour here. These are prehistoric landscapes where years and seasons have no visible effects and only the hours of the day mark the passage of time. Sometimes the hot, arid light of noon seems to blaze over the sur-

faces, more often, the streaked, expansive jewel-tones of dawn or twilight or the deep greys, blues, greens and purples of dusk or night.

Also dreamlike is the relationship of the scene to the spectator. Her landscapes are without perspective, like relief maps. The artist manages to put the spectator in the sky; vast plains and ridges unfold as though seen from directly overhead. The spectator dangles in the air as the horizonless countryside spreads out beneath him. A sensation of falling toward it occurs, as details suddenly jut out, hypnotically clear, in areas that at first seemed far away and vague in surface. This hallucinatory effect was developed by the artist in a series of abstractions made several years ago.

But her abstract landscapes have a double existence as they also suggest the human body laid open. Then stark, geological forms and colors seem to soften and suddenly resemble close-ups of orifices, veins, arteries, glands, nerves, strands of muscle, glistening bones, unrolling viscera. Sometimes she carries this reference to human forms beyond abstraction, and faces and parts of bodies are unmistakably defined. (The names she gives her mosaics often refer to figures in mythology or folklore.)

"It's a Penelope kind of work," she says of her craft. "Everything that's done has to be undone. But I have to put it down first before I see how I have to change it. Then I edit, cut out." It is clear her method has very little to do with classic procedures. The traditional mosaic always follows a careful plan, leaving nothing to subsequent inspiration. Everything is worked out beforehand and then executed. The art is entirely in the preliminary design. In fact, most of the mosaics made since the Middle Ages have not been executed by the designer but by craftsmen. Miss Reynal's approach is constantly dynamic, subject to the intrusion of new ideas. Her method is empirical, like the painter's, or, more accurately, since her alterations demand a similar effort, like the sculptor's. She often begins without any preliminary sketch or, at most, with a rough charcoal drawing which has colors indicated in pastel. Working on one of her large mosaics for months she will change the drawing often, replacing stones or sections of magnesite with others. These constant alterations give the final version a fluency and variability of contour and surface unique in this medium.

As she uses an unconventional method of development and unconventional tesserae, i.e. inlays, so her setting bed is also not traditional. The usual setting is Portland cement. She prefers magnesite (Sorel cement) for several reasons, although admitting that many artists who have worked with it in the past have given it up as unsatisfactory. The disadvantages of magnesite are that it is "unmanageable—nasty with a trowel since it follows the tool," and that it sometimes develops a bloom from salt rising to the surface. The advantages— enough for her—are that it adheres to wood (ordinary cement pulls away) thus

making the portable mosaic possible; it has great tensile strength, doesn't need an armature and can be used in thin layers (Portland cement demands at least a half-inch thickness). Also unconventional is the fact that often the areas of magnesite are larger than the inlaid areas. Certain of her mosaics have so few tesserae that they could be described as paintings in concrete or, if they are monotoned, simply as low reliefs. Carrying this idea to an extreme, since a recent trip to Mexico, she has made several small mosaics, studded with pennies and nails, that could be taken as objects of sculpture. Though no one has exceeded Miss Reynal in the variety and daring of technique with this medium, her training was, in the strictest sense, conventional. For eight years, beginning in 1930, she worked as one of twelve apprentices in the Paris studio of the well-known Russian mosaicist Boris Anrep. Anrep, who designed the floor of the Bank of England, employed the most traditional methods. Under him, Miss Reynal mixed glue and cut stones and helped execute designs, laying out the tesserae in reverse on paper, finishing up section after section in preparation for installation. Architectural mosaics like these usually employ repeated motifs—she remembers 80 feet of acanthus leaves she pasted up for transportation to the walls of a Greek church—and demand an enormous amount of patience, but Miss Reynal enjoyed the practice of her craft and did not regard this kind of task as drudgery. However she finally decided that large commercial mosaics for public buildings were not her interest. A more intimate scale was required to accomplish what she wanted. In 1938, she left Paris and went to San Francisco where she had a studio for three years, then to Soda Springs, Calif., in the High Sierras, for five years. She made numerous trips to Nevada where she became familiar with the desert territory that was later to affect her work so deeply. In 1946, she came to New York.

As her art is bold, profuse and extremely definite in style, so is her home. Shelves are filled with American Indian and African statues in wood, decorated with beads, feathers and leather thongs, that range in height from 6 inches to 3 feet. Exotic plants in flower-pots surround a huge chicken–wire birdcage reaching from the floor to the ceiling at the end of the living room which extends the length of the building. Here small, brilliant, tropical birds have room to fly back and forth around an extravagant branched perch that looks like a piece of sculpture. One of the few artists who is in a position (and probably more rare, who has the inclination) to be a patron, Miss Reynal has packed the walls of every room and hallway in her house with large paintings, drawings and sculptures by her contemporaries: Gorky, Rothko, Max Ernst, de Kooning, Giacometti, Matta, Duchamp, Tanguy, Magritte, Noguchi, Sage, Sekula, Tanning, Hare, among them. Her studio is in the basement with windows facing on the garden, and here, under artificial light, she makes her mosaics.

The development of a mosaic, she says, "supplies all the childhood plea-sures—day-dreaming, making mud-pies, breaking someone's head." Her first step is to prime a plywood panel with a thin coating of magnesite. This mix-ture—two parts silica, one part magnesia and five parts sand, with magnesium chloride crystals diluted in water as the liquid—is made by feel to the consis-tency of whipped cream. She doesn't smooth it flat because often the irregu-larities suggest forms that she wants to define further. These are emphasized with charcoal. When the charcoal drawing on magnesite is roughed out, she decides on the colors of the different areas and on the stones that she will work with. She cuts all the stones she thinks will be necessary at the begin-ning since "it's maddening to have to cut more stones while the cement is drying." Cutting enough for one mosaic takes about ten days. The tesserae, cut one at a time, are held between her thumb and forefinger and given short thumps with the sharp-edged mosaicist's hammer. It looks dangerous, but Miss Reynal is surehanded. She wears a mask, however, to protect her eyes from flying particles. Although her tesserae often look irregular, the size and number of sides are decided beforehand and then precisely cut.

Although she has picked up many of her materials in her travels, the bulk of them come from sources she can turn to repeatedly. A marble works on Long Island supplies her with white marble from Vermont, yellow ocher marble from France and the Belgian black marbles. These come in small slabs which she then reduces to tesserae. Some materials, like sulphur sticks, she can get in a drug-store. Most are ordered from a mineralogist downtown: arsenic (the porous, grainy red and yellow substance used along the center of *The Keyhole*), or semi-precious stones like turquoise, beryl, amethyst, azurite, topaz. These last, she thinks of only in terms of color. "If any cheaper material is as beautiful, I would use it." Smalto, a Venetian enamel (manufactured by the Vatican) which comes in thousands of colors, is the material she uses in the largest quantities. A shiny, very hard substance made with a silica base col-ored by mineral salts, Smalto is ordered in unit sizes (usually ¾ inch by ¼ inch) directly from Italy. She ignores the range of colors offered and sticks almost exclusively to the primaries. Sulphur is the easiest material to cut; Chinese frit, rock-crystal and obsidian are the most difficult.

The next step is the mixing of the colored concrete. "You're supposed to keep the dry pigment down to six percent of the magnesite, but I load it until I get the color I want." The risk here is that the cement mix is weakened by the dry pigment and tends to become brittle and liable to crack, but so far the cracks have only been small fissures and have not changed the appearance of the surfaces, so the artist overlooks this disadvantage. The powdered pigment (water-solvent) is never added to the wet magnesite mixture because it would cause a streaky, marbleized effect that she finds undesirable. She mixes small

batches of colored magnesite at a time, and matches them by eye, liking the small accidents of misjudgment that occur. Ordinary ground colors in a range of umbers, ochers, the primaries, white and lamp black supply her with most of her pigments. But copper yields a series of colors ranging in pale tones from blue to green that she uses most often. Copper powder comes in several gold tones which turn grey when mixed wet with the magnesite but dry green. If she wants the tone to be still greener, she coats the magnesite with a magnesium-chloride solution the next day. She can also get an azure blue from this powder by brushing on ammonia when the magnesite is dry, arriving at different effects by her method of application: sprinkling it, for instance, can produce a dappled effect; dry-brushing, streaks.

When thoroughly mixed, the colored magnesite is then spread with a spatula over the area indicated in charcoal. Interested in "piercing the surface," she draws in the wet magnesite with various tools, her fingers, sticks, the edge of the spatula, or creates different textures by running a comb through it. While it is wet, the stones are dropped on, one at a time, and then after the magnesite is partly set, they are patted into place with the palm of the hand or a cobbler's hammer, which is made of tightly rolled leather and is remarkably hard.

The angle of the tesserae is important. They are rarely flat, but usually jut out from the surface, presenting corners. Sometimes their grouping seems haphazard and intended mainly for texture and color. But more controlled effects are possible. Strewn out thinly over one area, accumulating thickly in another, for instance, they can create an impression of chiaroscuro. Or their conformation will be carefully uniform, as in the crescent shapes at the center of *The Keyhole*. This sudden formality in the midst of more casual arrangements of the tesserae gives the ordered areas a nuclear importance out of relation to their size, like a small group of houses huddled together in a large valley. The color of the stones is carefully related in contrasts with, or approximations of, the background color of the setting bed. Also the balance between glittering stones and light-absorbent or lusterless ones like the marbles is carefully observed. Often, after the stones are in place, she takes a kitchen strainer and sifts the dust left over from the stone-cutting into the wet concrete, patting it down with the leather hammer to fix it in place. This creates an effect like a glaze in painting, as though the color underneath is seen through a veil.

Her working time varies with the humidity. She has about six hours on a damp day to work over an area of magnesite before it dries, less when the atmosphere is dry. Usually the original layer of magnesite is completely covered with new colored areas early in the development of her mosaics. She utilizes different levels in the manner of low relief, making some of them

bulkier than others, adding more tesserae in the manner outlined above. Then the alterations begin. Dissatisfied with an area, she will dislodge the stones with a chisel. A dentist's chisel is used if she wants to dislodge one stone from a tight mass leaving the others intact. Sometimes when the stones are removed leaving the Magnesite pitted with their craters, she allows the area to remain in this state, feeling that the pits can be as expressive as the stones themselves. Recent works are not as heavily studded as those of even two years ago. Often she will continue hacking away to remove all the colored concrete and lay in a new coat.

To change a color she will sometimes make a thin wash of magnesite and using a brush, paint over an area, covering the stones and obliterating their luster. The stones then exist simply as texture, having lost all separateness from their setting. If she changes her mind and wants to remove the wash of magnesite and return the glitter to her stones, she uses a mixture of hydrochloric acid. She will also change the color of the magnesite with Ripolin enamel or tempera. If she paints on the cement when it is wet, she achieves a kind of flat, fresco surface; but laid down in several coats on dry magnesite, the Ripolin will retain its shininess.

Once the magnesite is dry, she thinks of it as a surface on which to carve, as she had first modeled in the wet areas. She will gouge out a canal, fill it with magnesite and set in a line-up of stones to function as a contour (as in the upper center of *The Keyhole*). All through the development of a mosaic, she works with the panel laid flat on a large work table. Working on it from all four sides, she packs in her forms, thus creating her positive, skyless terrain that is at every point equidistant from the eye and without perspective. This approach allows for different interior balances and she will occasionally change her mind about which side is the top. When she settles on a theme, she often makes several versions. Before she began to work on *The Keyhole*, she finished the similar, but more elaborate, work *Stallion Oat*.

Comparing the two, one finds that in most areas, the development from the first to the second results in a more active magnesite surface and fewer tesserae. When she is finished with a mosaic, the drawing is carried by several elements: the carving and modeling of the surface of the setting bed; the shapes described by the different colors of the magnesite; the configurations of the stones. And over it all, with an action of their own, play the flashes of light as different facets of the stones pick up their changeable, glittering pathways in even the dimmest room. In a strong, flat light, her mosaics look almost like painting. It is in oblique half-lights that the full force of this medium appears.

Subject:
What, How, or Who?

(1955)

Artists in the far and near past have often been violently partisan about style and subject as distinct elements of painting: Ingres being led through a roomful of Delacroix's paintings with a cloak over his head because he could not bear the style of painting; Charles Le Brun, insisting certain themes were proper for painting and others not—grand subjects for the Grand Style; Courbet, fiercely convinced that the "realism" of his subject should be matched by the "Realism" of his style. But, after Cubism, the idea of making style itself the subject of painting emerged as a new basis for controversy. The more vehement defenders of this view apparently find that the inclusion of a "representation of nature" forces styles-as-the-subject out of the picture—a state of affairs to be avoided at all costs. Here certain abstract painters are acting like suffragettes.

But actually the fight is over, and they have had the vote for quite a while. The issue, then, seems to be that some want to take the vote away from the other side. One well-known spokesman for this attitude recently claimed that any painter today not working abstractly is working in a minor mode; and another, that some of the young painters have "lost heart and abandoned Abstract-Expressionism in cowardly fashion to return to representational work." The fact is undeniable: while the White House, the State Department, the Vatican, the Communist Party, and the artists and critics who simper at the public-at-large still regard "naturalism" as the only legitimate painting, the painter *in the avant-garde* who takes any visual aspect of nature as a subject for his painting is being put on the defensive. The tables have been turned. Docile art students can take up Non-Objective art in as conventional a spirit as their predecessors turned to Realism. The "taste bureaucracy"—museums, schools, art and architecture as well as design and fashion magazines, advertising agencies—all freely accept abstraction, if largely on a false premise, as a matter of style, not of subject. Seeing art in terms of style, they (and many painters) accept it and reject it on this basis only. Esthetics, here, is entirely the subject of politics and common sense.

In terms of common sense, nature is objective reality and art is subjective reality. Nature is what we have, and art is what we want. Nature is the present,

and art is the future. But common sense is only the past. Common sense is worldly thinking. Its aspiration is prestige. The technique of prestige, however disguised, is force. The emotion of force is anger. And today the artist is often an angry man, involved with the values of common sense. But art was never made with common sense, and nature has always eluded its grasp.

One angry claim, expressed often and in detail by many artists, is that a painting containing any element other than itself is not art, or that it is that much less art than it is something different from "pure painting." Purity and experience are made antithetical. Purity is exclusive and exercises choice; experience, nature for the purpose of art, invites *anybody. Enter nature, exit art* is the battle-cry of this camp. Values are based not on the direction an artist takes, not on how far he has gone. Here, if wishes were paint rags, a great deal of art would be wiped out of existence in the sweep of a category.

With another group, for whom the *personal* is the only authentic style, art, with or without overt suggestions of nature, is taken for granted, but artists are valued on the basis of some vague sensation, cherished for its vagueness. Here definition is resented as tyranny. Like Hollywood stars, artists have *it* or they do not. This faction breathlessly accepts Giacometti but draws the line at Picasso, or accepts Picasso but draws the line at Jackson Pollock, or accepts Pollock but draws the line at Barnett Newman. The important thing for these sensitives as for the purists, whether the grounds are idolatrous or ideological, is to *draw the line* and leave somebody out.

Most artists today, unlike the Impressionists or the Cubists, feel they are alone with their aspirations. They find company in their antagonisms. Sometimes, oddly, the antagonisms seem to work in opposite directions simultaneously. That is, artists who are in favor of a representation of nature may be opposed to the inclusion of actual bits of nature in abstract painting and collage, or the other way around. In both cases, they feel some sacred canon of art has been violated. The exclusion or inclusion of nature is, however, not a matter of the individual artist's choice. For art, nature is unavoidable. There is no getting away from it, or, as the painter Leland Bell said, "nature is all we have."

Nature might be defined as anything which presents itself as fact—that includes all art other than one's own. And after a while, one's own too, if one begins to be detached from it and influenced by it, which happens to almost every artist. Nature does not imitate art; it devours it. If one does not want to paint a still-life or a landscape or a figure now, one can paint an Albers or a Rothko or a Kline. They are equally real visual phenomena of the world around us. That is, there is a point where any work stops being a human creation and becomes environment—or nature.

There is also a point, or course, where environment can be turned back into an idea. At the point of exchange between nature and the idea that

makes art, the question of *influence* arises. Contemporary artists and audiences alike tend to regard evidences of influence with contempt. "Those guys are a bunch of Boswells," one well-known abstract painter was heard to say irritably of some younger artists. But the fact is that there is a good deal of Boswell in every artist, including the one who made the remark. It is just a question of how obvious the Boswell element is. The life of Johnson is nature for Boswell and what he makes of it is Boswell's art. Western art is built on the biographical passion of one artist for another: Michelangelo for Signorelli; Rubens for Michelangelo; Delacroix for Rubens; Cézanne for Poussin; the Cubists for Cézanne; and Picasso, the philanderer, for anyone he sees going down the street. That something new in art cannot come into existence despite influence is a ridiculous idea, and it goes hand in hand with an even more ridiculous idea: namely, that something totally new, not subject to any influence, *can* be created. It is proposed, in this "creation-out-of-nothing" creed, that Boswell, by simply changing his subject and writing a life of Boswell, could have "liberated" himself from nature, society and previous art, that autobiography can be the road to total independence. Any artist, however, who looks only into his own life for his ideas is still going to find the irresistible ideas of other artists there.

The desire of all artists for independence, for newness, for originality is really the desire for revolution—for its own sake. If he did not desire to change all art, he would never get past his love for the artists who first inspired him and be able to paint his own pictures. Revolution means existence, not progress, for the artist. But you cannot knock over a structure that has already been blown to pieces. In a period like the present, eclectic to the point of chaos, there is no way to contradict, because each revolution is immediately swallowed by a convention. Every new style is accepted without question by the artists and the audience of the avant-garde. (The often invoked larger audience that is not there, does not count, nor does the audience that is always against any innovation.) There is, however, still a prevalent belief that abstract art is, per se, revolutionary; that representational art is, per se, reactionary. Clement Greenberg recently wrote: "It seems as though, today, the image and object can be put back into art only by pastiche or parody—as though anything the artist attempts in the way of such a restoration results inevitably in the second-hand." This, if true, is a half-truth. The same claim can be made for the opposite. It also seems as though the image and object can be *left out* of art only by pastiche and parody. Neither to "return" to a representation of nature nor to relinquish it is in any way new, of course. And artists, abstract and representational both, unless they are singing themselves to sleep, are engulfed in an overwhelming sense of the second-hand. Shocks today are mock-shocks. The opponents are all straw men. Parody is king.

Some artists pay tribute to King Parody by throwing the idea of inner necessity and outer novelty of the wind, by frankly choosing subjects and styles without personal or social urgency. Larry Rivers, painting his studies of *Washington Crossing the Delaware*, is invoking established standards. Robert Rauschenberg is referring to more recent standards with his gorgeous, theatrical objects—paintings and collages—the whole intention of which is to be gorgeous, made in a wild conglomeration of styles from Dadaism through Abstract-Expressionism.

The parodist always works for a sophisticated audience, and his art is a commentary on other art. A true believer in external values (including those of mockery), he enthusiastically makes use of the offerings of the past and the opinion of the world. He is playing the virtuoso. As a commentator, he has to be witty. As a believer in the values of his audience, he has to be good, better, best. Searching for an identity like all artists, he can achieve it only in "success." If he fails, the world he trusts says of his work: "But I have seen this before."

For the artist who searches in his autobiography for a "private myth," there are no standards—no such thing as success or failure. But resisting parody, he does not always escape it. Disdaining the past he runs the risk of finding the "future" in last week's or last year's work—his own or someone's else's. The work of many of the painters who insist on novelty or uniqueness as their only value is beginning to seem curiously alike—with the uniform originality of a "herd of independent minds." The private myth has become public property.

There are other artists who attempt to combine the contradictory values of the parodist and the "unique" painter. Like the parodist, they face the fact that art is always about art; and like the "unique" painter, they feel that novelty of vision is essential. But unlike both, they feel art should make no reference to life—public or private. All these values, for them, can only be met by relinquishing nature as a subject. These artists feel that their art has dispensed with illusion. Its space is *actual,* as the space of "representational" work is fictive. The physical presence of the painting is considered its only end. Ideally, a painting is what you see. It suggests nothing. These artists talk in esthetic terms of decorative unity, the play of shape and color, rhythm, texture, composition, optical effects, etc. "The artist must respect the integrity of the picture plane" (integrity here is a synonym for flatness and, for some odd reason, there is a great deal of respect for flatness in this doctrine). But all this is again the terminology of common sense. Flatness is purely a pragmatic concept, meaningless except in the uses of daily life where it makes sense to a person driving a car or setting a table. In art, flatness is just as much an illusion as three-dimensional space. Anyone who says "the painting is flat" is saying the least interesting and

least true thing about it. Anyone who looks at a painting simply as a concrete, colored object is putting the reality of almost all other art into question. The reality of art, for them, is limited to its visual appearance. If that appearance or image suggests or invokes anything other than itself (which it usually does), then that other element, they feel, takes precedence over the image and dilutes its force. If there is a meaning other than what you see in art, then what you see becomes subservient to that meaning.

For less exclusive painters, the subject is not limited to its appearance on the canvas. The relation between image and subject can vary greatly from artist to artist. The subject can include both the intentional and the unintentional. Hans Hofmann makes a practice of working from nature, usually from still-lifes, but to make a still-life is not his intention, therefore no one thinks of his paintings as still-lifes. Hyman Bloom rarely works from nature but his intention is always some particular subject—a rabbi, a corpse, a chandelier, and that is what we see even if, in some of his paintings, it is hard to recognize the subject. If an abstraction happens to look like a landscape or an interior, the artist does not have to feel that it is his subject, if he did not intend it to be. On the other hand, he may accept this resemblance and even take a hint from it. Wilfred Zogbaum may have been inspired by sea-gulls over the dunes and white-capped waves or he may have been surprised by their evocation on his canvases. Joan Mitchell can agree that some of her abstractions look like mountainous landscapes or turbulent seas, without feeling the space has been altered by this suggestion; or Miriam Shapiro, that hers can look like lush forests and figures; or Giorgio Cavallon, that the primary colors and rectangular forms of the interiors he used to paint linger on in his present work. None of these artists feels his imagery is "representing" what it actually though indirectly resembles.

But the same holds true of artists who intend a resemblance. Wolf Kahn is obviously more interested in the activity of his fierce, separated colors and wild impastos than he is in communicating any particular sentiment about the people and scenes he depicts. Nell Blaine's recent landscapes have the same powerful contours and heavy impastos as the abstractions she used to paint. Fairfield Porter, in his intensely close views of his family and his surroundings, alters his tones and forms in terms of painting rather than characterization.

The non-abstract artist who starts out with a subject in mind may be surprised by his final image. The abstract artist who starts off with an image in mind may be surprised by the subject that evolves from it. And there are artists, abstract and not, who have both image and subject in mind before they begin on a canvas (Mondrian and Balthus, for instance). Finally, there are artists who start out with neither subject nor image, the "action painters."

The main difference, then, between abstract and non-abstract art is that

the abstract artist does not have to choose a subject. But whether or not he chooses, he always ends up with one. There is a large field of subject matter—the Sunday scenes behind the shimmering, surfaces of Impressionism, the indignant scraps of environment of Dadaism, the mountains and apples and bathers and seated men of Cézanne, the city and seascapes of Marin, the Bohemian interiors of Cubism, the blank surfaces of Suprematism, the machinery of Futurism, the assertion of human rights in the right angles and primary colors of Neo-Plasticism, all the debris of thought and opinion in previous styles—that lies in wait for the artist who thinks that, by painting any kind of abstraction, he is not choosing a subject. For the artist who thinks he *is* choosing a subject, this debris of style might be something he consciously utilizes and it might not; but if it is not invited, it forces its way into his work. Often the non-abstract artist, not facing this fact, chooses a subject in an attempt to free himself from the "look" of abstract art. But in art there is no getting away from a look. A look is simply another name for style and there is no style today not found on both sides of the fence of subject matter. The artist cannot pick or avoid a subject except through a style, and that style automatically becomes part of his subject. You can be influenced by the style of Géricault and paint an abstraction. You can be influenced by the style of Kandinsky and paint a landscape. Influence always rides on style, never on subject. But styles always begin with ideas about a subject.

A style in art, when it is vital, is a mode of thinking. When the style becomes the conclusion of its own thinking, as in decoration, it is dead. Its corpse becomes the property of commercial artists. A style can also die in the hands of the artist who created or developed it, if by continuing in it he is simply imitating himself (like Dufy) and not making discoveries through it (like Cézanne). But a dead style can be brought to life—sometimes a larger life than it had originally—by a living subject. The reason that artists can be endlessly enthralled by previous styles of painting is that they can bring new motives to them and thereby confiscate them. Picasso is an obvious example. Dadaism, in the hands of the artists who directly utilize its forms and techniques today, has become a classical style, completely shorn of its original bitterness, as respectable as any other and more graceful than most. New esthetic values have swallowed the old anti-social, anti-art motivation.

Impressionism has also had its original motives altered in the ideology of its followers, the Abstract-Impressionists (who outnumber Abstract-Expressionists two to one, but, curiously, are seldom mentioned). Retaining the quiet, uniform pattern of strokes that spread over the canvas without climax or emphasis, these followers keep the Impressionist manner of looking at a scene but leave out the scene. The scale of the structural unit may change (it is usually vastly blown-up in contemporary work), but the bal-

ance remains the same. As the Impressionists attempted to deal with the optical effects of nature, the followers are interested in the optical effects of spiritual states, thereby giving an old style a new subject.

Then there are artists who impose their ideas on the style of an individual artist rather than on a school of painting. And there are artists who are looking for identity in eclecticism. Their origins are hardest to divine. Arshile Gorky, whose work presents an intense, single individuality now widely influential among young painters, was variously inspired by Uccello, Rembrandt, Poussin, Cézanne, Picasso, Miró, Kandinsky—proving that, often, the longer the list, the more original the artist.

In choosing subjects or styles, the artist has only partial control. His reasons are never completely deliberate or logical. They are also passive and psychological—a matter of compulsion. But compulsively choosing, the artist can choose his compulsions to a certain extent. How far he can choose depends on his consciousness of what there is to be chosen. There is, further, a large element of his subject matter that is *completely* outside his choice—either conscious or unconscious. It is often even outside his awareness of its existence in his own work. This is the social or historical element. Not *How* or *What* the artist paints, but *When* and *Where* and *Why* he paints is involved here. Motives for similar—or even identical—acts change in history. No artist who paints abstractions today can possibly have the same motives as the artist of thirty, forty or even ten years ago. A Crucifixion by an anonymous Gothic artist has a completely different subject from a Crucifixion signed by a Renaissance or Baroque artist. The difference is not only the obvious one of style, but it is the relationship of the artist to his subject. The anonymous artist revered the autonomy of his subject and stayed outside it. The man who signs his name to his painting is climbing into his subject and competing with it. Mondrian, who was against the "exclusiveness of individuality," who strove for a totally impersonal art, contradicts his own theories with that little PM he affixed to his finished canvases. That is, he is just as involved with the question of his own identity as he is with the identity of his subject. El Greco loved his own brushstrokes as much as the tears in the eyes of his saints, or, rather, tears for him *were* brushstrokes. For the more innocent Gothic artist, tears were nothing but tears as far as he knew. A saint's tear in a painting was a real tear. Reality belonged to *what* he looked at, not to *how* he looked at it.

Today, for the artist with a signature, there is no simple *what*—no reality, no subject, that does not include *who* he is and *how* he perceives it. As his subject includes his style, nature includes his way of looking at it. The Mont St.-Victoire you can climb might be seen as a formless approximation of the visually real Mont St.-Victoire on Cézanne's canvas.

Renoir: As If by Magic

(1956)

Editorial Note: This essay was written on the occasion of the exhibition of thirty-two paintings by Renoir at the Clark Institute, Williamstown, Mass.

There are two images the spectator gets from every work of art: one while looking at the work, the other—the after-image—while remembering the work. These two images are usually disparate. The spectator is often disappointed in seeing again a painting profoundly admired at first sight. The painting now has grown to fill out the ideas or the ambitions of the artist beyond what he had actually accomplished. Artists who produce an after-image larger than the work itself are founders of styles: Michelangelo, Raphael, El Greco, Poussin, Rubens, Delacroix, Cézanne, Kandinsky, Matisse. . . . Their followers, without imitating them in the least, can work in the space between the painting and the after-image.

The artist creates the after-image, the painter makes the painting. Michelangelo or Cézanne, therefore, are greater artists than they are painters. Their paintings could never come up to the sense of art which they create. The founders of styles (except, maybe, for Rubens) always feel themselves to be failures. They do succeed, however, in making their ideas or their desires visible to the mind of the spectator. The painting itself is a simple physical fact.

Renoir deals with simple physical facts. A larger painter than he is an artist, he leaves an after-image that is irritating to most artists, though not to most people. It seems natural to resist him. He seems always to take the easy way. The self-indulgence implied by his paintings is suffocating. The appetite is surfeited with visions of big, fat, pink pictures; endless yards of boneless, pearly flesh; quantities of pretty, bovine faces; sentimental portraits; fuzzy, idealized landscapes—everything submerged in fluffy, feathery, sugary translucence.

One can resist Renoir with the mind—but not with the eye. The eye is dazzled and enslaved. He is an artist to be seen, not thought about. His achievements are far greater than his ambitions. His method is seduction and one must be in his presence to be seduced. Appreciating Renoir is primarily a physical experience—and an overwhelming one. And being physically confronted with him is always a surprise.

Renoir in general is very different from Renoir in particular. Although his manner is always unmistakable, he changes his way of finding his forms from picture to picture. One forgets his variety. And from the variety of his particular manners a strong-minded collector can ferret out the Renoir he prefers. The Clark Collection's Renoirs run counter to the popular conception of the artist. There are very few ruddy hues: the prevailing tones are cool greys and blues. The warmer colors are local, not atmospheric. The pictures are compressed, not expansive. Each is an isolated example of a technique, not one of a series, as is the case in most exhibitions of his work. While *Blonde Bather* is full of the exuberance that, of all qualities, is typical of Renoir, it has an uncharacteristic refinement and precision in the drawing and in the pale, shining tones. And here, as always, Renoir keeps a decorous distance from his subject and looks at a nude as her mother might, tenderly attentive to the facts that she's pretty, clean, innocent, untroubled, young and healthy. His portrait of Mlle. Durand-Ruel, coarser and more animated in brush work than is usual, reveals his love for Courbet, but Courbet was never so radiantly cheerful, and nobody, not even Matisse, ever found an orange as fiery as that—floating before the foliage—of the lady's hat.

While, like many modern abstract artists, Renoir needs a large canvas to give him the fullest effect of his color, it is in his smallest pictures that he finds his grandest compositions. There are several masterpieces here, unique, complete images. The little portrait of Mme. Monet is an astonishing and perfect painting. It seems impossible that the mild, feathery little strokes of grey, blue and green, so close in value that their edges vanish as you look, could build an image of such tense poise. The drawing seems to have evolved from nowhere, fixed by jewel-like little dabs of pigment, like the tesserae of a mosaic. As tautly if not as intricately composed, an odd, dark, cross-hatched study of a *Girl in a Garden* has an intensity of characterization Renoir rarely permitted himself, involved as he was with visual not literary elements.

When he gets away from the female form, which is not easy for him ("alas, I am a painter of figures"), his landscapes show him the road to his freest and most detached work. "The landscape is . . . useful to a painter of figures. Outdoors one puts tones on the canvas that one could not imagine in the light of the studio."

The outdoor scenes in the Clark Collection show the beginning of the road as the Renoirs in the Barnes Collection show the end of it in riotous little abstract landscapes that are the most advanced paintings he ever made.

The beginning of the road was Corot, and Renoir kept returning to his beginnings all his life. The *View at Guernsey* is closer to Barbizon concepts than to Impressionism although painted in 1883, ten years after he had begun exhibiting with the Impressionists.

He was an ardent and generous man and he never could forget any of his attachments—although he often tried. He recognized the value and the values of the artists around him and he was pulled in different directions. Corot, Courbet, Millet, Cézanne, Sisley, Monet—he learned something from every one of them (most from the first and the last). But his character as a painter lay in what he never learned from others—in what he apparently always had.

Non-, not anti-intellectual (was Renoir ever anti-anything?), learning and theorizing brought only disquiet to him and quietly he resisted. Influences, no matter how dearly cherished, affected only the surface of his painting. Delacroix was his idol, we are told, but we see Delacroix only in the costume of the *Girl with Falcon*—a gracious and unintentional little parody. He adored Wagner, too, but his *Scene from Tannhäuser* is lightest comic opera.

Even his association with the Impressionists was, in terms of his painting, superficial. He just happened to be living at the same time. They were his friends; they were very convinced about what they were doing and he didn't like to argue so he yielded, if rather reluctantly, to their notions of color and light, which notions, however, never became crucial to him as they were to the others. His light was never the naturalistic Impressionist light, never the light cast by the sun. Like Watteau, like Sassetta, he composed with a formalized interior light, no matter how highly keyed his palette. And surely he was thinking of Rembrandt when he painted the molten-haired *Girl Crocheting*. His colors seem always to be painted on gold. Sometimes only a deep glow remains, as in the powerfully brushed little sketch *Sunset at Set,* sometimes a blaze as in *The Doges Palace.*

The Impressionists make him feel guilty about painting indoors but they didn't succeed in convincing him that working outdoors was any better, and so he went anxiously back and forth, never at home in or out. In 1883 he wrote, "While painting directly from nature, the artist reaches the point where he looks only for the effects of light, where he no longer composes and quickly descends to monotony." In 1884: "I have lost a great deal painting in the studio, within four walls. I would have gained ten years by doing a little of what Monet did." In 1885, referring to the landscapes that Corot and some eighteenth-century artists painted in their studios: "Those people who seemed not to work from nature knew more about it than we do."

But the dissatisfaction that led him finally to say, "I had gone to the end of Impressionism. . . . I was at a dead end," was not serious and it passed and, of course, he went on painting without fussing any more about it. Although the Impressionists had him worried, the problems they presented were those of the philosopher not the artisan and Renoir couldn't be bothered with philosophy for long. "Painting is no dreaminess. It is first of all a

handicraft and it should be done as the work of a good craftsman." His art did not depend on his struggles but on what came easily to his hand. But only, with all of his ease and abundance, he was never a virtuoso. He never lost his ingenuousness. There is in every one of his canvases a kind of awkwardness and freshness that vanishes with professionalism. He instinctively turned away from "know-how."

Like a student and like only the most passionate masters his brush-work changes from one corner of the canvas to another as he tentatively discovers his forms. Uninvolved with motives, his constant experimenting was the result of feeling not thought, of inclination not decision. Throughout his life his gently imprecise drawing and hazy unemphatic tones were attacked by other artists and critics who apparently felt that accomplishment should be measured in visible quarts of sweat. His first teacher, Gleyre, said to him when he was twenty-one years old, "No doubt it's to amuse yourself that you are dabbling in painting." And Renoir answered, "Why, or course, and if it didn't amuse me, I beg you to believe that I wouldn't do it." Like certain of the more appealing saints, he had no trace of the fanatic and more than a trace of the frivolous.

Artists can't help expressing religious concepts in their work. At one extreme there is Mondrian who has translated his religion into a fierce Protestant morality, full of do's and dont's. At the other is Renoir, whose painting is an act of simplest faith, passive and positive, with not a renunciation in sight. To be natural (a thought most abhorrent to Mondrian) is, for Renoir, to be on the right track. And on the right track, he was a man with seven-league boots. He never aspired to the distances he covered. As Gauguin points out, he was simply transported. "A painter who never knew how to draw but who draws well, that's Renoir. . . . In Renoir's pictures, nothing is in place. Don't look for the line. It does not exist. As if by magic, a pretty spot of color and caressing light speak clearly enough."

His art is like the home he found for himself at Cagnes when he was sixty-two years old about which he wrote, "In this marvellous place, it seems that misfortune cannot reach you; you live in a padded atmosphere." His "caressing light" falls on an endlessly happy world where babies are all well-fed, cats sleek, and beautiful women wear beautiful clothes or don't, and ships lie in peaceful harbors and even onions are gay. Macbeth's witches have no place here. Yet is all absence of toil and trouble suggested by the final image of an aged painter with his brush tied to his hand?

Stuart Davis:
True to Life

(1957)

Today, when hectic, automatist techniques so often and so surprisingly result in ingratiating, decorative and vaguely naturalistic imagery, a painting by Stuart Davis, with its plain, strong, "ready-made" colors and sharply cut-out shapes, has somewhat the effect of a good sock on the jaw, sudden, emphatic and not completely pleasant.

Davis, now sixty-three, apparently always knew, as few painters have, what he wanted and who he was. The character of his work does not change through the years. The present show (at the Walker Art Center, Minneapolis, and coming to the Whitney Museum in the fall), covering the years 1925-56, is as scrupulously extrovert, conscious and uncompromising as his retrospective exhibition at the Museum of Modern Art twelve years ago, which included some scenes painted as early as 1912. Comparing the two shows, one is struck again with the singularly impersonal, almost disembodied nature of his art. One does not feel a contact with its inception (as with Abstract-Expressionist work) or recognize in it the sensuality of an individual effort. It seems to be there all at once—the product of an aggregate impulse and perception, like slang.

Fiercely independent, but not an eccentric, Davis reacts against the momentum of a current style with a reflex of self-insulation. He has successfully resisted the devouring intellectual camaraderie (or is it anxiety?) that keeps most avant-garde artists breathing down each other's necks and that makes group shows look like the game of Musical Chairs as artists grab each other's styles, subjects and mannerisms before the paint is dry. His style, developed between two continents and two wars, is as insistently remote from the Synthetic Cubism that was his starting point as it is from the American Action-Painting that surrounds him today.

He achieves his separated position by an act of will or rather, by an operation of logic: he chooses to be à rebours. His paintings made of, in or through Paris are swept clean of the gentle, expansive and complex intimacies that envelop Parisian art. When he began working in the Cubist manner, he immediately dispensed with their subtle tones, their discreet scale, their paraphernalia of private property and locale. His street scenes of that

period, rendered in an over-simplified, almost cartoon-strip style, have a kind of breezy, open, New England quaintness; his still-lifes are about as cosy as factories on Houston Street on Sunday. Cubism, after all, is an indoor art, full of nice, comfortable, old furniture and friends of the family. But, although for Davis, a pack of Lucky Strikes could be unobtrusively substituted for a guitar, you really can't have Whitman's Open Road run through the parlor without changing the look of things.

Davis' palette has always been, in spirit at least, strictly red, white and blue. His subject has always been America—not as seen in American art but as seen on a walk down Broadway or a drive past a harbor in a fishing village. He resists art by being true to life. More intensely than any painter in our history, he offers a specific, objective, national experience. It is the experience not of our natural landscape but of America as man-made. The brittle animation of his art relates to jazz, to movie marquees, to the streamlined decor and brutal colors of gasoline stations, to the glare of neon lights, to the flamboyant sweep of three-level parkways, to the fool-proof shine of stainless steel diners, to the big, bright words that are shouted at us from bill-boards from one end of the country to the other. In our common public existence (which is the only existence Davis, as a painter, is interested in), this is the land of layout and lettering, of engineering and industrial design, of big cities and long roads that Somebody built. Obviously Davis feels a profound sympathy for the grand and broad expression of *Abstract Artists Anonymous.* What are the names of the men who designed the words ESSO or REM or Coca-Cola? Who designed the viaduct at Sixty-first Street and the East River? Or certain juke-boxes? Like this company, he expresses in his work the concept that one glance should be enough to see what you're looking at, since the chances are you're going someplace else fast. And so, although his pictures are not big (as big pictures go nowadays), their expression is. If one were slapped against a building like a bill-board, it would hold its own. In fact, Davis is one of the few abstract painters in the country whose work authentically relates to modern architecture.

Like modern architecture, his art has a distinctly argumentative character. Nothing is suggested or implied. Everything is stated flatly. Here are no evasive tones or ambiguous colors, no vague distances or irresponsible implications of scale, no meandering sentiments. There is in his paint-stroke no description, no point of view; it delivers the unprimed fact to you. Every proportion is measurable, every effect predetermined. Detail is massive. The remnants of stylized representation—the roads, clouds, waves, smoke, chimneys, shingles, ladders, wagon-wheels, windows, barrels that still crop up in his work, superimposed in rigid patterns over the large paper-flat planes—are related with a cheerful, bold and heavy hand to the

whole. The taciturn impastos, the highly deliberate patterns, the inflexible scissor-sharp edges all seem to indicate an insistence on "the last word." And he has it. In the protestant economy of Davis' art, nothing is superficial and everything is necessary.

His is an art of solid certainties. He never seems to have been involved with those rather bitter changes of heart which beset so many artists and which result in their working consecutively (or what is even more painful, simultaneously) in contradictory styles in their search for an identity. For Davis, his identity was never in question. He is aware that his approach is in conflict with the approach of most abstract painters around him and he is somewhat contemptuous of their condition, which might be termed "the anguish of possibility," to use Harold Rosenberg's phrase.

"I think of Abstract Art," Davis wrote in 1951, "in the same way I think of all Art, Past and Present. . . . I see it as divided into two Major categories, Objective and Subjective. Objective Art is Absolute Art. . . . [It] sees the Percept of the Real World as an Immediate Given Event. . . . Subjective Art is Illustration, or communication by Symbols, Replicas and Oblique Emotional Passes. . . . Its Universal Principle has . . . the character of a Universal Bellyache. . . . It has a Perverse Passion for the Detour."

Clearly all the possibilities Davis sees, as an Objective artist, are in the realm of solutions not problems. If, as some critics have pointed out, his solutions always seem to fall more or less in the same territory, there is no sense of self-indulgence, of relaxation of the spirit in the fact that he has never substantially deviated from the style he defined for himself so early in his career. On the contrary, one might get the impression of an iron stubbornness in his cleaving to certain principles of clarity now largely abandoned by painters (although commercial artists and architects are of course still involved with them). His paintings have the "look" of another decade, specifically, the 'thirties—not the provincial but the International "look." But Davis, like Léger and Mondrian, with whom he shares a passion for conscious, objective art, has made his particular "look" timeless. Convictions that [are] ardent keep their immediacy.

In the sense that he starts with the idea that the canvas is a limited area to be divided, to be designed, he is following a European tradition. It is the opposite of the concept of the image which unfolds and spreads out, as in the panoramas of the Hudson River School or the panoramas of American Action-Painting where the edges of the canvas are the last facts to be considered, not the first. Many abstract painters today, for instance, work on unstretched canvas tacked to the wall, and decide on the size proportions of the painting after it is finished. This would be as unworkable an approach for Davis as it would for Mondrian or Léger, since the exercise of will and

consciousness can only be accomplished within a fixed space. For artists who insist on complete control, the world must be square; there must be boundaries to act *against*.

In the face of this framework of calculation, one of the paradoxes of his work is in its extraordinary animation—an element we usually associate with spontaneity. But even here he is deliberate, aspiring to what he called the "Consciousness of Motion" in art. This he achieves mainly in his use of color, and here he is a craftsman second to none. His colors, although strong and opaque, are oddly without physical presence. They do not create surfaces but rather, sheets or flashes of light. This spurting electric quality of his color has less to do with the choice of pigments—they could be interchangeable, one feels—than with the spacing, proportioning and repetition of the areas into which the colors are so carefully placed. The light doesn't act in but between the colors. The larger areas are pulled and twisted into different dimensions by the contradictory presence of the smaller. He uses the "scale" of different colors—their various propensities for expansion and contraction—to achieve the fantastic, mechanized activity of his compositions.

Pure Paints a Picture

(1957)

"**I**f any paint remains on the picture-surface at the end of a day's work, I have failed," states Adolf M. Pure, noted Anti-Post-Abstract-Impressionist. "And to fail," continues the enigmatic painter, "should be the highest aspiration of the fine-artist."

Brought up by a distant cousin on his father's side, young Adolf's creed developed early. His cousin, who sterilized milk-cans for a farmers' co-operative, often brought the tiny child to work with him, and this experience, Pure contends, first gave him the idea of becoming an artist. "I have always been thrilled by seeing impurities removed in any fashion." Here the artist expresses a fundamental principle of his art. "Purity cannot be created *directly*, nor does it exist beforehand in nature. It must be achieved negatively, i.e., by the removal of impurities. This negative approach is absolutely necessary for Correct painting, its only disadvantage being that it makes Correct painting seem much easier to beginners than the usual incorrect variety. However, the *only* way to arrive at Correct, Pure or Fine Art is by a series of rejections." This necessitates having a great many materials in his studio which he must not use. "A painting must have no color," explains Pure; therefore his shelves are lined with tubes of color that he never touches. (Permanent green light and alizarin crimson are the pigments he most prefers to reject.) The advantage of this attitude, he points out, is that, although it seems wasteful, actually it results in a saving of money, since you only have to buy your colors once, but you can reject them over and over again.

Black is no color, he discovered when he was an artist under thirty-five, and since he could not reject a color that did not exist, there followed the well-known series of totally black canvases. Later, for a short period, Pure dallied with the notion that a painting must *not* have *no* color, and from there to the concept that *no* painting must *not* have *no* color, but he gave up this avenue of investigation for obvious reasons and returned to using simple no-color, or black.

"There are three other important Noes to be mastered: no image, no scrimmage and, last but not least, no subject matter." However, one high-strung spectator, peering into the darkness of Pure's canvases, claims to have

discovered the subject—a graveyard at night. This is erroneous. "Art can be corrected but, alas," Pure sighs, "the public cannot."

When his dealer finally complained of the monotony of his canvases, Pure, after stifling a brief impulse to reject his dealer, countered the non-existence of black as a color with the non-existence of white. (He is, he admits, secretly troubled by persistent rumors in the scientific world that white is not only not no-color, it is, in the form of light rays, the sum of *all* colors and that black—or, at least, dark-brown—is the sum of all pigments. "But we live in this world," says Pure bravely, "and we must make the best of it. It's all right to have ideas but there's no use leaning on them too much.")

With his recent employment of white, however, Pure does not mean to imply that he finds monotony as a principle unnecessary to Correct painting. "The trouble with most contemporary painting," Pure has often been heard to observe in the drugstore where he dines nightly, "is that it lacks monotony. No fine-minded artist can create without an understanding of monotony. The value of monotony is yet to be ascertained.

"Nobody can tell what pure art *is*, exactly, but I can tell you what it is *not*, absolutely, and I'll tell you. The ten Nots to be memorized (in the order of their importance) are: 1) edible 2) credible 3) frangible 4) visible 5) salable 6) scrutable 7), remarkable 8) tenable 9) lovable 10) able. *The more pure your art is, the more you can give less.*"

All of Pure's compositions are circles. "The circle is the only form that has no straight lines," he claims. The artist cannot explain his intense dislike of any and all straight lines. "Perhaps," he ruminates, "it is because all straight lines seem to be going some place; they're too *active*: activity is the ultimate impurity. Art can't be too quiet," claims the artist, who is, for that reason, dissatisfied with his favorite artists, "the Quiet Ones," from Giotto, Ingres, Seurat, through Mondrian. "They are simply not quiet *enough*," says Pure, who suspects it is because straight lines, although often carefully disguised, can be discerned in all their paintings.

"A circle is as quiet as possible. There's no doubt about that," he announces cheerfully. But to arrive at a method for arriving at a circle took Pure several years. "A free-hand circle is out of the question," Pure remarks. "A circle to be a true circle must be a perfect circle." He disdains the easy way out: "A compass is an impure thing, full of associations of other things that have nothing to do with art, like the discovery of America, probably, or the pyramids. Besides, it's too direct." Paradoxically enough, Pure finally realized that he had the solution in the core of his own philosophy: the concept of rejection. To arrrive at a circle, one had simply to begin with a square and discard the corners and where was the square? "Sort of like taking a round peg out of a square hole," Pure explains.

The circular form makes the stretcher a difficult problem but one which Pure has dealt with ingeniously. The stretcher for the work-in-progress, not illustrated here, (now called *No-White—No-Black*, but this is not its title), is a bicycle wheel. These, his favorite stretchers, were, in the past, removed from Red Riders and Speed Kings to be found in the neighborhood, but "lately," Pure observes, "everybody seems to lock his bicycle in the cellar." This explains why Pure's recent canvases are larger. The two huge pictures which almost won second prize at a recent national annual were stretched on wheels he found while vacationing in Flushing last summer near a helicopter crash. "Every calamity has its useful side," quips the sunny-natured painter, delighted with his discovery of helicopter wheels, which he now gets through a friend in the F.B.I.A.A. at auction.

The term "canvas" describes a Pure picture inaccurately. It might better be called "foam-rubber." ("The thickness is not important, it's the resiliency that matters," says Pure of his ideal material. "And furthermore, Art should be porous. On this count, the esthetic implications of foam-rubber have not been plumbed.") Also, the term "painting" is inaccurate. Rather, one should refer to Pure's pictures as "injections." Two large syringes (Eimer & Amend) are his most important instruments. ("The trouble with most contemporary art," Pure maintains, "is that the paint is *on* the picture not *in* it.") A pair of scissors (for cutting off corners), several eyedroppers, rolls of cotton and gauze, a flask of glycerine, a small bottle of stain remover (potassium manganite), a bleach (mercury chloride and water) and a book of highly absorbent blotting sheets (for drying the picture) complete Pure's "painting kit." "A kit is a semantic problem," the artist often exclaims thoughtfully as he pursues his never-ending search for new materials which are then stored in the refrigerator for future rejection.

A tall, thin man with a dry smile, Pure, whose income is rather limited, although adequate, built his own studio on the roof of a large building in Yonkers. There is only one window, a port-hole which he removed from the Normandy after it caught fire several years ago. This window is always heavily curtained. "I prefer to work in the dark," Pure explains, "figuratively and otherwise." Except for an immense filing cabinet, a refrigerator, his easel—"a nail in space"—on which he pivots his stretchers, his studio, although square, is bare. Being an experienced leaf and branch reader, Pure finds the rubber tree an invaluable source of information about his fellow artists, critics, dealers, etc.—although it is much misunderstood by outsiders. The tree also offers him innumerable directions on how to paint which he refuses to take. "It's sort of like a wife to me," he notes.

Almost as important as the tree is his file of Renaissance and Baroque reproductions. This file inspires him with the emotion most necessary to

any creative effort: disgust. "Without disgust, life wouldn't be worth living," says Pure. "Disgust has permeated my happiest moments. Disgust has added real meaning to all my relationships—jobs, friendships, marriages. I wouldn't dream of beginning a picture unless sufficiently filled with disgust." Fifteen minutes of thumbing through his print collection is usually enough to offer a day's supply of the proper emotion. Another fifteen minutes of washing his hands and Pure is ready to begin work. After donning the cap, mask and white gown that make up his painting uniform ("the air is full of enemies," says the artist) and the bare-foot sandals that he wears winter and summer ("because my feet have claustrophobia"), he sterilizes the foam rubber surface on which he is to work. Then filling his syringe with black (he no longer uses Argyrol but now prefers a derivative of D.D.T.), Pure begins to fill certain pores of the foam rubber until a square is formed. The corners of the square (as described earlier in this article) are then discarded leaving a perfect circle. In forty-five minutes, the picture is finished. "To work on a painting more than forty-five minutes is to be a Bohemian," Pure declares. "Art should take as little time as possible. It should also take as little space as possible. For my next show, which I will paint next week, I am going to use dimes for stretchers. But except for this one instance, which is purely abstract, there should be no relation between art and money. Art is always getting involved with things outside itself and that keeps it from being fine. Take food. For one thing, food is an ugly word. For another, I don't like the taste of it. Never did. But we don't have time to go into that. What I mean is, I don't approve of the relationship between food and life and artists. Too interdependent. An artist is dependent *on* food *for* life. It's an unhealthy relationship! Commonplace, too. Food is food; life is life; an artist is an artist. Why this confusion between the boundaries? Everything should have its own place, its own entity, its own integrity. Of course, since this world isn't perfect, you can't be an artist without a little life, and you can't have life without a little food; just keep it to a minimum—and cold, of course."

Since his work takes so little of his time, Pure devotes the rest of his day to more conventional activities. Sixteen hours out of the twenty-four are spent sleeping. "An artist should be unconscious as much of the time as possible—get the *habit* of unconsciousness, so to speak; otherwise ideas might creep into his work and ideas are harder to get rid of than roaches once they get a foothold." He sleeps on a bed with no sheets, naturally. He has even removed the mattress-cover. "I love the touch of foam-rubber next to my skin," he says. "It's the one indulgence I allow myself."

A methodical man, he spends an hour every morning before breakfast writing letters to editors and museum directors. "Can't skip a morning.

Have to keep a close check. Can't tell *who* they'll be enthusiastic about next." An ardent and conscientious guardian of the morality of the contemporary art world, Pure dislikes getting paid for his helpful criticism of fellow artists. "It's a labor of love," he explains.

After breakfast—a spoonful of wheat-germ and yogurt—Pure spends three hours reading all the art publications from cover to cover and carefully files favorable reviews for future attack. A humanitarian, Pure is troubled by other artists' success even more than his own. "They're not on guard against it," he explains. News of the sale of a friend's painting plunges Pure into an abyss of gloom. "The trouble with most contemporary artists is they're riding two horses. You can't be an artist *and* a success. You've got to take your choice. As I've often said before, to be a Fine-artist, you've got to be a failure. Of course, I *don't* mean a failure at being a success, or a failure at being a failure (like poor rich X. . .) or, naturally, a success at being a success; I mean a success at being a failure." This distinction, Pure notes sadly, is mainly lost on his students (he has six teaching jobs), some of whom get over-enthusiastic and try to become failures immediately. "It takes time—years—to fail," says Pure. "What do these kids think . . . it's easy?"

On being asked about sculpture, Pure replied, "Sculpture is no problem. Nobody likes sculpture."[1]

[1] During the author's absence from New York in the summers of 1954-56, notes on the artist's style and techniques were recorded by Esteban Vicente.

Two Americans in Action: Franz Kline & Mark Rothko

(1958)

The cleavage between the present and the past for certain artists is as drastic as it was for Saul of Tarsus outside the walls of Damascus when he saw a "great light" and heard a great question, the popular version of which is *"Quo vadis?"*

For most artists, "Where are you going?" is a question so familiar it seems almost part of the ear itself. Usually it's just a nagging little whisper, or a whine if things aren't going well. Sometimes, however, it is a shout and the artist jumps, like Saul, from his Past into his Present: he is no longer Saul, he's Paul, and he knows where he's going. He didn't make a decision; he had a revelation; he is a Convert. His Present dates from the moment of his conversion. The work or actions that went before are part of his Past which no longer exists.

Naturally, too, if there is a great light, more than one artist is going to see it (the men around Saul also saw it). Most of the conversions among groups of artists are remarkably synchronized, especially since the latter part of the nineteenth century. When before the advent of Impressionism can a common style be dated within a year or two?

The transformation of consciousness in the late 1940s (for some artists, 1950) that resulted in the movement now widely referred to as American Action Painting—named and defined by Harold Rosenberg in *Art News* in 1952—was not easy to recognize because it had no "program" as had the previous schools. It did not produce a stylistic departure like Impressionism, Fauvism or Cubism, nor state a philosophy like Dadaism or Surrealism, nor rest upon an ideology like that of Neo-Plasticism or Futurism.

Its aim was not rebellion; it did not consciously "break with the past" as the other movements did. Like other innovating efforts in American painting since Copley, it took, in fact, the opposite road. The American artist traditionally seems to find something new (if he finds it at all) by passionately *following*—until there is nothing left to follow but himself. "America does not repel the past," said Walt Whitman.

A brand-new, ready-made, large-scale Past was imported to America by the Armory Show in 1913, and then by French magazines, American collec-

tors of School of Paris art and New York museums and galleries as well as by American artists from Paris. There were masters to be discovered and understood—above all Cézanne. It was this profusion of influences to which they were open for three decades that led American abstract painters of the 1940s to develop a distinctly different approach from any of their European forerunners or contemporaries. Abstract-Expressionism, Surrealism, Automatism were some of the inadequate or inaccurate labels being applied to the contemporary vanguard here in a misplaced effort to identify them with movements of their immediate European past. What distinguished these Americans was the moral attitude which they shared toward their art; that is to say, they saw the content of their art as moral rather than esthetic. Subject matter, not style, was the issue, and they had a new attitude toward it—an attitude closer to that of Dadaism than to any other school, but with a difference: the Dadaists placed themselves in opposition to society; the Americans, less social than the Dadaists, brushed the problem aside.

There is still prevalent, however, the superficial notion that abstract art is without content or subject matter. But while there are a few abstract artists who illogically support this view, most of them vehemently oppose it. "There is no such thing as good painting about nothing," wrote Mark Rothko and Adolph Gottlieb in a statement to *The New York Times* in 1943: "We assert that the subject is crucial." (Painting "about nothing" is of course, nothing but décor, and décor is not art unless it has subject matter, in which case it immediately becomes good or bad, more than simply décor.)

If, then, this art was *about* something, what is it about? Each artist has his notion; so does every spectator. There are the individual notions and there are the communal notions that emerge after a passage of time. The individual notions naturally affect the communal notion, and the communal notion—the one that ultimately counts—is constantly in a state of flux and under its passive judgments the content of works of art shifts, expands and contracts, and its value rises and falls. The layman's communal notion is always at the mercy of a few convinced professionals—who can bring to life painters and periods dead for centuries. But there is also *communal professional* thinking. (A recent example of such thinking, but one from which an important minority dissents, is the attitude of numerous American artists who, once overwhelmed by Picasso's work as long as twenty years ago, on being confronted with a body of it again at the Museum of Modern Art, declare themselves to be "disenchanted," "disillusioned," "disappointed." Passages of painting which once seemed to be examples of fabulous virtuosity now seem available to any painter on the block. Why did it once seem so difficult? "The *Demoiselles d'Avignon*—I can't tell you how that once threw me," a painter is reported to have said. "Now it looks like the

Mademoiselle from Armentières—she hasn't been kissed in forty years!")

Somewhere in the middle 1940s, Skill, Talent, Genius—and Originality—were thrown out of the ring as *values* by American vanguard painters. What counts now for the contenders is the *idea,* and the idea of "just painting" is out. All the old concepts were scuttled: Composition, for instance (what ever became of dear old Composition?). Painting for Americans is no longer the exercise of a talent, the practice of a craft or the satisfaction of a private inclination; it is now a bid for an individual identity. It is not enough to be new. Novelty can be appropriated by technique—which is why the term "avant-garde" has become farcical in the past decade. Thousands of followers are immediately abreast of the leaders, and the leaders could easily be lost in the shuffle of the omnipresent derrière-garde. When they are not lost, it is because they have achieved their identity: they are unique, not simply new.

"The test of the new painting is its seriousness," wrote Harold Rosenberg, "and the test of its seriousness is the degree to which the act on the canvas is an extension of the artist's total effort to make over his experience. . . . A painting that is an act is inseparable from the biography of the artist. The act-painting is of the same metaphysical substance as the artist's existence. The new painting has broken down every distinction between art and life. . . . With traditional esthetic values discarded as irrelevant, what gives the canvas its meaning is not psychological data but *role*, the way the artist organizes his emotional and intellectual energy as if he were in a living situation."

Never before has the brisk Coldness of Intentionality so cleared the overheated air of the art world. The element that further distinguishes this painting from the abstract art that immediately precedes it is its essential schizophrenia—not as a pathological state but as a principle. The Action Painter is his own spectator. He sees himself in his art, his art in his life. And he sees both his art and his life-as-an-artist in the world around him. He is a man standing before a canvas in a room, with mirrors for walls, located at the exact center of the universe. The question he asks himself is the one he has heard so often from his most naïve spectators—the gas man, the delivery boy, his wife's relatives—"What is it?" It is as difficult for him to explain what his art *is* as to explain what he himself *is*; but, since he paints with the question and not with the answer, explanation is not an issue.

Mark Rothko has, on various occasions, been professionally explicit in print (although recently he has taken to saying wistfully, "silence is so accurate"). Franz Kline, on the other hand, if asked about his approach to art might (and did) reply, "When I was young, I was nineteen. Does that answer your question?" Whether they talk or write or not—does not, of course, matter. The painting decides what the artist is to be exactly as much

as the artist decides what the painting is to be—and the painting has the last word. The last *word,* for Franz Kline, was spoken in 1950; for Mark Rothko, in 1948—the year each moved into his Present. (In neither case does the previous work represent the artist as we now know him.)

The most obvious change from Past to Present in the work of both Kline and Rothko—and in that of a host of other painters—was the apparent commitment to the Big Picture. But size here has to be conceived in a special relation to scale. Rothko had been painting large pictures before this, but suddenly what happened *inside* the canvas began to change scale, became ampler, simpler. On the other hand, Kline, whose paintings were always on the small side, became increasingly involved with smaller and smaller pictures and in the late 1940s was making numerous "studies" no more than five inches high. These tiny paintings have the scale of his later work. For Kline, the actual dimensions of his painting had to meet the scale of his concept, and suddenly his painting changed *size.* For both, it was a meeting of size and scale.

Breadth of size and scale, in these works, are paradoxically the result of the artist's closeness to his painting—which he regards as a private act for a private view; and they are, at the same time, the means to insure privacy. The painting is a hiding place. The magnified image here reverses its original function and suggests a state-of-mind associated in the past only with small paintings—intimacy. Usually, the large painting has had a public expression: as a mural, it was intended to project over distances; it was—even if the Day of Judgement was depicted—intended as décor. But there are for murals—any murals—other laws to be met than those of the subject and its treatment.

"The soul," says Walt Whitman, "has that measureless pride which consists in never acknowledging any lessons or deductions but its own."

Action Painting has no laws outside itself: it chooses its place in the world; refuses to have a place chosen for it. It does not have any relation to the wall on which it is eventually hung. The painting just needs a wall large enough—and even that, although preferable, is not entirely necessary. There is a recent case where the wall was not high enough and the painting encroached on the ceiling; and another, where the painting turns a corner on a wall that isn't wide enough.

Although Action Painting is being used by architects, it is used from the architect's point of view—which is as it should be: the architect's job is *placing.* If he is competent, the architect knows what he can expect from the artist he chooses, and he knows how to employ his work. But Action Painting cannot be philosophically related or indebted to architecture because any authentic relation between architecture and painting must be a formal one, and for these artists, formal elements are the unpredictable *remnants* of the act of painting, not the means to an end. The impracticability

of these paintings seems almost intentional. Any collusion between the artist and an architect, one Action Painter claimed, must be the result of a moment of irrationality on the part of the architect and a moment of cynicism on the part of the artist. Clement Greenberg to the contrary, the new painting is not décor and it is easel painting. It is easel painting in the sense that it is intended to relate only to the spectator and not to its physical surroundings. Its place-in-the-world is not an actual place. The easel, now, is simply the symbol of the isolation and self-sufficiency of the image.

Except for the appearance of the large image—and the large image can appear in many forms—there is no exclusive "look" to Action Painting. The tinted, hallucinated cloth of Rothko's painting has nothing in common with Kline's heavily loaded canvas which might as well be cast-iron from the look of it. Kline's image is fixed in the brutal gesture of a housepainter's brush dipped in a can of paint and slapped across the canvas. Rothko's image seems to settle on the canvas indirectly, leaving no traces of the means that brought it there (although he, too, uses housepainters' brushes). The "action" is not necessarily the action of pushing paint around as many Europeans and Japanese, apparently, take it to be.

These large images are always aggressive: they have to be to enter life. They do not stay on the wall. They invade human affairs. Kline's paintings elbow their way through the room in which they are hung; Rothko's envelop in a vast, smothering embrace. The work of both has an element of violence—in Kline's work, overt; in Rothko's, remote at first but increasingly evident. Kline's drastic blacks and whites plough through each other with heavy, wounding wedges and become interlocked in a precarious state of tension like that of a bridge about to fall. The tension of Rothko's work lies in its ominous, pervasive light—that of the sky before a hurricane. In his imperceptible shifts from one pure color to another, there is a sense of atmospheric pressure. His edgeless shapes loom oppressively in an incandescent void, wailing, breathing, expanding, approaching, threatening.

You do not have to pay attention to Action Painting. It pays attention to you.

Mark Rothko

Rothko's art supervises the clutter of daily life; it straightens things out. Hung in a room, a painting by him immediately affects everything in the room. His canvases have a curious way of transforming the people standing before them. Their skin, hair, eyes, clothes, size, gesture assume a dreamlike clarity and glow. It is as though the painting emptied the space before it, creating a vacuum in which everything three-dimensional takes on an absolute or ideal existence. Devoid of detail, his painting imparts magnitude

to any detail in its vicinity. It affects life by its separateness from it. There is in his art no "tie-up," no echoes or memory. The spectator has associations: the painting undertakes to reject them.

More consciously than most artists, Rothko looks at his paintings as an extension of his life and is not indifferent to their fate out in the world. "A painting lives by companionship," he wrote, "expanding and quickening in the eyes of the sensitive observer. It dies by the same token." He has concern that the meaning of the picture be not distorted, and if that involves refraining from exhibiting or from selling, he has been willing to face that, too. He has had, since he began to paint at the age of twenty-three, numerous one-man shows, yet he continues to have an excruciating sense of privacy about his work. This sense of privacy, in a profound way, actually reaches into the painting itself. A painting by Rothko is a *façade,* almost as though his art were trying to hide behind itself.

There is a good deal of controversy as to the meaning or intention of Rothko's art. People tend to have strong convictions about it which, as often as not, contradict the artist's own idea. Since he conceives of painting as a moral act, it follows for him that the *reaction* of the spectator, perceiving or misunderstanding the intention of the painting, is also in the sphere of the moral. His relation to the spectator, therefore, can often be one of opposition. His paintings are sometimes explained in mystical terms, but Rothko disclaims mysticism. When someone once asked him if his thinking had anything to do with the Zen Buddhism that was sweeping the art world, he replied, "It took five hundred years to produce a Renaissance man: here I am."

Another misunderstanding revolves around the "emptiness" of his work: the fact that he arrives at his clarity by exclusion. Value, shape, contour, visible brushstroke, impasto—all the elements that are usually conceived to be the means to the image have been eliminated. As Thomas Hess has pointed out, Rothko reduces the painting not to the skeleton but to the skin. Everything happens through color alone. In most of his recent canvases, his palette is mainly limited to two colors taken from one part of the spectrum—orange and red, yellow and orange, blue and green, grey and blue— so that one color literally *continues* into the other establishing a uniform surface or skin. (According to the inspired etymology of the painter Aristodemus Kaldis, the word for color in Homeric Greek was *Derma*: skin.) This suggests to many onlookers that Rothko has an ideological devotion to color. Yet he says he is not interested in color, "but since there is no line, what is there left to paint with?" It is a poignancy of mood that he is obsessed with, rather than color, which for him is "merely an instrument."

Although Rothko's public is, in general, an esoteric one, others too often have a strong reaction to his work which tends to be expressed by the

word "beautiful." "Beautiful" is a term that rarely can be applied to painting any more. The struggle with oneself that now produces art is more likely to leave harsh, even ugly tracks, but in Rothko's case, "beautiful" is not inappropriate. It is, however, not conceptually relevant: the beauty of his work has nothing to do with its bite. Besides being irrelevant, beauty in art tends to be misleading; to disguise—not express—the real content, as Mozart's tragic passion is obscured, for some people, by his elegance.

"Doorways to hell," a spectator (professional) remarked about a roomful of Rothko's work. It can be an unsettling experience to be surrounded by his mysterious "walls of light" (to quote Hubert Crehan's term). Yawning, receding, they might, indeed, be seen as glowing caverns. Another spectator: "They look forbidding, like those enormous weighted banners in Spanish religious processions." Still another was reminded of "the hues generated on different levels by the light falling through a fishpond." Hess, in his book *Abstract Painting*, found in them "an informality of revelation not unlike that felt in Whistler's misty etchings and pastels of lagoons inhabited by vanishing palaces." The fact that so many different people have been able to put so many, different things into these "empty" paintings is a vivid demonstration of their participation in life.

His paintings, reduced to about as close to nothing as a painting can be and still exist, have a remarkable range of expression in mood. "I exclude no emotion from being actual and therefore pertinent," says the artist. "I take the liberty to play on any string of my existence. I might, as an artist, be lyrical, grim, maudlin, humorous, tragic. I allow myself all possible latitude. Everything is grist for the mill."

Rothko's development has been consistently accomplished through the exclusion of *intricacies* of form. From his early Expressionist paintings, through Surrealist images, fantasies of undersea plant-life and cephalopods, monotone wash-drawings, his development has, at each new stage, abandoned some visual element to gain a spiritual one. In the late 'forties, his undersea forms began to lose their contours, and patches of color, still suggesting a submarine existence, began to appear on horizontal canvases. The patches became larger, closer in value, more luminous in hue. They lost their biomorphic shapes and began to arrange themselves in hazy, dignified, rectangular formations. His canvases became vertical although retaining their horizontal souls. The formations continued to grow in size, expanding into each other's territory; edges disappeared as they met and overlapped, until, finally, in his present work, it is as though the shapes got bigger than the canvas—their boundaries are outside it—and what is left is simply the *process* of expansion.

"The progression of a painter's work," wrote the artist, "as it travels in time from point to point, will be toward clarity, toward the elimination of

all obstacles between the painter and the idea, between the idea and the observer. . . . To achieve this clarity is, inevitably, to be understood."

Franz Kline

"Caution seldom goes far enough." Walt Whitman.

"The moon belongs to everyone, the best things in life are free; nobody can sing it like Ted Lewis," says Franz Kline. And nobody can sing *The Girls Go Crazy about the Way I Walk* like Kid Ory. And nobody can sing *Your Feet's Too Big* like Louis Armstrong. Jimmy Rosati, the sculptor, has an enormous collection of jazz records and he and his family and Kline and Earl Kerkam, and any other artists who happen to be around, spend long evenings playing records half-way through so they can hear the next one and argue about the relative merits of the New Orleans and Chicago styles.

English cartoonists are an enthusiasm Kline picked up in London: Philip May and Low; and, naturally, their predecessors, the great Munich graphic artists of *Simplicissimus*: then, Steinlen and George Grosz. And Pascin. In London, too, he became fascinated by the Japanese watercolorists, Hokusai and Korin and Sessun, and collected stacks of reproductions.

Kline was born in a railroad town in the Lehigh Valley—land of football and Indians, of Holy Rollers and Mennonites, of Quakers and Pennsylvania Dutch, of soft and hard coal mines, of hills and forests and little rivers, of tall tales and good manners. The subject of art might be one's sentiment about familiar things. Kline has always fastened compulsively on the familiar.

In 1939, when he returned to America from England at the age of twenty-nine, he exhibited at a booth in the Washington Square Show (flanked by Otto Botto and Earl Kerkam). A manufacturer named David Orr came along and bought a small painting of the Ninth Avenue El, and, in the following twelve years, Orr acquired over a hundred and fifty of Kline's works. The artist used to paint on his frequent visits to the Orr household— Long Island—portraits of the family, still-lifes, cityscapes. landscapes, sometimes from life, usually not. Kline has a phenomenal visual memory which never surprises laymen in an artist, and never fails to surprise artists. Orr's walls are covered with detailed Lehigh Valley scenes (one of which won a prize at the National Academy in 1944) that were painted in the studio without the aid of sketches. Orr would often commission him to do paintings of subjects that he chose for the artist: he wanted a painting of a synagogue and gave Kline a verbal description and a vague photograph. He came up with a luminous, brownish painting reminiscent of Rembrandt, in the complicated dilated perspective through which he saw his subjects.

Kline was never averse to commissions and in the 1940s would take on anything. He covered the walls of a Greenwich Village tavern with superb

pencil portraits of the patrons (for 50 cents apiece) at the suggestion of Reginald Marsh, who admired his draftsmanship and recommended him to the proprietor. For another bar he painted murals of burlesque queens. For the American Legion Hall of his home town, Lehighton, he painted a panorama of the vicinity with everything included. But his favorite story of a commission is that of the three brothers who asked him to paint a portrait of their deceased father from a photograph. They intended, they explained, to rotate the painting among them. When it was finished, they all agreed it was a satisfactory likeness of the old man and it was placed with the first son. A year later, the second son brought back the painting and asked the artist if he could make some alterations. "His nose was a little narrower and his forehead a little higher," the man claimed. Franz made the necessary adjustments and the man returned home with the freshened painting. A year later, the third son—now the temporary possessor—appeared and said there were a couple of things about the portrait that bothered him. "My father had a ruddier complexion," he said, "and more hair; you made him a little bald." Franz again obliged and everything went smoothly until the following year when the first son got the portrait back. "I liked the picture the way it was when I had it. Couldn't you remove all those changes my brothers made you paint in?" "Sure," Franz says he said, and went to work with turpentine and paint remover. But with a little too much, unfortunately, and suddenly the likeness of the father had vanished and an old self-portrait of Franz appeared from underneath. The three brothers were delighted with it and now circulate the portrait of Franz.

A portrait of Theo van Cina, an old Dutch academic painter, well-known in the Village, also had another picture painted over it, and when van Cina died Kline scraped off the new painting to get back the likeness of an old friend. Nostalgic about the present, Franz sits in the middle of his anecdotes like a man drowning in his own life. He talks in shorthand; his gesture is his identity. He is a virtuoso—but a passive one. He didn't decide on his different approaches to painting; he drifted into them.

His content was always *gesture*—the gesture of landscapes, of buildings, of women, of cats, of interiors. He even understood schools of painting in terms of the gesture of form. Highly eclectic in his methods, obsessive about his subjects, he would paint one scene or one interior or one person over and over in various styles—or cover different subjects in a single style. Cubist, Impressionist, Expressionist, even Fauvist, most of his paintings were small, compressed, introverted, usually dark in tone, profoundly involved with drawing. An intensely personal element occurred mainly in the way he applied his paint, scrubbing it on with a small, stiff brush, or laying it on like cement with a palette knife.

In his tiny oils on paper, done in the late 1940s, color, although bright, is arbitrary, and the gesture of the paintings resides in the heavy contours. Still involved, in 1950, with elements of representation, he began to whip out small brush drawings of figures, trains, horses, landscapes, buildings, using only black paint. The speed and the weight of the line kept increasing until finally the objective image was overwhelmed by its own outlines. The line, now a heavy brushstroke, no longer described solid forms: it had become, itself, the only solid form on the paper. The next step, logically—or emotionally—was a bigger brush and a bigger area for it to careen through. He began to work on sheets of newspaper with a three-inch housepainter's brush and black enamel. The size of the newspaper, almost immediately, was unbearably confining. Then came the six- or eight-inch brushes, the six- or eight-foot canvases, the five-gallon cans of paint and the big, black images with the bulk and the force and the momentum of the old-fashioned engines that used to roar through the town where he was born. His past came rushing up to be transformed: the first names he gave these paintings were associated with the railroads he knew so intimately as a child: *Chief, Caboose*. Nijinsky, a subject he had been painting for years, sprang onto the canvas with no semblance but gesture; cityscapes like *High Street, Hoboken* burst into their towering, rude scale; the witty rocking-chairs, the haunted interiors, the eloquent faces, the wild horses and springy cats, the centrifugal landscapes and explosive flowers—nothing was left out.

Rothko came to his present style by a gradual elimination of his past; Kline, by swallowing it in one big gulp.

Statement

(1959)

For me the most important thing about the words "painting" and "drawing" is that they end in ing. A painting to me is primarily a verb, not a noun—an event first and only secondarily an image. For years these events occurred for me in vertical space. Now they interact in horizontal areas.

The interaction of color in these events is one kind of drawing. Drawing of any kind has always been my passion, drawing can be swift or slow. Through the years, I seem to have increasing desire for an increasing tempo. In the past, I wanted compressed Gothic space squeezed upward, dense hidden colors, forms cornered and crammed into the surface, airlessness—a sense of suffocation. At that time, the main thing about a painting for me was that it was against the wall.

Now my colors have become claustrophobic; they want to burst the boundaries, to expand, radiate, explode—anything can happen just as long as it's outward.

If a man wants to come and sit down in my painting, he's welcome, and he can leave when he pleases. If a bull finds himself charging through, if bullfighters wave their capes, if ballplayers want to play in my colors, it's O.K. with me. Or if El Greco or Tiepolo wants to throw in a pile of old magenta robes, I can always use them. I don't choose my subjects or my style or my colors, they choose me and I'm grateful to them. Nor do I ever decide to abandon them; I'm torn away from them.

There are conflicts. The excessive liberality of idea struggles with the illiberality of desire, and desires contradict each other, but the strongest desire always wins. I inform the painting of my ideas; the painting informs me of my desires. Right now, I gather, I want pageantry, splendor, panoramas, clamorous color—trumpeting reds and shrieking yellows—the phony glitter of tough bordertown façades, the heraldic colors of the corrida.

If I fall in love with a tree, as I did with the yellow-leaved cottonwood in Albuquerque, or with a New Mexican twilight that scoops up the ground under my feet and turns it purple, these experiences yearn to get into my painting. So do my feelings for the go-for-broke champ: for Joe Louis and Sugar Ray, for Herzog and Johnny Acropolis and Caryl

Chessman. I do not "recollect" these feelings—I just have them—and there is no way to "represent" them, nor am I interested in doing so. I want more than composition in painting.

For one thing, I want gesture—any kind of gesture, all kinds of gesture— gentle or brutal, joyous or tragic; the gestures of space soaring, sinking, streaming, whirling; the gestures of light flowing or spurting through color. I see everything as possessing or possessed by gesture. I've often thought of my paintings as having an axis around which everything revolves.
. . . When I painted my seated men, I saw them as gyroscopes. Portraiture has always fascinated me because I love the particular gesture of a particular expression or stance. I'm enthralled by the gesture of the silhouette (for portraits or anything else), the instantaneous illumination that enables you to recognize your father or a friend three blocks away or, sitting in the bleachers, to recognize the man at bat. Working on the figure, I wanted paint to sweep through as feelings sweep through. Then I wanted the paint to sweep the figure along with it—and got involved with men in action—abstract action, action for its own sake—the game. And finally, I wanted the paint to sweep through, around, over and past, to hack away at contours and engulf silhouettes.

If the gestures are inhabited by landscapes, arenas, bodies, faces or just by colors, it makes no difference to me. However, if red is blood or wine or a rose or a box of matches or a muleta or earth, if red is smeared or dripped or dragged or glazed or spattered or trowelled on, it makes all the difference in the world to red. Red can be tormented or serene or ecclesiastical. Red can be anything it wants. Likewise yellow, blue, green, black, etc. Every color has a million ideas about itself—but fortunately desire has veto power, otherwise nothing would ever get painted.

Participants in a
Hearsay Panel

(1959)

Script conceived and recorded by Elaine de Kooning after three evenings of private discussion by Joan Mitchell, Elaine de Kooning, Frank O'Hara, Mike Goldberg, and Norman Bluhm of the panel, with careful attention to misattribution and misquotation in keeping with the spirit of the art world. (Some of the quotes, however, are accurate.) The script was then tampered with by Frank O'Hara with further alterations by the other members of the panel. Final tampering and typing by Elaine de Kooning.

Joan: We'll open with a question. Is style hearsay?

Frank: Well Pavia says, nowadays everyone talks about you behind your back in front of your face.

Elaine: Yes. Philip Guston told Andrew Wyeth that Louis B. Mayer told John Huston: Well, if you don't like it here, go back to Greenwich Village and starve on a hundred dollars a week.

Norman: Frank says: Style at its lowest ebb is method. Style at its highest ebb is personality.

Mike: Norman is worried because lately he finds himself being polite to everyone. He meets someone and he says How do you do? I'm very happy to meet you when he's not happy at all.

Elaine: At openings, Norman says, the greeting of people has nothing to do with the greeting of people. Norman also thinks the Whitney Museum looks like a drugstore.

Norman: The fear that someone else is liable to know something around here touches me.

Frank: Harold Rosenberg says that artists read paintings and look at books.

Norman: Would the noisy Black Mountain Boys stop picking the change off the bar. We will buy you your beers anyway.

Elaine: Betsy says, In matters of art, it's Vanity and Vexation not virtue that triumphs.

Mike: It has been rumored that rats have eaten the major portion of the paintings at a major uptown gallery.

Frank: Elaine says Pavia says Dogs don't mind being dogs. The panel has heard—hasn't it, Joan—that certain galleries have dropped all their artists and are looking for promising new talent. Now, if some of you look fast—

Joan: Norman, you have a letter?

Norman: Yes, I do. Open letter to the new, that all the tears of arrival, the problem of eating at Rikers, the tragic element of the pat on the back, the events of the show that will never arrive, the forever nagging wife . . .

Mike: Ah, there should never be those civil marriages!

Norman: Till death do us part means you'll never get out alive.

Frank: Lovers always think their glances are invisible.

Norman: But if the heart of man can scratch the balls of the earth, brothers raise up your lonely brushes, great paint at the Brata, a new surface, loin cloths at the cave galleries . . .

Elaine: Lewitin has a small reducing glass that makes everybody's paintings look like his own. But that doesn't make him *like* everybody's paintings.

Norman: To you who are before my eyes, if you think that we are about to speak of art in the tears of space, light, and the elements of line etc. plus factors that have been cried and continue to cry, do you think that we are about to open that which is the feeling of man himself. . . . Then all of the questions would open the eye that is never able to reach from the darkness of the darkness of the dark. Is there any light? (applause)

Elaine: Fairfield says: Why is irrelevancy so often taken for profundity?

Joan: Pat Passloff thought this panel should be called Artists in Armor.

Frank: Someone in the know says more women artists keep journals than men do.

Joan: Now, possibly, the panel will discuss the question of craftsmanship.

Norman: It's all crapmanship to me.

Frank: Elaine says sharpening pencils is practically a lost art.

Mike: Maureen says she doesn't like to draw in pencil because she doesn't know how to sharpen pencils.

Norman: When I was studying architecture with Mies in Chicago, we were taught to sharpen pencils toward ourselves, like this. It took two weeks to find the correct position of the blade.

Elaine: Toward you is the masculine way. I always sharpen pencils away from myself.

Mike: That's only natural. Anything that can hurt you, you do away from yourself.

Elaine: Then men have an advantage.

Norman: Only in terms of craftsmanship.

Elaine: Well, isn't that what we're discussing.

Norman: Not any more.

Mike: Frank says Elaine says Norman is being stuffy again.

Elaine: I'd like to recite a little poem about Norman I commissioned from

Frank: I think Norman's swell,/he doesn't seem to like Mies/anymore but

he talks about him/all the time, especially when/he's drawing. I think that's/
sweet. It means that things last/and not only buildings. Oh lake! Oh shore!
Norman: Thanks, Frank.

Elaine: Frank has asked me to announce that none of the sentiments
expressed in this poem are his. They're mine.

Frank: Ernestine Lassaw told Franz Kline and Tom Young that Bob
Rauschenburg told her that Joseph Cornell saw a beautiful girl in a box, a
cashier's box, outside a movie house and he used to ride past the movie
house on his bike every day to look at the girl in the box. Then, one day,
Ernestine said Bob said, he—Cornell—picked a little bouquet of blue wild
flowers and carried them up and down on his bicycle in front of the movie
house before he finally screwed up his courage and thrust the flowers
through the hole in the box at the girl. She screamed for the manager who
called the police but the police let Cornell go.

Mike: Right now, I notice, there is a worship of the New.

Norman: Well, naturally. There's only one thing new to anyone. That's
himself. That's why we paint in the first person singular.

Mike: It doesn't look so singular to me. Why is it that Hot-off-the-griddle
art is usually hot off somebody else's griddle?

Frank: Bob says we're a generation of swipers.

Elaine: Joan says Norman said: It's third person art parading as first person art.

Frank: George says Mayakovsky says Third person art involves craftsmanship.

Mike: All art involves craftsmanship.

Elaine: Dada didn't.

Mike: Yes, but Neo-Dada does. As soon as any gesture is repeated, craft is
involved.

Joan: Neo-Dada has become Neo-Mama.

Norman: Neo-Mau Mau, you mean.

Frank: Neo-Meow Meow.

Mike: Neo-Moo Moo.

Elaine: Well, according to a noted museum director, the only thing that sells
right now is Neo-Me Me.

Frank: Someone who recently left the country said: Why is it all right to be
influenced by a dead artist and a scandal if you're influenced by a live one?

Mike: Well, it's much more dangerous to kill a live artist than a dead one.

Norman: You mean it's much harder to rape a live artist than a dead one.

Elaine: Frank says nobody looks at dead artists anymore. Living artists have
become snobs about being alive.

Mike: Milton says somebody told him somebody in the New Testament
said: There is a path which seemeth right to a man but the ways thereof
lead to death.

Frank: It just proves you can't depend on the Bible for guidance.

Joan: The panel should buy a Bible and read it under a tree until an apple falls on its head. Then it might discover gravity.

Frank: Simone de Beauvoir says Sade said: There would be neither gravitation nor movement . . .

Norman: She also says he said: The idea of God is the sole wrong for which I cannot forgive mankind.

Elaine: Anne Porter's Godmother, Miss Kelly, says: You have to believe in Hell, but you don't have to believe there's anybody in it.

Mike: I'd like to ask a question. If you rub a nylon stocking against a plaster wall, will the stocking fill with air?

All: Yes.

Mike: That's all I wanted to know.

Norman: Has the situation changed from what we don't have to do anymore to what we don't have to do again to what we still don't have to do?

Mike: Everything will be all right if we stay up there with the top 98% of the nation's painters.

Frank: I agree with Auden about Henry James. Henry James is the only twentieth century artist who . . .

Mike: I'd like to ask a question: Why is it so many artists after taking one lesson on the piano want to play like Horowitz?

Norman: It's like some bourgeois would say that, you know.

Elaine: Peter Stander said if Giotto had a one-man show tomorrow, he'd be famous. Peter also said: Tradition holds your pants up and the Academy is what you put in your pocket.

Joan: Perhaps now the panel should discuss the cult of ineptness although Joe LeSouer says it's the sort of think Lionel Trilling would talk about. You know the cult of peeling paintings. Mine have cracked but they never peeled. Larry's have blistered. Some artists are said to be envious of Larry because of the Museum fire.

Mike: I don't think inept painting is bad painting.

Norman: NO?

Mike: Not necessarily. The subject matter of inability comes across. There are some painters who begin a painting lacking lucidity They start off with a great deal of desire and a lot of stupidity and bludgeon their way through their pictures—and succeed in making forceful honest pictures and then, after awhile, they become masters of their own inability and the honesty of their pictures becomes veiled.

Norman: Why talk about artists who want to master their own mistakes. Let's talk about artists who want to master other people's mistakes.

Mike: That gets us back to craft again—the race to master and surpass the

"look"of others. The look is in quotes, you know.

Elaine: Naturally.

Joan: That's an Aryan idea.

Norman: What idea is that?

Joan: The master the mass of the super-past. Is there no way of talking about what we're for?

Norman: Ortega y Gasset says no. It's a form of exposure. If you feel strongly, you're not sentimental. If you're in love, you don't explain, you itemize. After all, the Song of Solomon reads like a grocery list. For myself, I don't like to talk about what I'm for. I like to talk about what I'm against. I don't like that word Hi. As a matter of fact, that's one word I don't like.

Joan: What's wrong with Hi. It sounds lighthearted.

Norman: Well, I don't like it.

Joan: Well, I don't like a lot of words you use. Now, let's discuss the stigma of the enigma.

Mike: Speaking of the time element in art, is it true that today paintings get old faster than songs do?

Frank: Getting old is not so bad. It's non-existence that hurts.

Mike: One's real level is the present. Painting get old when they try to shock. And shock is no longer possible so contemporary Dada becomes wishfully remembered decor—

Elaine: Allen Oppenheimer would like to know if you're speaking of Herr Dada or Señor Dada or Monsieur Dada.

Mike: Mister Dada to you.

Norman: Why Dada again? You don't want to return to the same thing twice in a row.

Mike: Say, what kind of love life do *you* have?

Frank: George says Dada is an art movement that was born in a train wreck and died the same day.

Mike: About Dada—style becomes inevitably the structure on which one hangs nothing, not even oneself.

Norman: Joan says style's not a structure. It's a skin. It's not inside. It's outside.

Elaine: Fairfield says it *comes* from inside. When asked: Where does it go, Fairfield says—I don't care; anywhere it likes.

Mike: Style is some thing one builds brick by brick on which one *hangs* the skin.

Norman: There's only one reason I don't like that word, skin. It reminds me of architecture.

Mike: I *want* it to remind you of architecture.

Norman: It reminds me of the architect I never became.

Joan: Why do you want to bring in architecture?

Mike: I think the individual artist in relation to his art has a structure within himself that he's built up out of all the previous pictures he's ever painted and that, to me, is an architectonic concept.

Joan: Sounds like a pile of stones to me.

Norman: Gall-stones, guile-stones, milestones, stylestones, tomb-stones . . .

Mike: That all goes into marriage.

Norman: According to Sarah's husband-in-law, there seems to be quite a few would-be widows (candidates for a dead husband) in the art world but nobody seems to want to marry them, including me.

Mike: Well, what do you expect of an anxious single younglady?

Norman: What's a glady?

Mike: You know, a sub-cultural lady with hopes.

Norman: Oh, you mean a cultural lion-hunter.

Mike: There's nobody more refined than a younglady who wants pink minks.

Frank: Well, I don't know what you're all fussing about. Anyone who chose Goneril and Regan deserved what Lear got. Even a dog would know that. What do you think a great artist is, somebody who buries his dung? No. Somebody in whom it *floats.*

Elaine: Speaking of dung, I was talking to my mother about architects and their boring designs . . .

Frank: Speaking of chair designs, Harold Rosenberg says the only way to criticize a chair is with your bottom.

Elaine: Well, to go on, my mother said: Isn't it odd—thousands of years and the human race has come up with only five pieces of furniture.

Norman: Mr. Wizard says: Look through the lenses of a pair of eye-glasses held at arms length. If the wearer of the glasses is far-sighted, you will probably see upside down images in his convex lenses. This doesn't happen to be true because we've all tried it but anyhow . . .

Mike: Walk into any room and look around. It is certain that there are a couple of lenses around. Where. Right in your eyes!

Elaine: Michel Sonnabend says: What are eyes? Those holes in front of your brain.

Joan: Bill said: If you've never loved blindly, you love only God.

Elaine: Emily Dickinson said: Nature is a haunted house. Art is a house that tries to be haunted.

Frank: Thoreau said: No matter how I try to think of Nature, my thoughts go constantly to plotting against the State.

Mike: Elaine's brother, Peter, to whom I'm personally devoted, said: Why live simply when it's so easy to make life complicated.

Norman: I've heard that if you like men whose lips move when they read silently to themselves, then you won't like Matthieu.

Joan: Can you honestly tell me why anyone *should* like Matthieu.

Elaine: Frank says the Greek heroes were damned lucky to have their tragedies revealed to them. Otherwise they would have spent their whole lives bored.

Frank: Marie says: People who bear their troubles are dunces. When asked what people should do about their troubles, she said: Get rid of them.

Joan: Everyone agrees.

New Mexico

(1961)

Sometimes a region creates an artist as Arles did van Gogh and Aix, Cézanne. Other areas, equally splendid, don't do it: the Hudson River scene, greenly ingratiating, produced minor artists.

Pascin is reputed to have stepped off a train on a visit to New Mexico and have gotten back on again immediately, saying, "This light is too bright for me." It is certainly a light that consumes, a light to make moths of artists. So the fabulous golden cottonwoods and aspens, the flayed pink earth, the jagged stampeding mountains, the reverberating sunsets, are celebrated only in the sugar-candy Buckeye canvases that cover the walls of restaurants and hotel lobbies—to be bought by Texas tourists in the summer. The real art in New Mexico—mostly abstract—turns its back on nature and has the veiled, greyed quality of a room entered after a period in the blinding sunlight. A great color photographer like Eliot Porter of Santa Fe can cope with these opulent vistas. For painters, the environment is so overwhelming that they have to look inside. Here is strongly introspective art, stubbornly original and personal, yet not eccentric. Revealing an awareness of East- and West-Coast painting, the work of New Mexican artists reflects neither. None of the slashing brushstrokes and drips of the former, none of the brilliant colors of the latter. The art seems to relate more to French painting: disciplined, intellectual, contained. The soul of Cézanne looms large. Isolated and individualistic, the New Mexican artists have enough in common with each other and enough difference from artists in other areas to be called a school; American schools of art are distinguished from the European in having not an ideology but a character.

With few exceptions—Peter Hurd and Henrietta Wyeth in Roswell, Georgia O'Keeffe, Eliot and Aline Porter in Santa Fe, Agnes Martin, Beatrice Mandelman and Louis Ribak in Taos—the serious artists in New Mexico live and work in Albuquerque, the biggest city in New Mexico. When I first arrived there, I asked a lumber salesman named Rocky (he turned out to be a New Yorker who loved the Southwest and couldn't bear to leave) about the population of Albuquerque. "The second floor of my apartment house in the Bronx had more people," said Rocky.

Some 20 excellent artists per 200,000 population is not merely a good percentage, it's sensational in relation to other cities I have visited. One casts about for reasons. Albuquerque is a college town. Most of the artists were students at the University of New Mexico or, like Lez Haas, Ralph Lewis, Kenneth Adams and Sam Smith, are members of the faculty. The art department is first-rate and brings instructors from all over the country. But other university towns with comparable populations and art departments have not produced any such school.

The unique element in Albuquerque, I feel, is the presence of a dynamic, 70-year-old artist named Raymond Jonson, whose work, in its metaphysical character and meticulous, non-objective style, evokes Kandinsky. Director of his own "museum," which houses some 1,500 of his own paintings, carefully framed, catalogued and racked, Jonson is probably the factor most responsible for encouraging the large amount of work and high level of professionalism of the young Albuquerque artists (most of them in their middle thirties) by offering them one-man shows at his gallery. Without this goad, many of them feel they might have become too discouraged to go on in a vacuum. In his generosity, vitality and ability to stimulate other artists, Jonson is comparable to Hans Hofmann.

Another special feature of the Albuquerque scene is the high percentage of women artists—about one-third—which situation does not seem to occur in any other city in the country except New York. Most impressive among these are Connie Fox and Joan Oppenheimer. The work of both of these artists, although essentially abstract, takes its cue from nature while contradicting it. Joan Oppenheimer magically evokes the distances of the Grand Canyon in stony, closely-impacted masses of bleached color that encroach vaguely on each other to yield an image of luminous magnitude. Connie Fox, living high in the mountains where there is snow a good part of the year, chose a site for living and painting which denies the general flamboyant tonalities of the Southwest. A magnificent draughtsman and colorist in that section of the spectrum where colors relinquish their names, Connie Fox paints her starkly-articulated mountains and trees, huddled birds and grandly isolated figures in elusive, cold umbers, ochers, blues, grays and whites.

All of the other artists here seem to paint "interior" abstractions. Jack Garver's minutely-painted surrealist forms suggest Yves Tanguy's except that Garver crowds them into his space to create a sense of loneliness one might feel in a subway rush-hour. This curiously-crammed space also characterizes the work of Don Ivers, Bill Howard, Ralph Lewis, Richard Kurman and Jean Armistead. Except for the last two artists who communicate a sense of motion—even turbulence—in their work, this compression of

forms makes for a quality of urgent stillness. Don Ivers, in particular, interlocks his somber grays and blacks in cavernous compositions of an almost painful equilibrium. The strength of this art is in its resistance to fluency. Like Cézanne, these painters don't take it easy.

Franz Kline:
Painter of His Own Life

(1962)

The most inclusive of artists in his attitudes, methods and long development, Franz Kline seems to get rid of everything but immediacy in the momentous black and white image, now internationally recognized as his unmistakable insignia. Its great energy lies in a naked, physical presence. Its time is now, the place is here.

All-American in effect, this final image, disclosed in twelve years' work (1950–62), presents a unity of expression and singleness of purpose that sets it apart. His work is complete, independent; it is all there, in front of you. Any extensions of its visual actuality into history or biography inevitably would appear to be falsifications. Shorn of all reference, association or allusion, his art seems to reject any attempt at explication.

William Faulkner, who died a few months after Franz Kline, maintained that speculations about the methods, the motives or the history of an artist are irrelevant to an understanding and appreciation of the work. Certainly response to art does not involve analysis: there is the revelation made by the artist and there is the recognition by the onlooker: mission completed. Our reaction to Grünewald's *Crucifixion* would not necessarily be amplified by discovering that he was an atheist or a saint. But knowing that an eighty-year-old painter, sitting in a wheelchair, fully aware that he was dying, selected certain colored sheets of paper and made cutouts to be tacked on a wall under his supervision is a piece of information that illuminates the last masterpieces of Henri Matisse.

What we know of any artist's life *may* or *may not* be revelatory. Some artists hide. Others—Michelangelo, Cellini, Delacroix, Van Gogh, Dostoyevsky—expose themselves, keep journals, write sonnets. And some, like Franz Kline, talk. For these, nothing they have done or thought or said is irrelevant. Everything helps. For Franz Kline, "talk" was an activity which he always kept going around his art. He was never silent or secret. Everything he said, the wisecracks, the miscellaneous bits of lore, the hilarious reminiscences are pertinent to his creation and our understanding.

The authority of Kline's art has nothing to do with authoritarianism; his ideas have nothing to do with ideologies. "Hell," said Franz, "half the

world wants to be like Thoreau at Walden worrying about the noise of traffic on the way to Boston; the other half use up their lives being part of that noise. I like the second half. Right?"

His acceptance of things-as-they-are had nothing to do with resignation, but with a rare, panoramic enthusiasm. A great spectator, open to everything, Franz Kline appreciated art, past and present, with passion and perception, as he appreciated the time and place in which he lived. This genius for responding had a humorous, childlike, vulnerable quality—a sense of absolute faith—like that of a Jehovah's Witness who announced to a group of artists some years ago: "This world is a marvelous place. Everything is so convenient. When you get out of bed in the morning, the floor is always there, right under your feet."

His black and white image, with the massive scale, blunt finish, uncaring, unlistening presence of industrial structures, often loomed with an uneasy contemporary sense of the tragic. First exhibited in 1950 at the Egan Gallery, his painting did not reflect the dominant attitudes of the European art that had been shown so widely for the previous decades, nor did they seem to feed on the other new American painting then just gaining its first small acceptance. Certainly the big, automatic canvases of Jackson Pollock had their effect on Franz Kline (as they did on the whole climate of the artists' world), as did his friendship with Willem de Kooning, a dynamic and inspirational relationship (like that of Monet and Renoir, as against the intellectual, collaborative ties that linked Picasso to Braque).

Franz Kline's image found its virile originality in his responses to non-art or life. The shock of original art comes from the form it gives to a consciousness that was there, formless, beforehand. As the poet Frank O'Hara observed, Franz Kline's work both expresses and lives "by virtue of the American dream of power, that power which shuns domination and subjection and exists purely to inspire love."

Franz Kline recognized the gestures of American Style wherever he looked and had an uncanny ability to project its particularities and breadth through paint. American style, as he saw it—with a fan's zest and expertise—had an element of the comic; the big, brash, breezy gesture that, carried to its extreme, becomes a not-unconscious parody of itself, as in the design of the Cadillac or the cut of the zoot-suit, as in the movie-queen's inevitable role of female impersonator, as in the fanciful sentimentality of Tin Pan Alley songs, as in the films based on the lives of stars, played by the stars themselves (Gloria Swanson in *Sunset Boulevard*), as in the jovial mechanized rhythms, so instantly recognized abroad, of popular dances, from the Charleston, the Black Bottom, the Tango, through the Bunny-Hug, the Lindy, Big Apple, Truckin' to the Twist, the Fly and Mashed Potatoes.

Humor, for Franz, was always a kind of appreciation. Talking about a painter who became a comedian in the Borsht Belt and who never got back to painting, Kline remarked, "He had such marvelous heart. He *cared* so much." Franz had a special love for comedians (particularly the slap-stick that went out with vaudeville) and was himself a magnificent mimic. His anecdotes, told in half-sentences and unfinished gestures, expressed the inexpressible. His jokes, for which, with a helpfully contagious laugh, he was his own best audience, were inimitable. His stories, half-told, half-acted, communicated to a point beyond words. There was always, one felt, a deep message that somehow, a moment later, couldn't be interpreted. But it didn't really matter. "To be right," Franz pointed out, "is the most terrific personal state that nobody is interested in."

"Mirth is the mail of anguish." Franz Kline's favorite comedians were always the helpless ones, "the lost souls," like Laurel and Hardy, W. C. Fields, Buster Keaton, whose acts perpetually meshed into the fatal chain of events of tragic heroes, Ajax, Oedipus, Sisyphus. . . . In the years when he lived in bleak poverty, one of his jokes was about the Bostonian who defined a bohemian as "someone who could live where animals would die."

Anecdotes were Franz Kline's shop-talk. Literature, religion, philosophy, art theory were subjects to be avoided (too vague, too ponderous). He was in love with the actual and the specific: the time it took Cunningham to run a mile in the Melrose track meet, why they took Jim Thorpe's medals away after he won the Decathlon, how many fights Phainting Phil Scott lost before he retired a rich man, how Ronald Colman mounted a horse in an old French Foreign Legion film, why Toulouse-Lautrec wanted to draw like Degas who wanted to draw like Ingres . . . the stream of Franz Kline's observation was a matter of illuminated fragments, poignant facts, nuggets of insight. A festive man, committed to the moment he was living, ready to dance all night, the last to leave a party, Franz had a paradoxical loyalty to the past. The American rage to discard the "obsolete" was intolerable to him. He never abandoned an enthusiasm and there was no such thing as a passing fancy. Nostalgia played a curious and powerful role in his development. It was as though he proceeded in his life and in his art by looking backward.

While young Americans in the late 1930s were reacting variously to School of Paris and Mexican art, Franz was in London, poring over the work of English and German graphic artists and cartoonists with their references to Daumier, Blake, Fuseli, Rowlandson, Dürer and Goya, and collecting old prints of the Japanese.

In the early 'forties, when New York galleries and museums were devoted to Picasso et al., Franz was entranced with Velásquez, Rembrandt,

Vermeer, Corot, Courbet, Manet and with the introverted American landscape painters—Ryder, Blakelock, Wyant. When he did yield to twentieth-century styles in the mid-forties, it was with reservations, as though he viewed them through a scrim in a previous style.

There were artists he admired but kept his distance from—that is, his admiration did not invariably involve the hand that held the brush. "It would take a top kind of egotist to say, 'Velásquez is related to what I'm doing.'" His feelings for other artists as echoed in his work during this period were not sequential but acted in an interplay. A flashily brushed, monotoned oil of a Negro couple is at once reminiscent of Daumier and of Kline's friend Reginald Marsh. A tiny, glittering portrait of a two-year-old in red overalls, painted in an hour in swirls of bright pigment, evokes both Delacroix and Soutine. El Greco and Cézanne cast their light intermittently over the cramped, industrial landscapes, painted from memory, of central Pennsylvania, where the artist was born and spent his adolescence before going to Boston to study art. Through this decade, his highly varied studies of women invoke the artists who specialized in painting women: Modigliani, Pascin, Toulouse-Lautrec, Matisse, Rouault and, of course, Picasso. "A great part of every man's life," wrote Sir Joshua Reynolds, "must be employed in collecting materials for the exercise of genius. Invention, strictly speaking, is little more than a new combination of those images which have been previously gathered and deposited in the memory: nothing can come of nothing; he who has laid up no materials can produce no combinations."

An excruciatingly conscious artist, Kline was passive about his erudition. He didn't *apply* it. It imposed itself on his brush.

His relation to his patrons also had an odd, passive quality, like that of artists of past centuries when they used to have patrons. Nowadays, artists are supported (or are not) by collectors who buy their works as objects to be hung among other objects. Patrons, who support the *making* of art, are rare. Franz had two: Dr. Theodore Edlich, whom he met in 1936 and who bought some thirty-five of his works during the lean years, and David Orr, who bought some one hundred fifty of his paintings during the 'forties.

Franz Kline had a very close relationship with both of these men who were instrumental in keeping him going in the decade before he became famous. (Edlich was his family doctor and was in attendance during his last illness.) Whenever the artist was more than usually broke—which was constantly—there was always a portrait of a wife or a child to be painted. In 1946, after years of hard work, when Franz hit one of those overwhelming slumps which most disciplined artists experience and make it seem impossible to pick up a brush for months at a time, Dr. Edlich lured him back to his easel by commissioning a portrait of the late Mahatma Gandhi, whom

the doctor revered. Franz painted a gentle, impersonal and uninvolved study as though he hadn't given the subject much thought, but was willing to empathize with someone else's feelings.

David Orr, who discovered Franz exhibiting in Washington Square in 1939, was an even more active patron, commissioning numerous portraits of himself and of his family and constantly suggesting scenes and subjects to the artist whose work he knew by heart. If someone else bought a landscape or a still-life or a portrait that Orr liked, he often had Franz paint another version—and the later version would always be larger, bolder, freer.

During this period, Franz Kline compulsively returned to the same themes over and over: the figure of a woman seated by a table, an empty rocking chair against a window, a train impacted in a green landscape, a bouquet of big, pale, yellow flowers. And the different versions of one subject would vary drastically in style. Preoccupied with his own ideas of form, the painter could let them cluster around any possibility. André Gide's observation on a Vuillard would be applicable to any of these pictures: "I know of few works where one is brought more directly into communion with the painter. This is due, I suspect, to his emotion never losing its hold on the brush and the outside world always remaining for him a pretext and a handy 'means of expression.' "

Affectionate towards his subjects, he could accept any subject. In fact, a subject was necessary to set his ideas of form in motion. His occasional abstractions of the late 'forties, although graceful and learned, were eclectic to the point of anonymity and lacked the conviction of the representational pictures he was making at the same time.

During this period, Kline would often return to finished paintings, taking them down from Orr's walls and reworking them (he had a studio set-up in the household). Sometimes he would get bogged down and paint out the picture. His process was one of constant adjustment, refinement, addition and reduction, as he probed for the image in an approach closer to that of Ryder than to any other artist. Like Ryder, he painted an interior world, rarely working from life except for his portraits and, even then, the portraits would generally be finished without the presence of the sitter. His self-portraits were the only works completely painted from life. Working painstakingly on small canvases (the average is 18 by 20, the largest 40 by 50), Kline was never finicky as his compact images evolved in dense non-illusionistic space.

Drawing rather than color was Franz Kline's passion in these works. Color was tonal and employed in terms of lights and darks. Even when he used bright color it was arbitrary and ended up in a monochromatic scheme—portraits, landscapes, interiors all might be described as yellow or

green or ocher or red paintings as, in each case, the drawing picked up the leading color and ran away with the picture. Drawing was carried not only by the contours, but in the intense, quirky application of pigment as he twisted, pulled, dragged brushes, palette knives, pencils though the wet paint in constantly changing ways, always ending up with a completely coated canvas whether he finished the painting in weeks, months or in a day.

The extraordinary memory for essential gesture, structure, and detail that made him a great mimic, enabled him to reconstruct sweeping cityscapes in his studio—the old Ninth Avenue El, Chatham Square, Hudson Street, the Fulton Fish Market—in characterizations so keen that any New Yorker would immediately recognize the specific neighborhood, from its feel rather than from any circumstantial detail.

Emotions were characterized, too, in the forlorn but jaunty studio-interiors, the lonely seated figures, the lighthearted, preening cats and frol-icking horses, the almost invariably melancholy portraits. The pressing sense of bleakness, of isolation, of alienation in the black and white structures was foreshadowed by his preoccupation with the image of Nijinsky in the role of Petrouchka, the clown with the classically lost love. He painted numer-ous studies of the great dancer, always with the head cocked to one side in a hopeless, disjointed gesture. With the abject, blood-red eyes burning sadly in a pasty white-powdered face, this painting fixes the star's private tragedy on his public image. Like Camus, in *The Artist at Work*, like Henry James in *The Death of the Lion*, like Marilyn Monroe, summing up her own life in the interview published a week before she was "suicided by society" (Artaud's phrase), Franz appreciated how a celebrity's public myth can drain his private blood.

The masterpiece and the last of his serious representational pictures, *Nijinsky* was painted on commission for David Orr in 1950 after Kline had begun working in his new style which is reflected in the radiant brushwork of the portrait. He painted a few more landscapes, portraits and still-lifes in the early 'fifties, but these were no longer meaningful in his development and were done on commission purely to earn money because his black and white paintings, although widely acclaimed, were not being bought. In fact, Franz Kline had a very short look at his success—six years at most.

A "pro" in a sense that is rare in the art world today, when sanctimo-nious stands are being taken by so many vanguard artists who apparently were *drawn* to art as a way of life (or a way of preaching), not *driven* to it, as Kline was by the simple need to work, he painted for the joy of the activity itself and used to take on any commission. The 'forties were the interim years, after W.P.A. had vanished and before artists could support themselves

with the teaching jobs that are now so numerous, but Kline managed a livelihood, sternly modest though it was, from his art. Purely commercial jobs, like the murals of burlesque queens painted for a Greenwich Village tavern or a panorama painted for the American Legion Hall in Lehighton, reveal an incorruptible effort that kept them from being common potboilers. And the pencil portraits—still scattered on the walls of the Minetta Tavern where the artist drew customers for fifty cents apiece—are direct and exquisite examples of draftsmanship, the result of doing what comes naturally after years of learning how to be natural.

All during the 'forties, while he labored over his paintings, he was making hundreds of tiny sketches in small pads, menus, napkins, envelopes, on the backs of bills, on any scrap of paper around a park, cafeteria or studio. Battered and spattered, smudged and creased, but somehow always saved, these lucid sketches became the key to his self-discovery. Fragmentary jottings of ideas, notations of possible compositions or formalized reductions of finished paintings, Cubistic studies of figures flashing through brittle planes, violent little brush drawings of horses, cats, trains and rocking chairs, fluid pen and ink drawings of friends with the contour skimming around the figures, trapping fantastic resemblances in the fleeting line, these small sketches reveal an astonishing range of invention. Kline carried on his private investigation of his non-verbal thoughts on paper in the same spirit that he "performed" his anecdotes, attempting to fulfill his endless urge to comment, to analyze, to deduce, to combine, to act out—and finally—to amaze, to offer something brand-new. "Art has nothing to do with knowing," Franz said, "it has to do with giving."

Although they seemed to be made in the nature of doodling, these tiny sketches were highly concentrated efforts. Stark and spare, they have an open, unpremeditated quality not possible to worked-over pictures. Talking with friends or listening to music (Franz was partial to Wagner and Bunk Johnson), he drew with pen or pencil. Alone in his studio, he worked mainly with mixed mediums—crayon, India ink, pastel, watercolor, tempera, laying in flat areas of clear color, heavily outlining his forms with black in pencil, crayon, ink or paint.

A crucial element in the evolution of his final concept was the fanatic care he exercised in locating the limits of the rectangle surrounding a sketch. He would never start with a fixed rectangle and compose or expand within it, in the traditional Renaissance manner (still employed, quite unconsciously, by most abstract painters), but would zero in to the final rectangle from changing arrangements and proportions. Sometimes he would draw six different rectangles around a single motif, or he would make several duplicates, each differently delimited.

It was as though his search for a new image had to be pursued on the side and not attacked frontally in a controlled effort where habits of mind could intrude and overwhelm spontaneity and strangle new ideas. Buckminster Fuller once observed that some of the greatest discoveries in the field of engineering came about through the spirit of play.

One day in '49, Kline dropped in on a friend who was enlarging some of his own sketches in a Bell-Opticon. "Do you have any of those little drawings in your pocket?" the friend asked. Franz always did and supplied a handful. Both he and his friend were astonished at the change of scale and dimension when they saw the drawings magnified bodilessly against the wall. A 4-by-5-inch brush drawing of the rocking chair Franz had drawn and painted over and over, so loaded with implications and aspirations and regrets, loomed in gigantic black strokes which eradicated the image, the strokes expanding as entities in themselves, unrelated to any reality but that of their own existence. He fed in the drawings one after the other and, again and again, the image was engulfed by the strokes that delineated it.

From that day, Franz Kline's style of painting changed completely. It was a total and instantaneous conversion, demanding completely different tools and paints and a completely different method of working with a completely different attitude toward his work. Any allegiance to formalized representation was wiped out of his consciousness. The work, from this moment, contradicts in every way all of the work that preceded it, and from which it had so logically and organically grown.

The artist got hold of large pieces of canvas and tacked them around his walls. He bought housepainters brushes and enamels in a hardware store since artists' brushes didn't come in large enough sizes and artists' colors were much too expensive in terms of the quantities he needed, and, more important, they were the wrong consistency—not fluid enough for his new needs. His image was immediately conditioned by the properties of the enamel—the drag on the brush caused by quick drying, the coarse and uneven textures that record the speed and the weight of the stroke, the predictable thickening of the whites and shifts from mat to shiny in the blacks. No matter how simplified his imagery, it was never facile (like that of some of his followers on both sides of the Atlantic). Part of its tension, for the first few years, comes from his fight with intractable materials. Later, when he could afford the best pigment, it took months before the artist, used to struggling with rubbery, stringy paint, could adapt himself to its easy flow and yielding ways. He was appalled when he first began to use good tube whites—titaniums, zincs, permalbas, flakes—with their uniformity of surface and lack of body, and, again, he had to evolve a completely different way of working—this time to avoid slickness and ingratiating effects.

In 1950 his sketches, measuring in feet instead of inches, were slashed out on the pages of telephone books and sheets of newspaper with black enamel. Using these as a kick-off, he would work on several large canvases simultaneously, going from one to another over a period of days or months, hacking away forms, painting over black with white and white with black to carve out or build up his image.

It was Kline's unique gift to be able to translate the character and the speed of a one-inch flick of the wrist to a brush-stroke magnified a hundred times. (Who else but Tintoretto has been able to manage this gesture?) All nuances of tone, sensitivity of contour, allusions to other art are engulfed in his black and white insignia—as final as a jump from the top floor of a sky-scraper.

The upheaval in Kline's approach was not accompanied by a verbal mystique, as has been the usual case since Courbet initiated the practice of stating revolutionary aims. Since the first appearance of abstract art a half-century ago, its practitioners have been busying themselves with manifestos and ideologies, explaining what their art is and what Art should be. And contemporary painters, more than ever before in history, worry about the interpretation put on their work and are preoccupied with verbalizing its meaning to themselves and to the world. The problem, of course, is that abstract artists often feel that they are going to be misunderstood or that the content of their work is being misinterpreted somewhere. A curious thing is that the most articulate of the self-explainers from Mondrian, through the Bauhaus, down to Ad Reinhardt, spend a good deal of their energy labori-ously spelling out what other artists should *not* do. Kline had no desire to explain his work, or to set it up as an Ethos. The painting had its own con-viction and that sufficed for the painter. The ideas were all locked in the image and could not be released by words. "The subject has become the problem," Kline said after he had abandoned any representation. "You can say 'painting is the subject,' but you can't just stand by with a shelf full of paint cans.

"Sometimes you do have a definite idea about what you're doing—and at other times, it all just seems to disappear." When he had to give titles to the paintings in his first one-man show, he invited two other artists to his long, narrow studio on East Ninth Street and discussed the possible refer-ences. He talked about everything except painting: about his adolescence in a mining town and about the fascination railroads had for him (*Chief* and *Cardinal* were the names of particular trains he remembered); he talked of football games that he played or watched as a child; of the Victorian rose-wood furniture designed by John Belter with which his mother furnished the house; of his year in London where he met his wife, Elizabeth, who

was then a dancer with the Sadler Wells Company; of Olympic champions, Pennsylvania Indian tribes, etc. The conversation rambled on for eight hours, animated and directionless, interrupted by one artist or another picking a word out of the discussion as a possible name, which had to be unanimously convincing to be accepted. Its evocation, preferably ambiguous, had to be true to some aspect of Kline's general experience, not to any particular aspect or possible strained resemblance suggested by a painting itself. Titles were identification, not description, and *Caboose* or *Bridge* or *Hoboken* were names that could have been given interchangeably to other paintings. Although he preferred names of places, he occasionally would use one as an homage to a person: *Nijinsky, Elizabeth, Merce C.* (the dancer Cunningham), *Probst* (the painter). And if a private connotation had another implication for the public, that was O.K. too: who would guess that the series called *Mars* was named after a girl he knew in his student days in Boston?

When he had his first show, much was made of a supposed resemblance to Japanese calligraphy, but from the very first, his approach to his large canvases involved an interaction between black and white that was totally alien to calligraphic concepts, techniques and expression. His black forms did not float on a white expanse with the fluency that is a requisite of calligraphy, Japanese or otherwise. Fluency was not the intention or the result as Kline's blacks and whites jostled each other for position in a tense, unrelieved conflict. His way, at that time, of brushing past one color with the other was much closer to the methods of American (as opposed to European) sign-painters who laid in letters in one color and then cut them with another to achieve a knife-edge impossible through direct application. Although some of the crucial "doodles" of the 1940s were influenced by his long-held admiration for Japanese art, even in these, the forms are straitened and non-calligraphic in expression. Indeed, far from being derivative *from*, his black-and-white image had a wide influence *on* Japanese artists almost immediately after his works were published. The Japanese re-evaluation of the great tradition of Zen calligraphy was, in a way, triggered by their special interpretation of Kline's style.

In his first blacks and whites, Kline often allowed the painting to dry before altering the forms, and the two colors would shear off each other's edges, staying clean and separate. As in the small sketches, the placement of forms in the rectangle was pivotal. Never panoramic, always aggressively close-up, his paintings in the years that follow are like different versions of one immense, complicated machine seen from different angles, from above, from underneath—huge fragments wheeling, rising, toppling, veering, in an always precarious balance. His forms kept becoming more and more massive, the space more dense, as reverberating greys appeared along edges

and crashed through blacks and whites, cementing them in increasingly complex structures. Watchful at every moment for the climactic equilibrium, Franz Kline approached his big canvases in a spirit of attack. His gesture of painting might be reckless but was never automatic. From the first carefully aimed sweep to the last, his control was always fiercely evident.

In the middle 'fifties, he began attempting to use color and, at first, it seemed as though his identity was irrevocably caught between black and white. Although his first use of color—great rushes of blue, green, purple—had a marvelous lyrical quality, it lacked the force of his black and white imagery and, over and over, black would get back into the act and solve his problems. Again, he resorted to small sketches, making hundreds of oil studies on large sheets of paper which he would then cut up into smaller rectangles, isolating a flurry of greens here, a flash of purple there, in his search for the scale of color. But on his large canvases, the color seemed to thin out and lose volume and as the paintings developed, color was allowed to remain only in shreds and intermittent washes that acted in terms of value not hue. Then, as he kept struggling, interweaving black and white with weighty blues, oranges, reds, his color made its breakthrough and entered the dynamism of his imagery as an equal actor.

The stage was set, the new action had started.

A recurrent illness forced Franz Kline to stop work in the winter of 1961–62; he died the following May at the age of 50.

The big thing about Franz Kline's art is its inclusiveness. Franz, laughing in front of one of his big black and white paintings, obviously making a wisecrack, in the wonderful photograph printed in *Life* after his death, has the open gesture of his own painting. It is not surprising that this photograph is tacked on the walls, coast to coast, of the studios of artists who never knew him. Franz Kline had an extraordinary gift for establishing intimacy through his art.

Painting a Portrait
of the President

(1964)

In the winter of 1962-63, Elaine de Kooning traveled to Palm Beach to execute a portrait commission of President Kennedy, destined for the Truman Library, Independence, Mo. Challenged, she immersed herself in the task, producing a whole series of studies and finished paintings.

President Kennedy was off in the distance, about twenty yards away, talking to reporters, when I first saw him—and for one second, I didn't recognize him. He was not the grey, sculptural newspaper image. He was incandescent, golden. And bigger than life. Not that he was taller than the men standing around; he just seemed to be in a different dimension. Also not revealed by the newspaper image were his incredible eyes with large violet irises half veiled by the jutting bone beneath the eyebrows.

One of the reasons I was asked to do the portrait is that, with luck, I can start and finish a life-size portrait in one sitting (after a couple of preliminary sessions of sketches to determine the pose and familiarize myself with my impression of the sitter). After years of working on my portraits (mostly of friends) for months at a time, I found myself getting bogged down in overly conscious effort and discovered that by working swiftly I could enter into an almost passive relationship to the canvas and get closer to the essential gesture of the sitter. However, working at top speed this way, I require absolute immobility of the sitter. This was impossible with President Kennedy because of his extreme restlessness: he read papers, talked on the phone, jotted down notes, crossed and uncrossed his legs, shifted from one arm of the chair to the other, always in action at rest. So I had to find a completely new approach.

I began with fragmentary sketches—first in charcoal then in casein, sometimes just heads, sometimes the whole figure. For the first session (during a Medicare Conference), I sat on top of a 6-foot ladder to get an unimpeded view of him. Concentrating on bone structure, most of my first sketches made him look twenty years younger. This was also because the positions he assumed were those of a college athlete. I made about thirty sketches at the first session and rushed back to a big studio that had been

turned over to me by the Norton Gallery, made further drawings combining different aspects, and finally, after a couple of days, decided on the proportions and size of the first canvas—4 by 8 feet.

In succeeding sessions of sketching, I was struck by the curious faceted structure of light over his face and hair—a quality of transparent ruddiness. This play of light contributed to the extraordinary variety of expressions. His smile and frown both seemed to be built-in to the bone. Everyone is familiar with the quick sense of humor revealed in the corners of his mouth and the laugh lines around the eyes, but what impressed me most was a sense on compassion.

Everyone has his own private idea of President Kennedy. The men who worked with him had one impression, his family another, the crowds who saw him campaigning another, the rest of the world, which saw him only in two dimensions, smiling or frowning on a flat sheet of paper or a TV screen, still another—and this last, by far the most universal. Beside my own intense, multiple impressions of him, I also had to contend with this "world image" created by the endless newspaper photographs, TV appearances, caricatures. Realizing this, I began to collect hundreds of photographs torn from newspapers and magazines and never missed an opportunity to draw him when he appeared on TV. These snapshots covered every angle, from above, below, profile, back, standing, sitting, walking, close-up, off in the distance. I particularly liked tiny shots where the features were indistinct yet unmistakable. Covering my walls with my own and these photographs, I worked from canvas to canvas (the smallest 2 feet high, the largest 11), always striving for a composite image.

Jackson Pollock:
An Artists' Symposium

(1967)

Jackson Pollock raises all sorts of questions—the relation of the artist to his public image, to psychoanalysis, to his self-image, to critics and collectors, to words, to booze, to success and to the present that was his future. Today's situation in art was foreshadowed by Pollock's conflicts.

Pollock's fierce, twinkling bull eyes and great shoulders are there in his work. Some artists' faces are embedded in their work in this way, as a kind of personal resonance, others not: Picasso's face is in his work, and Modigliani's, Klee's, Van Gogh's, Delacroix's, Raphael's, but not, say, Soutine's, Mondrian's, Seurat's, Grünewald's. This resonance—a trace of the personal—is an attribute which doesn't add meaning to nor detract from the work: in fact it invites false values. It is the attribute—much prized by hucksters in the entertainment world—that makes readers of movie magazines regard the roles of stars as an adjunct to their private lives. The serious audience for art has not vanished, it has merely been deluged (for how long?) by the fan-magazine mentality of a much larger, spurious audience, as is evidenced by the coverage in the press, whether it be Louella Parsons or John Canaday: How much does Liz Taylor get for a picture? And how much does Andy Wyeth get? The proof's in the pudding, ducks.

Thus Pollock's vivid personality invited recognition before his painting did. He was the first American artist to be devoured as a package by critics and collectors (whom he cowed), by *Life* magazine in the late '40s in a spread which asked, somewhat wryly, if he were America's "greatest artist," and subsequently by the fashion magazines and gossip columns and the rest of the P.R. paraphernalia.

Serious artists can enjoy the W. C. Fields aspects of this kind of success, as Franz Kline did when he went from being totally broke to instantly solvent, whereupon he strolled into a Park Avenue automobile showroom and said, pointing, "I'll take that black Thunderbird," or, like Jackson, when he strode into the Cedar Tavern one night and, tapping his bulging wallet, announced, "J.P.! Those are the right initials for an artist." He was greeted with a burst of hilarity and hugs and no hard feelings. Success was not unimportant to Jackson and he was constantly testing his position and prone

to put-down competition, several times coming close to blows after delivering himself of detrimental opinions of other artists' work to their faces. He tested the way a child does, and as innocently. When he approached Gorky at a party in the spring of '48 with some unflattering comments about Gorky's painting, Gorky responded with a dangerously affectionate smile, took a pencil out of one pocket, a lethal looking jackknife out of another, and, without removing his eyes from Jackson's face, slowly sharpened the lead to a point an inch long. "Pardon me, Mr. Pollock," purred Gorky, "you and I are different kinds of artists." Jackson studied Gorky's face and the pencil point alternately, weaving a bit, then gave Gorky a small, sly, approving grin and wheeled away, satisfied.

When Pollock's work was shown for the first time at the historical exhibition chosen by John Graham in 1942 for the MacMillan Gallery (including de Kooning, Stuart Davis, Lee Krasner, Graham himself), he was immediately recognized by other painters as wise in the ways of School of Paris art—hardly a distinguishing characteristic at the time. What did distinguish the man and the work was a unique and astonishing energy. There was no existing framework for this energy and it was not until 1947 that, throwing away what he *knew*—the preconceived forms which hampered him—he arrived at what he *was*—which he didn't know, finding paths impassable for anyone else in his own labyrinth. Hunched over his huge canvases, completely in control of his new-found whiplash skeins of paint, he evolved his radiant panoramas that inspire relief along with a lurking sense of disquietude characteristic, it seems, of all great art.

The beautiful poet Frank O'Hara, who now lies a few feet away from Pollock in the graveyard at The Springs, East Hampton, wrote of the artist in 1959 in answer to his own proliferating questions and insights: "This new painting does have qualities of passion and lyrical desperation, unmasked and uninhibited, not found in other recorded eras; it is not surprising that faced with universal destruction, as we are told, our art should at last speak with unimpeded force and unveiled honesty to a future which may well be non-existent, in a last effort of recognition which is the justification of being."

A Recollection

(1982)

"**I**t's wonderful to hear young people talk about their art," said Edwin Dickinson in 1951 as he discreetly slipped out of the door of the Artists' Club where a panel of painters from the Tibor de Nagy Gallery was involved in a heated discussion, "but I don't have to listen to them."

He didn't have to listen to their elders—the founders of the Abstract Expressionist movement—either:

Walt Whitman wrote: "The soul has that immeasurable pride which accepts no deductions or conclusions but its own." This observation applies to Dickinson as it does to very few artists. Fiercely autocratic, he resisted the prevailing trends and pursued his own cryptic rules and regulations as though he were alone in a private dream world where imagination has as much authority as the floor under one's feet.

Although he worked in the center of the American art world with a studio in New York City and, in the summers, near an artists' colony at Wellfleet, Massachusetts, he didn't respond to the concepts of the painters around him as he did to those of Cézanne or El Greco. "When I saw *The Burial of Count Orgaz,* I knew where my aspirations lay." El Greco was a lifelong devotion. As a highly accomplished artist with a large body of work behind him, Dickinson went back to this source in the early 1940's, spending long months at the Metropolitan Museum copying the *View of Toledo*—a passionate investigation that yielded a taut, fresh commentary on that sublime painting. Dickinson could aptly join Willem de Kooning in a sly self-appraisal: "The more I'm influenced, the more original I get."

The Abstract Expressionist painters around Dickinson recognized his originality, and if he didn't respond to them, they responded to him with great enthusiasm and reverence, and he was included every year in their artist-juried show at the Stable Gallery in the early 1950's.

Contemplating Dickinson's large-scale "salon" paintings with their hallucinatory content—the haunted landscapes and interiors, the brooding, shadowy forms, the unearthly atmosphere and light, the pervading sense of tragedy—one might think of writers rather than painters, nineteenth-century writers in particular—Edgar Allan Poe, Nathaniel Hawthorne,

Ambrose Bierce, Stephen Crane. And Dickinson himself could have stepped out of one of their stories.

A tiny, immaculate, perfectly proportioned man, all edges, corners, contours, he seemed to belong to another period, an impression he cultivated in his elegant Edwardian attire—narrow trousers, high-buttoned jackets and beautifully groomed beard (which he was in the habit of combing when one's back was turned).

Witty, erudite, opinionated, Dickinson sparkled in company. But most of the time, he was isolated with his work, spending years on a single canvas, inventing, destroying, rebuilding, struggling with his complex frameworks of multiple perspectives. This excruciating conscientiousness can be dangerous for an artist as it was for some remarkable nineteenth century American painters, finally leading to constraint, timidity and provincialism. Dickinson, always daring, escaped to the grand manner. Through all of his rigorous control, his fanatic concentration on every element of his large compositions, he kept the spontaneity that characterizes the dazzling little paintings made from life that he would finish in one day at Wellfleet.

de Kooning Memories

(1983)

Bill had his first one-man show at the Egan Gallery in April of 1948, the month I began writing reviews for *Art News*. Nothing sold from Bill's show, and my reviews brought in only two dollars apiece. We were looking forward to the summer with trepidation. We were penniless with no prospects. The previous four summers of our married life spent in the city had taught us that living hand-to-mouth, at which we were expert, was more difficult in July and August than during the rest of the year when "something would happen."

Bill's dealer, Charlie Egan, in desperation, kept the show up through May and June until it became an embarrassment to Bill. It made things seem more hopeless. The show went unnoticed in the press except for one short, ardently favorable review in *Art News* by a brilliant young critic, Renée Arb. As a result of this review, a letter from a stranger changed all.

Josef Albers, whom we knew only in connection with the Bauhaus, wrote to Bill, asking him to teach at Black Mountain College in North Carolina for the summer. Bill would receive $200, room and board, and round-trip railroad tickets for both of us; and we would each have a studio. All of our problems were solved. Seventy dollars would be used for Bill's New York City studio rent for the two months we'd be away; thirty-six dollars would cover the rent for our cold-water flat on Carmine Street where I had my studio, leaving us ninety-four dollars and few expenses except art materials and cigarettes. We were overjoyed at the prospect of a vacation in the mountains.

At the end of June, in great good spirits, we packed our brushes, paints, pads, jeans, bathing suits, one "good" suit for Bill, and two dresses for me and took off for Asheville on an overnight train. At 10 P.M., a porter came around with pillows he was renting for fifty cents apiece. Bill and I looked at each other and a silent agreement was instantly reached: if we had only ninety-four dollars for the whole summer, a dollar for pillows for one night was a disproportionate luxury which we felt we should not allow our-selves—a decision we regretted as the night dragged on and we found hard surfaces and jutting corners wherever we twisted and turned to rest our heads. We finally gave up trying to sleep and read the mystery stories to which we were addicted at the time, all through the night.

When dawn broke, the train was making an incredibly steep ascent up the side of a mountain and a gorgeous, heavy green landscape unfolded before our delighted eyes.

Groggy but exhilarated, we were met at the Asheville station by a stooped, long-haired bespectacled student who drove us to the college in an old station wagon. We were somewhat dismayed by our first glimpse of the campus, which seemed rather desolate to us—evocative of Faulkner's South. There were isolated students sunning themselves on the grass, looking, we thought, peculiarly listless and forlorn. "I feel like turning around and going home," Bill said apprehensively. But Josef Albers' hearty greeting lifted our spirits. "Ach so! The De Koonings!" he smiled, embracing us like old friends. With his fresh pink skin, sunny blue eyes, sparkling white hair, and genial German accent, he radiated cheer and enthusiasm.

We immediately felt at home when Albers walked us to our cottage. We approved of the bare wood floors and sparse furnishings—table, a couple of chairs in one large room, a bed, a bureau, and a closet in the other. We strolled around the campus with Albers animatedly describing the manner in which each building was erected and the care in the choice of location. We very much liked a small, empty, high-ceilinged building nestled in the woods called *The Quiet House.* It was a place for meditation, Albers told us, built by a student as a memorial for another student killed in an automobile accident— the son of Ted Dreier, one of the founders of Black Mountain College.

A long, plain building, with two tiers of identical tiny rooms barely large enough for the narrow cot, the sturdy work desk, and the chair in each one, exemplified the frugal spaces and the stark, unadorned surfaces of Bauhaus design. Bill took one look at these studios and announced that he would paint in our much more ample living room. Albers, defensive about his response to the limited space, explained that most of the students painted or drew on paper on the desks. I immediately decided to push my desk over to the window, use it as a palette table and paint on wrapping paper tacked to the wall. The window, the saving feature of the studio for me, faced a dreamily beautiful lake with lush dark-green foliage all around it. Off in the distance, there was a long dock with students diving off and splashing around in the sunlight. I made another immediate decision to join them after we finished our tour of the grounds with Albers, who now led us to the Great Hall that served as dining room, theater, dance studio, and lecture hall. "Because of the school's strict budget, there is no choice of food. It's very democratic. Everyone eats the same things. Whatever the chef prepares. That way, there's no waste."

The main course that day was a frankfurter-and-banana salad. Bill was incredulous: "Looks like something Elaine would make." Albers and I beamed at each other over the mutual compliment. "Very unusual combi-

nation," Bill went on but ate his portion as uncritically as Albers and I. He was having two bowls of soup beforehand, he explained, so that he could regard the salad as dessert.

Albers told us that meals were announced with a loud bell, and we agreed to meet him at six in the dining hall and returned to our house to unpack and to set up our studios. We were sitting on the dock deep in conversation when the dinner bell rang. To our amazement and amusement, we saw people running from every direction to converge on the dining hall. "Look at them run at the sound of that bell," Bill laughed. "Pavlov's dogs," I said smugly. We continued our leisurely conversation and strolled over to the dining room some twenty minutes later to discover that the food was all gone—every scrap of it. From then on, at the sound of the bell, Bill and I proved to be more than adequate sprinters and never again came late for a meal.

We circled around the dining room, pleased to discover some familiar faces from New York: sculptor Peter Grippe, painter Florence Grippe, and John Cage and Merce Cunningham. Merce told us that he would be teaching a two-hour dance class six mornings a week. I had taken dance classes, on and off, from the age of six and seized the opportunity to study with Merce, enrolling on the spot.

"There are going to be quite a few interesting visiting instructors. In fact, too many," Albers confided. "Buckminster Fuller and Richard Lippold were invited and said they couldn't come, so we got Charles Burchard from Harvard for the architecture class and Peter Grippe for sculpture and now we just heard that Fuller and Lippold are coming after all." Albers shook his head, frowning: "It will make for complications." He was right. This was our first tiny whiff of the feuds and intrigues that characterized the summer.

Albers proceeded to introduce us to a bewildering number of the regular faculty members whose names we promptly forgot; and, for weeks afterwards, we'd refer to people by profession and build—"that tall photographer" or "that fat weaver." A weaver whose name we immediately registered was Albers' wife, Anni, a distinguished tall, thin woman with a small face and a winning smile. We were invited to a get-acquainted party to be held later in the evening at the Alberses' house. We noticed that certain faculty members weren't at the party—our second whiff of the open and veiled hostilities that provided a constant and oppressive undercurrent that whole summer.

The next morning, we visited the work areas and met with students, some of whom made an immediate impression on us: Ruth Asawa, Donald Droll, Joe Fiore, Ray Johnson, Albert Lanier, Hazel Larsen, Pat Passloff, Kenneth Snelson, Ray Spillinger, Susan Weil. For some reason, I had no trouble at all remembering their names. In the following week, Bill's class expanded to some ten students.

Albers' class in color theory and Cunningham's dance class were much larger—about thirty students each. The many evening lectures—Winslow Ames on printmaking, Beaumont Newhall on photography, Isaac Rosenfeld on Tolstoi, Erwin Bodky on Beethoven, Edgar Kaufmann, Jr., on industrial design—were dress-up events to which everyone came. The most spectacular of these was Buckminster Fuller's introductory lecture.

"He looks stuffy," I whispered to Bill as Fuller, short, stocky, dapper, strode briskly toward the podium. "Wait until he opens his mouth," Bill, better informed than I, whispered back. Bucky then whirled off into his talk, using bobby pins, clothespins, all sorts of units from the five-and-ten-cent store to make geometric, mobile constructions, collapsing an ingeniously fashioned icosahedron by twisting it and doubling and tripling the modules down to a tetrahedron; talking about the obsolescence of the square, the cube, the numbers two and ten (throwing in a short history of ciphering and why it was punishable by death in the Dark Ages); extolling the numbers nine and three, the circle, the triangle, the tetrahedron, and the sphere; dazzling us with his complex theories of ecology, engineering, and technology. Then, he began making diagrams on a blackboard. He drew a square, connecting two corners with a diagonal line. "Ah," he said affectionately, "here's our old friend, the hypotenuse." That did it for me. "I'm taking his classes," I said to Bill. "I knew you would," said Bill.

Bucky's classes (all male except for me) were attended by a tight little clique of architecture and engineering students from Harvard—elegant, businesslike young careerists, very different from the rest of the Black Mountain students who seemed to have vaguer aspirations, nebulous and idealistic. Bucky also attracted some intensely motivated art students, most notably the sculptor Kenneth Snelson, who immediately comprehended what was new in Fuller's concepts and who made some innovations on his own that Bucky found very impressive.

The shimmering pale blue expanse of Bucky's eyes—immensely magnified behind his thick glasses—had us all mesmerized. They were, to us, the eyes of a visionary, a saint, all-comprehending, all-forgiving. We loved him and we hung on his every word. In turn, Bucky was wonderfully responsive, free with his praise, totally absorbed in each of us as he directed his fabulous gaze from face to face.

One day, he held up two jagged, irregular lumps of metal. "If these are put together a certain way, they will form a perfect cube," Bucky explained. The two lumps were passed back and forth between the students for an hour and a half with much discussion of how and why they didn't fit. Then Bill wandered into the room. Bucky had a special regard for the intuitive approach of artists. "Let's see what someone from another discipline can

do," Bucky said to the class and explained the problem to Bill, handing him the two lumps. Bill hefted them and studied each one separately and then snapped them together, forming the perfect cube on the first try. Bucky nodded approvingly, not at all surprised. But I was surprised. "How did you do it?" I asked Bill later. "Well, I figured all those smart engineering students had tried all the logical ways," he shrugged, "so I just looked for the least logical way."

Bucky, with his emphasis on how things *worked* and his total disregard for the Bauhaus concern with design—with how things *looked,* was a bit of an irritant to the regular faculty. Albers listened in on a class one day when Bucky was using the specialized terminology of an automobile motor. "They don't know what you're talking about," Albers scolded. Bucky and the students all turned puzzled faces toward Albers and then burst out laughing. "Well, *she* doesn't know those terms," Albers said in an accurate but somewhat lame attempt to save face.

The main work of Bucky's class that summer was planning for the erection of his revolutionary geodesic dome. The students and Bucky worked on the computations for the junctions of the six "great circles" that would crisscross the dome in triangulated formations. We figured out the tensile strength of the Venetian-blind stripping to be used and concluded that double strips were necessary for the size dome that Bucky had envisioned. The school came up with half the amount of money needed, enough only for single strips. If done with the double strips, the dome would have arisen by itself as screws were put in place, radiating out from the center—but as we had only half the tensile strength needed, we all knew the dome would not go up. "Let's put it together anyhow," Bucky said. "One never knows the ways of the Almighty." The whole school turned out that rainy day to scoff as Bucky's dome, all fastened together, lay crumpled on the grass like wet spaghetti. But we all knew, as the whole world would know a few years later, the dome was a brilliant success.

The school activities engulfed us like a warm breeze. After an early breakfast, Bill would go off to find his students while I took Merce Cunningham's rigorous dance class from 8:00 to 10:00 A.M. From 10:00 to 12:00, a couple of mornings a week when I didn't take Bucky's class, I sat in on Josef Albers' color theory sessions, fascinating to me both for content and for Albers' authoritarian style of teaching, which struck me as hilarious. Evenings, I would regale Bill with my imitations of Juppy (Anni Albers' nickname for him): "Ach so, Mr. Dublin. You are smiling. You are finding something I am saying funny? . . . "Miss Wilson, you will please stop filing your nails while I am speaking. . . ." The students singled out would quail and snap to attention. I don't think I've ever seen an instructor more

involved with teaching as a military performance. However, all of us learned a tremendous amount from him that summer. He began by demonstrating what we didn't know that we thought we knew.

"Here are four different greens. One of them is a green you've been looking at all your life—Coca-Cola green! Which is it?" Looked at singly, each one seemed to be exactly right. It was unnerving. He had us write our names with our right hands, eyes closed; then, left hands with eyes open (for left-handed students, of course, the other way around) to demonstrate that an important element in drawing is kinetic rather than visual. He had us turn each other's signatures upside down and slowly and laboriously copy them to demonstrate how effects of velocity and spontaneity could be achieved in a slow and deliberate manner. But mainly, his class was exciting for the complex problems in the optics of color, working with combinations of primary, secondary, and tertiary colors: finding the exact complement of a brownish purple is not that easy. He liked to give us strictly limited projects. Once, I attempted to solve several of the problems he posed in one composition. Albers snatched it from my desk and tore it up. "Helen (his name for me) runs away with herself. She's too extravagant." I was thoroughly flattered by his vehement response, extravagance being a virtue in my opinion.

Bill and Albers had diametrically opposed methods of teaching. Albers preferred to talk to students as a group, Bill liked to talk to students one at a time. Albers' students sat at desks and worked cautiously on small, neat compositions; Bill's stood at easels painting boldly on large canvases. Albers presented his students with the same specific problems, Bill waited until they had evolved their own set of problems on canvas before discussing the range of options open to them. Since most of the students worked under both of them, the different approaches proved to be stimulating rather than mutually exclusive.

Bill was gentle and sympathetic with his students in terms of the possibilities inherent in their work; but at his own easel, the possibilities he unleashed were Furies. At first, he was at a loss within the brick walls of the cottage. In his New York studio, surrounded by his previous work, he felt the necessary sense of continuity. Here, he was in a vacuum that he began to fill with pastels, working feverishly on one after the other for a couple of weeks until the walls were covered with them.

Finally he taped a sheet of paper 25 x 32 inches to a board placed on his easel and began to use oils, scraping off the excess pigment at the end of each day to keep the surface fresh and smooth. Bill was now working with a rhythm I knew well. Flaming pinks and oranges and yellows would sweep across the paper in ever-changing forms, eventually crystallizing in an image

that suddenly presented an identity. For most artists, this is the moment of truth when they know the picture is finished. But Bill, in those days, had a built-in discontent that denied that moment. Time after time, I had the familiar but still painful experience of coming home to find an image I loved blasted away. This seemingly endless process was the method by which he had arrived at the paintings in his first show earlier that spring.

Bill resented having to spend time away from his embattled painting, but once outside his studio, he relaxed and enjoyed each day's surprises. Not only the days but the evenings were full. John Cage gave twenty-five half-hour concerts devoted to the music of Erik Satie, of great interest to us because until then we had heard him play only his own music—to which we were passionately devoted. These concerts, three times a week, were festive occasions. Sometimes, Cage performed in the great hall but more often, in his cottage while we all sat around on the grass outside. The brevity of the pieces assured concentrated listening; and John, with delicacy and precision, communicated his reverence for Satie.

The Ruse of Medusa, a light little play by Satie that had been produced only once in Paris, was translated by the poet and ceramist M. C. Richards for John, who wanted it done at Black Mountain with Bucky Fuller playing the part of the Baron Medusa and me as the Baron's daughter, Frisette. Since her only words were "Yes, Papa," I accepted. The handsomest student on campus, William Schrauger, was chosen for an equally mute part as her suitor. The novelist Isaac Rosenfeld played the part of the Baron's surly butler. But it fell to Bucky to carry the play. His role was a kind of W. C. Fields aristocrat who talked constantly in non sequiturs. Bucky's marathon lectures had made it clear that he had a prodigious memory, and we were not surprised at his great gift for comedy. It took many rehearsals before we could perform our parts without breaking up at his droll antics as the scatterbrained Baron. Arthur Penn, a student-instructor, was the director; and he was ingenious, indeed, at extracting characterizations from total amateurs. I was enchanted with the pert, mincing walk and fluttery gestures he devised for Frisette.

Since nobody else seemed interested, I designed the sets and costumes—if *design* is the word; *allocate* might be a better one. Bill transformed a huge stodgy desk and two nondescript columns into magnificent pink and grey marble with a technique he had learned at a decorator's shop in Holland when he was sixteen years old. The list of props—telephone, candelabrum, feather pen, inkwell, magnifying glass, thermometer, and Bucky's top hat—was turned over to students who were told they had a whole month to come up with things that were suitably oversized and flamboyant. Mary Outten, a pretty girl who was a wizard with a sewing machine, made

a marvelous white Victorian dress for me out of gauze we bought in town for sixty cents a yard. And she sewed stripes of grey satin ribbon to Bucky's khaki work pants for a comical effect of elegance.

John Cage played the Satie score, and Merce created wonderful little entr'acte dances for his role, a "costly mechanical monkey." Everything went flawlessly the night of the performance. The participants all felt it was a sparkling event and that was that. There were no photographs to speak of and no recordings. The sets and costumes were saved for a while and then vanished. I wore the lovely dress the following year in a movie called *The Dogwood Maiden* by Rudy Burckhardt (who also appeared at Black Mountain that summer to show his extraordinary city movies), and then the dress vanished too.

While I spent much time in student activities, Bill had also become deeply involved with his students. Too involved, Albers thought. He said to Bill at the end of the summer, "You had ten students. Six of them are leaving the college to go to New York City this September. Do you know anything about it?" "Sure," said Bill. "I told them if they wanted to be artists, they should quit school and come to New York and get a studio and start painting." Albers seemed not to take this amiss. When he was appointed chairman of the Art Department at Yale two years later, Bill was the first artist he hired to teach there.

With so much happening, so many new faces, so many new experiences, the summer seemed to roll on endlessly. We attended more parties during those two months than we had in the previous five years—small cocktail huddles given by the students in their tiny studios; much larger after-dinner affairs in the faculty cottages; and one great big dancing ball at the end of the summer when I waltzed with Bucky, who paid me a compliment that could have been plucked from one of his lectures: "You're a terrific performance per ounce!"

"I'm getting sick of crowds," Bill said one night at a particularly noisy gathering. "Let's take a walk." After ten minutes on the moonlit road, none of the lights from the school were visible to interfere with the vast, heavy, velvety blackness of the sky, nor did sounds of laughter and music penetrate the almost terrifying hush. We stood still, enveloped by the awesome multiplicity of stars. "Let's get back to the party," said Bill. "The universe gives me the creeps."

Despite all of the unaccustomed student and social activity, I still managed to come away with a roll of enamel paintings on wrapping paper—a testimonial to the durability of paint, if nothing more. And Bill, struggling day after day on his one painting, finally completed "Asheville."

A Stroke of Genius

(1984)

Elaine de Kooning recounts the making of the four-part PBS series "Strokes of Genius," films about Willem de Kooning, Arshile Gorky, Jackson Pollock, David Smith, and Franz Kline. The series was hosted by Dustin Hoffman and directed by Steven Spielberg.

In the spring of 1948, I went to a cocktail party given by Clem Greenberg to introduce Leo Castelli to some American artists he had heard about and was interested in meeting. Among the guests were Arshile Gorky, Jackson Pollock, David Smith, Franz Kline, and Willem de Kooning—the five artists chosen by Courtney Sale for her series of films "Strokes of Genius."

Courtney Sale, who was born in that same spring, grew up with these artists as her mythological heroes. Her interest in art led her to open her own gallery in Dallas at the age of twenty-one. In 1976, while working on an exhibition originated by Governor Carey in Albany, she began to think it would be a wonderful idea to make a film of the show—to be able to expose it to a much wider audience, to capture the experience for all time. While producing this film, called *The Big Picture,* she became fascinated with the mechanics of making a movie, and the idea for the present series began to take shape in her mind.

She was critical of the brief time span and limited audience for any exhibition of painting or sculpture and the inaccessibility of museums for so many people. But movies, she felt, are forever and can reach to the corners of the earth.

She was clear about what she wanted—to present the artist in a way that would be comprehensible to a wide audience, not only in terms of his work but also his identity as a human being. And she was clear about what she didn't want—the smell of the schoolroom.

These films, produced over the past five years, have no written scripts— none of the usual art-historical jargon. The words are spoken by the artists themselves, and there are spontaneous observations and recollections of people (most often, other artists) who knew them and their work intimately.

Artists don't talk about art like critics or historians trying to construct a

theory or prove a point. They express themselves in shorthand—briefly, directly, simply, and often humorously. Through their comments, an authentic picture emerges of how their art is created.

These artists, all born between 1904 and 1912, have in common the depression years in New York City, where they converged from places as far apart as Armenia and Wyoming, Holland, and Pennsylvania. All, except for Willem de Kooning—a healthy and productive eighty-year-old—are long dead. And all, after the persistent poverty of their early years, had a taste of recognition, success, and affluence.

Gorky was the first to get an uptown gallery in the early forties, the first to support himself and his family, if frugally, on the sale of his work. But he was also the first to die—in 1948—before critics, collectors, museum directors, or the media paid much attention to American artists.

Jackson Pollock, who died in 1956, was the first to achieve national prominence through the famous *Life* magazine article "Jackson Pollock: Is He the Greatest Living Painter in the U.S.?," that instigated the flood of media attention to the abstract expressionist movement. But it was Clem Greenberg's art criticism in *The Nation* that prompted *Life*'s question: Greenberg was the first critic to dare to call a contemporary American artist "great."

David Smith, also passionately championed by Greenberg, was the last to arrive at prosperity through the sale of his work and the last to die (in 1965). He was the only one of the group who had a steady income and a comfortable life through most of the lean years.

Franz Kline, who died of a heart attack in 1962 at the age of fifty-one, loved elegant clothes, fancy cars, and eccentric furniture, although during his brief period of affluence (about six years), his life-style changed not one whit; he kept the same hours and saw the same people and gave of himself unstintingly. One could almost say he gave himself away and died exhausted.

Willem de Kooning, as the only survivor, was the logical choice for the first film of the series, but, protecting himself from the ravages of fame by being a recluse, he did not warm up to the idea of having a film made in his studio. After his initial reluctance was overcome, he tolerated—even enjoyed—the concentrated preparations of the camera crews, sound recordists, grip men, gaffers and production assistants noiselessly going about their jobs.

Willem and I became close friends with Courtney as the filming progressed. The crew would descend on us for two or three days at a time, creating a festive atmosphere as they carried in huge amounts of food—fruit, cold cuts, cheeses, salads, breads, and pastries. We got to know and be much impressed by the director, Charlotte Zwerin, a silent, enigmatic presence, everywhere at once. And Karen Lindsay, Courtney's invaluable associate who collaborated on all the films in the series, charmed us with her quiet efficiency.

There were some twenty days of shooting in the studio—long sessions of Willem at work at his easel—taken over a period of ten months. He didn't mind the camera while he was painting, but he clammed up when he was being interviewed. He seemed to relax and open up only when talking to Courtney, and finally, at my suggestion, she agreed to be filmed with him to put him at his ease. Then there was the enormous accumulation of film devoted to particular paintings that were to be included in the picture, rare passages of film from earlier years that were dug up after much research, countless snapshots. And finally, there was the back-breaking job of whittling down all this material to manageable time lengths. I sat in on some of these sessions with Courtney and Charlotte and the brilliant film editor Larry Silk, and viewed hours of excellent passages that—necessarily—ended up on the cutting-room floor.

Courtney had originally decided that she needed a new director with a fresh approach for each film. She made an exception in the case of Charlotte Zwerin, whose proposed treatment of Arshile Gorky was radically different from her film on Willem de Kooning—as different as were the two artists' lives and work.

In keeping with her insistence that there be live footage of each of the artists at work, Courtney unearthed a rare film of Gorky taken in 1941 by his brother-in-law, Moorad Mooradian. This film, intercut with eloquent close-ups of his extraordinary face—all in stark black and white—evoke Gorky's presence with stunning force.

The undercurrent of tragedy that stalked Gorky all his life is recalled in anguish by his sister, Vartoosh Mooradian, for whom the death of their mother by starvation in Gorky's sixteen-year-old arms (as they fled the Turks in Armenia) seems to have happened yesterday.

There are passages of a happy period in Gorky's life. The beautiful Agnes Magruder (now Agnes Fielding), whom I introduced as a teenager to Gorky in 1941, reminisces, sitting next to a lovely brook in the Virginia countryside where she and Gorky lived when they just got married, and where he began—at first working from nature—the magnificent series of abstractions that was to be his final statement. There is a lyrical quality to her recollections: "Once he was out here in this field, and it was later in the year because the milkweed had grown very high, and he came back in the most tremendous discouragement and stood beside me watching this tractor, which had started to cut down the weeds so that the grass could grow for the cows, and Gorky said, 'They're cutting down the Raphaels.'"

Here, superb camera work—close-ups in shifting focus of the weeds and wildflowers that Gorky drew from—is interspersed with the opulent drawings and paintings they inspired.

Keen observations about Gorky's character and work are offered in lively sequences by the painters Ethel Schwabacher (one of Gorky's first patrons in the thirties), Peter Blume, and Willem de Kooning and the dealer Sidney Janis, and Gorky himself through a voice reading his letters. All of this complex treatment is communicated in only half an hour, to be shown on the same program with the film on Franz Kline.

Willem and I spent a good deal of time with Franz sitting in Washington Square Park or the Cedar Tavern or in one or another of our studios. In 1953, I was writing an article for *Art News* on the painter Earl Kerkham. Earl had no place to work, so Franz let him paint in his studio (Franz always seemed to have some homeless soul staying at his place). I was there for weeks at a time—as I was later when I wrote an article about Franz himself. Franz seemed to subsist mainly on coffee in those days. His breakfast—at two in the afternoon—used to be beer and Danish pastry; his other breakfast—at four A.M.—was bacon and eggs at a diner on Eighth Street. When you were with Franz, you laughed a good deal. He was irresistibly comical and tender.

In this film, sensitively directed by Carl Colby, Franz comes to life in the warm recollections of his friends. The sculptor Peter Agostini dwells on the odd freedom then offered by poverty: "You didn't have to have any money, you could live on your wits. There were no shows. We showed in the outdoor show. Those days in the Village were most ideal for an artist."

The same note is sounded by the owner of the Minetta Tavern, Eddie "Minetta" Sieveri, as he tells of Franz making drawings of the patrons for fifty cents apiece (the drawings still hang on the walls) in 1939 when "we were selling beer for five cents, whiskey for fifteen cents, and we had a big free lunch counter. . . ."

The painter Conrad Marca-Relli talks of a later period: "It was this jamboree of reviews—of acclaim, of saying this is terrific and that is terrific. That's just as bad as saying that it's lousy, because it locks you up, and the spotlight of criticism—if it has any effect—can be devastating."

The movie covers Kline's work from the marvelous but little-known landscapes and cityscapes (most of them in the collection of his earliest patron, David Orr), juxtaposed with vivid photographs of New York City from that period and of the bleak Lehigh Valley in Pennsylvania where he grew up, to the great black-and-white abstractions that made him internationally famous.

The film on David Smith, directed by Jay Freund, also relies heavily on the recollections of intimates to evoke the sculptor's attitudes and character. There are illuminating evaluations and descriptions of the man and his work by painters Kenneth Noland, Helen Frankenthaler, Robert Motherwell, and Herman Cherry. And Smith's two wives—the first, the

sculptor Dorothy Dehner, and the second, Jean Freas Pond, a former student at Sarah Lawrence, where Smith was teaching—have fascinating personal observations, both indicating, in a generous spirit, that life with David was somewhat stormy. Or, as Ms. Pond delicately put it, "He didn't like wives. He liked girls."

Of all the artists in this series, I would say that Smith was the most susceptible to the trappings of success—a tendency that is revealed in shots of the sculptor beaming happily at elegant dinner parties and openings and in statements made by friends. Motherwell says, "There were suppressed desires in him to have a tweed jacket made or to start getting cigars at Dunhill's and have his own sort of safety-deposit box with his name on it. . . . You see, one of David's geniuses was the ease with which he could move from class to class. I mean, he could be in black tie at the Rockefeller's and be charming. . . ."

Herman Cherry, talking of David dropping old friends (including himself) remarks, "I think he was moving into another world, because he was really becoming famous, I mean world famous."

Clem Greenberg, who was so important for David Smith's career, appears several times, amplifying or contradicting what someone else has said in a casual, sometimes delightfully irreverent fashion.

Smith: "Art is always an expression of revolt and struggle. Progressive man and progressive art are identified with this struggle. That is our history as artists."

Greenberg: "David had a lot of hot air to him, yeah, and how. You can see that in his recorded remarks."

True, but when talking about how he starts a sculpture, Smith can be neatly pertinent: "They can begin with any idea. They can be a found object. They can begin with no object. They can start out as chalk drawings on the cement floor. They can sometimes begin even when I'm sweeping the floor, and I stumble and kick a few parts and happen to throw them into an alignment that sets me off thinking, that sets off a vision of how it would finish if it all had that kind of accidental beauty to it."

Throughout the film, the camera action is ingeniously related to the spoken word. There is a marvelous moment when the sculptor Mark di Suvero follows Smith's remarks with: "And he'd arrange them on the floor, weld them there, and then stand them up. And they'd have this look, as if they'd been thrown into the air and frozen"—a sequence magically captured on the screen as the sculpture seems to be flying against the sky.

The film on Jackson Pollock, directed by Amanda Pope, is a miracle of compression. An enormous amount of information—verbal and visual—is given in brief, sparkling juxtapositions. A narrative unfolds in leaps from one person to another, beginning with William Rubin talking about Pollock's show in Paris at the Beaubourg in 1982; we wander through the

show as he talks. The composer John Cage picks up the thread and relates Pollock's work to that of his peers. The painter Mercedes Matter recalls the impact of her first view of Pollock's work forty years ago.

Then we hear Jackson Pollock talking of his childhood and the emphasis of the film switches from people to panorama—wonderful scenes of the West—as Pollock drawls, "I grew up in the country. Real country. Wyoming, Arizona, Northern and Southern California. . . ."

The next series of shots deals with Thomas Benton's classes at the Art Students League, as *New Yorker* cartoonist Whitney Darrow, Jr., wittily describes Benton's character and teaching methods. Pollock, terse as usual, says, "He gave me the only formal instruction I ever had. He introduced me to Renaissance art, and he got me a job in the league cafeteria. . . . I'm very grateful to Tom. He drove his kind of realism at me so hard, I bounced right into nonobjective painting. . . . I'm also great grateful to the WPA for keeping me alive during the thirties."

The painter John Little bubbles over with affectionate laughter as he tells how Jackson painted a nine-by-twenty-foot canvas on commission for Peggy Guggenheim's house in twelve hours, and William Rubin suggests that "The speed at which he executed this very large picture represented a kind of galvanic quality on the surface that we'd never seen before—that anticipated what came later."

Pollock's wife, the painter Lee Krasner, talks of meeting Pollock through an exhibition organized by John Graham, of their marriage, and of moving to East Hampton: ". . . I don't know how to describe it. It was hell, to put it mildly, for me because, for instance, it was during the war period, so that you couldn't get a supply of fuel. Cold water. No hot water. No bathroom. No . . . it was a rough scene. It isn't like most artists know today."

William Rubin: "Lee Krasner was a vanguard mentality, probably before Pollock was himself. And so instead of trying to keep him back, she certainly encouraged the things he did which were, in a sense, farthest out. And I think Pollock was very fortunate to have someone urging him on rather than keeping him back."

All during the various commentaries, the camera ranges over the subjects mentioned—grim black-and-white depression scenes of breadlines and May Day parades, cross-country drives in a Model-T Ford on plains where the horizon is visible for 360 degrees, the rim of the Grand Canyon, where Pollock did roadwork as an eighteen-year-old, American Indian art and calligraphy, the Peggy Guggenheim's gallery in the early forties, glimpses of the Pollock home in East Hampton, the Cedar Tavern—in intricate shifts between live footage and still shots so beautifully integrated, you don't notice where one form ends and the other begins.

The value of these films in capturing the testimony of eyewitnesses is made poignantly clear by the untimely death of Jimmy Ernst this past February, just as his memoir, *A-Not-So-Still-life,* was coming out and his latest paintings were hanging on the walls, ready for his opening the next day. His elegantly detailed description of Mondrian's reaction to Pollock's work at Peggy Guggenheim's gallery is doubly valuable now.

Postscript

The Pollock film—the last to be finished—will be the first to be aired.

Courtney Sale, now Mrs. Steven J. Ross, was married the day after the premiere of the Gorky film at the New York Film Festival, and their baby, Nicole, was born during the production of the Pollock film.

While she was pregnant, she bumped into Dustin Hoffman "literally," she says, and they reminded each other that five years before, she had asked him if he would host her series when it was finished. Her image of the host as a sensitive and unpretentious person, who could make this somewhat difficult art accessible to the general public, was exemplified, she felt, by Dustin Hoffman.

The next step was to find out if her friend Steven Spielberg could spend a weekend to direct Hoffman. He could and would.

When the crew again gathered at Willem's studio, he was relieved to have someone else be the focus of attention. Willem and I both by now had seen all of the films and were glad to be able to tell Francis Kenny, the director of photography, how magnificent we thought the camera work was. Willem, who rarely sees movies except on television, didn't know who Steven Spielberg and Dustin Hoffman were, but he vastly enjoyed their company. When Steven was directing Dustin, placing him in different parts of the studio and trying out different shooting angles, Willem followed them around delighted with Dustin's antics as he experimented with a wild variety of intonations and droll stances, which made even the crew laugh.

Husbands and wives and babies began to appear at the studio—Dustin's wife, Lisa, and two-year-old Jacob, Courtney's husband, Steven Ross, and three-month-old Nicole, and Karen Lindsay's husband, Ron Blum.

Although a professional photographer was covering the proceedings, everyone seemed to be taking photographs of everyone else and passing Polaroids around like peanuts at a cocktail party. After filming wound to a close, Dustin's admiration for Willem came through when he said it was an honor for him to be there, and Willem's affection for Dustin and for Courtney and her crew came through as he said, somewhat ruefully after they all left, "The studio seems awfully quiet now."

Busa's Festive Imagery

(1985)

"It looks like a Renoir scene—so festive," said a longtime friend and collector of Peter Busa's work, observing the crowd spilling out on the lawn behind the East Hampton Center for Contemporary Art at his opening Saturday. "Festive" might also be the word to describe the colors that surge through Mr. Busa's imagery, which spans five decades in the mini-retrospective assembled here.

An incandescent pale ochre appears in an atmospheric vertical panel in a small early figure painting, "Gypsies" (1932); in a freely brushed portrait of the artist's daughter, "Marianne" (1969); in an economical little oil on paper of a woman in a bathing suit against three equal horizontal areas—beach, sea, sky (1985). The same ochre meshes with jaunty lavenders, reds, and blues in a 1985 series of rollicking little paintings on paper—playfully imagined scenes of boats, houses, trees, hills, figures, animals, and birds. "The Mediterranean response to the Minnesota winter!" observed his wife, Alex. "Peter's Sicilian, you know."

More somber in color and sweeping in brushwork are a group of abstract seascapes executed in Provincetown, Mass., in the '50s. Heavy slashing blacks collide with alizarin crimson in a strong Abstract Expressionist work, "Anchor" (1958), but in the other smaller paintings surrounding it, sensitive, luminous grayed tones predominate.

Gray Foil

Areas of gray are a crucial foil for the exuberant pinks, oranges, yellows, and greens of the four largest canvases in the show, all executed in the past year after Mr. Busa's decisive recovery from a serious operation last October. Wittily stylized figures, faces, cats, fish, tables, flowers, and windows emerge and disappear in the rigorous geometry of these stunning joyful compositions. "Blue Interior With Pussy Willows," a spacious interior with flowers in a turpentine can and a small figure of a woman on a sculpture stand, evokes Matisse; "Venetian Ladder" has echoes of American Indian imagery. Mr. Busa's wide erudition is evident everywhere but his originality radiates from the "Mediterranean response."

On the Work of
Willem de Kooning

(1983–84)

Editorial Note: *In the following text, Elaine de Kooning comments on Willem de Kooning's retrospective at the Whitney Museum of American Art, New York, December 12, 1983–January 6, 1984. From a videotape produced and directed by Connie Fox. Copyright © 1992. Used by permission.*

When I first met Bill the year after I got out of high school and visited his studio, he was working on paintings of men. Although all of the paintings were imaginary, he worked from drawings he made of himself in the mirror. So the shoulders and the chest and the neck, particularly the trapezoid muscles, were very much related to Bill's own physique. *Seated Man* [c. 1939], owned by the Hirshhorn Museum in Washington, D.C., is characteristic of this period. It bears a strong resemblance to one of his best friends at the time, the poet Edwin Denby. It has his fragile face.

Bill worked a great deal on Masonite. At the end of each day he would use fine sandpaper to smooth down the surface of the Masonite. He hated to paint on a rough surface. Later on he evolved different attitudes, but at that time he wanted a very smooth surface. All of the paintings done in this period had rectangles in them. It was the figure related to rectangular forms. He would work on one of these paintings for months and months, all day long, ten to twelve hours a day. Often, as he put new, fresh paint into still-wet paint, the colors would sink in, and it would infuriate him because this would muddy it, especially if he added red. So often he would take a spatula and scrape all of the paint off. Sometimes he'd have a color like green, cover a large area, and then, later, he would cut in with another color. Whenever you see forms like stripes—they are left over from areas underneath. He would not paint a stripe on top; the paint would cut in. Often, too, he would utilize charcoal. Charcoal in the wet paint would be permanent. Or, sometimes he would use a fine brush to make a contour. It was a play between contours and flat areas of color.

Hands he found particularly difficult. He constantly complained about them, and would paint them away and draw them over and over and over. Often he had the same problem with feet. In *Seated Man*, a three-quarter

figure that he often did, the leg has been painted over.

Often when he was working on these early paintings, someone would come in and buy the one on his easel, and it would be saved. Otherwise it probably would have been painted away. So many absolutely terrific paintings simply vanished because he changed them and painted them away. I would say that almost every de Kooning painting in existence today from the late thirties remains because it was taken from him by someone buying it.

There were two small abstractions hanging on the walls of Bill's studio when I first met him, when he was also working on the male figures. They were done several years before. Althought the Whitney put the dates 1937 and 1938 on them, these paintings were actually done in 1935 and 1936. They really show where he was coming from. They are pre–his style. I don't like the way I phrased that, but they show influences—for instance, Miró, and certainly his interest in Brancusi and Mondrian. They are not fully evolved paintings, but they are interesting historically. In his early paintings of men, the two colors that Bill used in a very intense way were yellow ochre and a rose color. He constantly shifted back and forth between them. He worked on the painting called *Seated Figure* [*Classic Male*, c. 1940] for months and months. Sometimes the contours almost disappeared, and he would reiterate them with charcoal lines, or sometimes even with pencil lines. Also, there's a good deal of pentimento. He would sandpaper and the painting underneath that might have been on the surface weeks before would come through. As I said before, in many of these paintings, he put rectangular forms behind the figures. They could have been windows or mirrors. They were an important part of the structure of the paintings. At the end of each day, as I mentioned previously, he'd sandpaper the paint and the act of sandpapering left tracks in the paint.

Again, in *Seated Figure*, the form of the neck is very much Bill's own anatomy. John Graham came in while Bill was working on this painting and thought it was absolutely terrific. Bill said, "If someone gave me fifty dollars, I'd let him have it." John said, "I'll be right back." He left and came back in half an hour with fifty dollars. Bill was a little taken aback, but on the other hand the rent was thirty-five dollars and that left us fifteen dollars for meals. Also, he was very irritated with the painting, so he let John have it. Again, this was an instance where a paintings was saved simply because someone bought it right off his easel, still soaking wet. The interesting point of this story is that ten years later, in 1951, John Graham offered the painting to Bill for five hundred dollars, and Bill bought it back.

Bill once told me while I was studying with him, "Work as though every stroke might be your last." In each of these paintings, the idea of its being finished or unfinished is not really the question. There are echoes in

Seated Figure of the previous drawing, and there is an eye left over from a time when the head faced the other way. The figure constantly went through many small adjustments. He simply was never satisfied.

At the same time that Bill was paintings the figures of men, he also worked on abstractions. His painting titled *Summer Couch*, 1943, was done a couple of years after the ochre and pink men and the colors got higher in intensity. But his way of cutting in with one color . . . I hesitate to use the word background because Bill never thought of background, or objects, or foreground—he just thought in terms of colors cutting in on each other. In *Summer Couch*, as in many of the others, he began with some kind of calligraphic line. Often he would write a word and then paint out areas of it. He liked the flow of calligraphy. It was very important to him.

I asked Bill why he always painted men, and he said, "Well, I don't understand hair." He then began to make drawings of me. As a matter of fact, he made a series for *Harper's Bazaar* of hair drawings. We arranged various fanciful coifs. Then from those drawings he began his series of women paintings. He really began them in the late thirties—about 1939. The colors of the women paintings were much higher. He stopped, more or less, using the yellow ochre. But his approach to the surfaces was very similar in that he changed his forms around constantly, and dabs of color were left over from previous planes of flat paint, as seen in *Pink Lady* [c. 1944]. He kept changing the poses as he did with the male figures but in a much more animated way. He continued to use the charcoal, not so much as contours, but as guidelines, because he would usually follow the charcoal contours with paint strokes though every now and then they were just left untouched.

When Bill had his first show with Charlie Eagan, he decided not to show any of the women that he had been working on or any of the abstractions that had a different direction or were high in color. At that Eagan show in 1948, he showed only black and white enamel paintings. He wanted his first show not to be a retrospective. He wanted it to be as if done all in one breath. All of those paintings were done in one year. One of them he called *Attic*, explaining, "Well, you know, you put everything into the attic." The drawing is, of course, what's important in this.

The painting called *Woman* [1949-50] was painted in the same year as *Attic* was painted and it has very much the same kind of forms—the clashing forms. The figure kept moving back and forth and her gestures are left in the echoes. The arm went through a great many configurations. You can't really tell if it is up one way or down another way. The head was moved up and down and sideways and the anatomy was changed around. The figure was in a constant state of flux. I think the tracks of all those movements are left. It's an extremely animated surface. Bill's point was, if there's a face on

top then it's a figure. It was just the surface of a painting in different colors and forms. He'd think, well, breasts, but do them with a very free gesture, or the arms, but not in realistic terms. He worked on *Woman* for months, every day, all day. Yes, all day, every day. He worked on these one at a time—just all day, every day. Even the small ones. Even if it took a year. I should make the point here that on any given canvas, I saw hundreds of images go by. I mean, paintings that were masterpieces. I would come in at night and find thy had been painted away. And when he'd finish one he would start another immediately. No vacations. Not even Sunday. When he wanted an arm to go up or down, he'd make drawings. He'd ask me to pose, or he'd have *Police Gazettes*, with their photos of women, and he would thumb through to find some arm that he could work from.

On *Study for Woman* [1950], a small painting, he pasted a mouth that he cut out of a magazine. He used that as a key to this painting as he did with some of the larger ones. When he worked, he was extremely tenacious and just worked on that one surface. He did not move from painting to painting, but worked on the one painting until it was either destroyed and painted away or allowed to exist.

Bill was very irritated with his facility and he was constantly struggling against it, going against the grain. He didn't like things to come easy. He wanted to have his image evolve out of a sense of conflict. In fact, it wasn't so much that he wanted it to come out of a sense of conflict as that he was born with divine discontent. I don't know where the term "divine discontent" came from, but Bill had it.

Often when he worked on these paintings of women, the image would become obliterated by the very forms that were delineating the figure. As I said before, Bill said if you have a head in it, then the rest of it is a figure. His brushstrokes began to become larger and more turbulent and the charcoal more drastic.

Bill's paintings during the fifties kept enlarging in scale—both the actual size of the paintings and the size of the brushstrokes and the sweeping forms—the huge gestures. When he finished the painting titled *Bolton Landing*, in 1947, it reminded him of a visit he had made to David Smith's place up in Bolton's Landing in the Adirondacks. Somehow, it just echoed David Smith's forms. He always named his paintings by something that triggered him at the end, when he was finished.

The painting called *Rosy Fingered Dawn at Louse Point* [1963] is characteristic of Bill's kind of humor. The year, 1963, was the one he really moved completely from New York City to East Hampton, and the effect that living near the seashore and living out in the country had on Bill's paintings was a heightened attention to the quality of light in color. Huge

areas that just express light and much less of a stress on contours. The city paintings were very congested and full of close forms and compacted areas, but these paintings were unleashed. It was almost the feature of light caught up in the pigment of the sweeping strokes.

The ocean was a very important presence in Bill's paintings of the seventies and they began to have a turbulence like the sea. In his paintings of the seventies, there is much more viscosity. The paint slides around much more. For one thing, Bill began to change the ratio of the medium to his paint. He used a lot more oil and the paint strokes slid into one another. Of course, it wasn't that cut and dried, but somehow in the back of his head there was a consciousness of the ocean and the quality of the light around the ocean affected his palette and his way of working.

LaGuardia in Paper Hat [1972] referred to Mayor La Guardia whom we used to listen to on the radio in the early forties and Bill always found him very delightful and droll. Somehow he just felt that the painting was an image of La Guardia.

The title of the painting *Dream of Children Come from Seagulls* [1975], again, is very characteristic of Bill's fancifulness.

The painting titled *Woman Accabonac* [1966], like the one of La Guardia, is very viscous. It looks slashed on. Often people don't realize the tremendous discipline that goes into a painting like this because it looks so arbitrary. But Bill would paint it out and do it over and over again to get the exact gesture that he wanted, not that he knew the gesture beforehand, but he knew it when he finally arrived at it.

In the painting *Pirate* [1961], which is now owned by the Museum of Modern Art in New York, he developed a new approach to the surface and, again, as in the very early works, the surface became smooth. At the end of each day, he now scooped off the paint. He troweled it off, and left the surface of the canvas absolutely flat. Often, too, he flattened newspapers to drink up most of the oil. But the important part of his technique now was to scrape off the surface of the paint, which allowed him again to work on a painting for months. Here, he returned to some of the contours of earlier work against large areas of paint.

When Bill worked on his paintings and got stuck, he'd pull out his drawings. He made hundreds and hundreds of drawings. Areas in the paintings and the drawings would then take on a life of their own. He used an eraser the way he used a paint brush. As a matter of fact the eraser was very, very important in Bill's approach to drawing and his way of carrying through. Also, the darker areas of his drawings always have a sense of the flow of paint, as seen in the drawing *Five Women* [c. 1952]. I don't think there's another artist in the twentieth century that has turned out as many

drawings as Bill did throughout his life. It was just his occupation, part of his painting, part of his thinking that went on constantly. For all the paintings and their many stages, there were always drawings that were very crucial to each stage of the paintings. He would work on a drawing, often for a week, in the same way that he worked on his paintings, but where in the painting he would obliterate an area of pigment, in the drawing he would erase or slash through the image.

An important area of Bill's drawings were pastels. He used pastels the way he used a pencil, always directional. He did, of course, with pastel add an element of color that he would not have had with charcoal or pencil. Pastel was his only lightweight medium. He never used watercolor, for instance, nor ever used acrylic paint. He used only pencil, crayon, pastel, ink occasionally, and oil paint. Often in his pastels, color would just be an echo, but its importance was more in terms of the direction of the forms. *Woman* [1951], done in charcoal and pastel on paper, has the complexity of some of those paintings and it makes it clear what the struggle was.

Bill's drawings, like his paintings, underwent changes. He, as I've often mentioned, constantly had to figure against his own facility. He made a series of drawings with his eyes closed, or he tried to draw with his left hand. He didn't care for that, but using his right hand with his eyes closed, he was in control of the drawings. Oddly enough, they never really surprised him because he remembered where his hand had been. In *Three Figures* [1968] his line began to become more fluttery, like the viscous paintings. He used smudging the way he used paint. The drawings were always very closely related to the way he painted.

Every now and then Bill would have a theme in the back of his head that he would keep returning to in his mind, saying, "I'd like to do that." The idea of a crucifix interested him, I mean, absorbed him. And every now and then he made drawings—he tried to make a drawing of the Crucifixion as in the 1966 drawings *Untitled* and *Untitled (Crucifixion)*.

Selected Solo Exhibitions

Where the exhibition bore only the artist's name it is listed without a title. Unless otherwise stated galleries listed are in New York City.

1954
Stable Galley. April 6-27.
1956
Stable Gallery. April 23-May 21.
1957
Tibor de Nagy Gallery. November 12-30.
1959
Lyman Allen Art Museum, New London, Connecticut. *Retrospective.*
1960
Ellison Gallery, Fort Worth, Texas. *Themes of the Bull.*
Graham Gallery. *Arena.* December.
1961
Roland de Aenlle Gallery. *Drawn for Poems.* April 1-29.
1963
Graham Gallery. April 23-May 11.
1964
Peale House Gallery, Pennsylvania Academy of Fine Art, Philadelphia. *25 Portraits of J.F.K.*
1965
Charlotte Crosby Kemper Gallery of Art, Kansas City Art Institute, Missouri. *President John F. Kennedy: An Exhibition of Portraits and Oils.* February 12-March 7.
Graham Gallery. *JFK Portraits.*
1973
Montclair Art Museum, New Jersey. *Portraits by Elaine de Kooning.*

1975
Merwin Gallery, Illinois Wesleyan University, Bloomington. *A Retrospective of Portraits and Abstractions.* March 6-21.
Graham Gallery. *Recent Paintings,* November.
1979
Lauren Rogers Library and Museum, Laurel, Mississippi. *Bacchus, Works on Paper.* January 7-28.
1980
C. Grimaldis Gallery, Baltimore. *New Paintings.* November 5-December 1.
1981
Spectrum Fine Arts Ltd. *Hoops and Homers.*
1982
Phoenix II Gallery, Washington, D.C. *Italian Summers* (watercolors). January-February.
Gruenebaum Gallery. *The Bacchus Paintings.* October 9-November 6.
1983
Arts Club of Chicago. *Elaine de Kooning and the Bacchus Motif.* September 14-November 5.
1984
Vered Gallery, East Hampton, New York. August.

1986

Elaine Benson Gallery, Bridgehampton, New York. *Creatures.* August 2-27.

Gallerie Sylvia Menzel, Berlin, West Germany. *The Cave Series.*

Gruenebaum Gallery. *Time of the Bison.* May 3-31.

Guggenheim Gallery, Miami. *Cave Walls.* December 4-January 6, 1987.

1987

Flossie Martin Gallery, Radford University, Virginia. *Medium of Encounter.* February 27-March 26.

Wenger Gallery, Los Angeles. *Cave Walls.* March 7-April 21.

Vered Art Gallery. *Horns and Hooves.* September 5-24.

1988

Wenger Gallery, Los Angeles. *Grissaille Caves.* April 16-May 31.

Benton Gallery, Southampton, New York. *Sumi Cave Paintings.* August 13-September 11.

Fischbach Gallery. *Recent Paintings.* November 5-30.

Elliot Smith Gallery, St Louis. *Bacchus Paintings.* December 2-31.

1989

Guild Hall Museum, East Hampton, New York. *Portrait Drawings.* August 20-October 1.

1991

Brooklyn College Art Gallery, New York. *Elaine de Kooning Portraits.* February 28-April 19.

Washburn Gallery. *Black Mountain Paintings from 1948.* October 1-November 2.

Selected Group Exhibitions

1951
60 East Ninth Street. *Ninth Street Show.* May 14–June 2.

1953
Stable Gallery. *Second Annual Exhibition of Painting and Sculpture.* January 1–February 7.

1954
Stable Gallery. *Third Annual Exhibition of Painting and Sculpture.* January 27–February 20.

1955
Stable Gallery. *U.S. Painting: Some Recent Directions.* November 29–December 23.

1956
Walker Art Center, Minneapolis. *Expressionism.* January 22–March 11. Traveled to Institute of Contemporary Art, Boston; San Francisco Museum of Art; Cincinnati Art Museum and Contemporary Arts Center; Baltimore Museum of Art; Albright-Knox Art Gallery, Buffalo.
Stable Gallery. *Fifth Annual Exhibition of Painting and Sculpture.* May 22–June 16.
(organized by) The Museum of Modern Art, New York. *Young American Painters.* September 1956–July 1958. Not shown in New York. Traveled to Southern Illinois University, Carbondale; Michigan State University, East Lansing; Carlton College, Northfield, Minnesota; University of Manitoba, Winnipeg; University of Florida, Gainesville; Marshall College, Huntington, West Virginia; San Francisco Museum of Art; Portland Art Museum, Oregon; Henry Gallery, Seattle; Long Beach Municipal Art Center, California; Tucson Fine Arts Association; Atlanta Public Library; Lauren Rogers Library and Museum of Art, Laurel, Mississippi; Western Michigan College, Kalamazoo; Kansas State Teachers College, Pittsburg.
Carnegie Institute, Pittsburgh; *Pittsburgh International.*

1957
Jewish Museum of the Jewish Theological Seminary of America. *Artists of the New York School: Second Generation.* March 10–April 28.

1958
Dallas Museum for Contemporary Arts. *Action Painting 1958.* March 5–April 3.

1960
Tanager Gallery. (Elaine de Kooning, Katz, and Freilicher). February 19–March 11.
Walker Art Center, Minneapolis. *60 American Painters 1960: Abstract Expressionist Painting of the Fifties.* April 3–May 8.

1961
Graham Gallery. *Elaine de Kooning and Norman Bluhm*. April 11-29.
The New School. *The Creative Process*. May 16-June 10.
Whitney Museum of American Art. *Annual Exhibition of Contemporary American Painting*.

1964
The Art Institute of Chicago. *67th Annual American Exhibition: Directions in Contemporary Painting and Sculpture*. February 28-April 12.

1980
Hirshhorn Museum and Sculpture Garden, Washington, D.C. *The Fifties: Aspects of Painting in New York*. May 22-September 21.

1984
Phoenix Gallery. *Elaine de Kooning and Alice Neel*.

1985
Amarillo Art Center, Texas. *Eight Modern Masters*. April 20-June 23.

1987
New York State Museum, Albany, in association with the Smithsonian Institution Traveling Exhibition Service. *Diamonds Are Forever*. Traveled.
Picker Art Gallery, Colgate University, Hamilton, New York. *Twentieth Century Painting: Solomon R. Guggenheim Museum*. March 9-May 31.

1988
Newport Harbor Art Museum, Newport Beach, California. *Figurative Fifties: New York Figurative Expressionism*. July 19-September 18. Traveled to Pennsylvania Academy of the Fine Arts, Philadelphia; Marion Koogler McNay Art Museum, San Antonio, Texas.
Vered Gallery, East Hampton, New York. *The Americanization of Art*. September.

1989
University of New Mexico, Albuquerque. *'50s*. September 24-January 21, 1990.

Selected Bibliography

"Edwin Dickinson Paints a Picture." *Art News,* September 1949, 26–28, 50–51.

"Knaths Paints a Picture." *Art News,* November 1949, 36–39, 62–64.

"Hyman Bloom Paints a Picture." *Art News,* January 1950, 30–33, 56–57.

"Hans Hofmann Paints a Picture." *Art News,* February 1950, 38–41, 58–59.

"Andrew Wyeth Paints a Picture. *Art News,* March 1950, 38–41, 54–56.

"Albers Paints a Picture." *Art News,* November 1950, 40–43, 57–58.

"Kerkam Paints a Picture." *Art News,* February 1951, 42–45, 65–67.

"Gorky: Painter of His Own Legend." *Art News,* January 1951, 38–41, 63–65.

"David Smith Makes a Sculpture." *Art News,* September 1951, 212–15; reprinted in *The Art World: A Seventy-five Year Treasury of Art News,* ed. Barbaralee Diamonstein. New York: *Art News* Books, 1977, 212–15.

"Margule Paints a Picture." *Art News,* December 1951, 42–45, 55–57.

"Dymaxion Artist." *Art News,* September 1952, 14–17, 40–42.

"Diller Paints a Picture." *Art News,* January 1953, 26–29, 55–56.

"The Modern Museum's Fifteen: Dickinson and Kiesler." *Art News,* April 1953, 20–23, 66–67.

"Venus, Eve, Leda, Diana, et al." *Art News,* September 1953, 20–22, 54.

"Vicente Paints a Collage." *Art News,* September 1953, 38–41, 51–52.

"Reynal Makes a Mosaic." *Art News,* December 1953, 34–37, 51–52.

"Hyman Bloom." *Art News,* March 1955, 38, 66–67.

"Subject: What, How, or Who?" *Art News,* April 1955, 26–29, 61–62; reprinted in *Theories of Modern Art: A Source Book by Artists and Critics,* ed. Herschel B. Chipp. Berkeley: University of California Press, 1968, 571.

"Renoir: As If by Magic." *Art News,* October 1956, 43–45, 66–67.

"Stuart Davis: True to Life." *Art News,* April 1957, 40–42, 54–55.

"Pure Paints a Picture." *Art News,* Summer 1957, 86–87.

"A Cahier Leaf: Prejudices, Preferences, and Preoccupations." *It Is,* Spring/Summer 1958, 19.

"All-over Painting." Autumn 1958, 72.

"Two Americans in Action: Franz Kline & Mark Rothko." *Art News Annual,* 1958, 86–97, 174–79; reprinted in *The Art World: A Seventy-five Year Treasury of Art News,* ed. Barbaralee Diamonstein. New York: *Art News* Books, 1977, 289–95.

"Is There a New Academy." *Art News,* June 1959, 36.

"Statement." *It Is,* Autumn 1959, 29-30.

"Participants in a Hearsay Panel." *It Is,* Winter/Spring 1959, 59-64.

"New Mexico." *Art in America* 49 no. 4, 1961, 56-59.

"Franz Kline: Painter of His Own Life." *Art News,* November 1962, 28-31, 64-65; reprinted in *Franz Kline, Memorial Exhibition.* Washington, D.C.: Washington Gallery of Modern Art, 1962.

"Painting a Portrait of the President." *Art News,* Summer 1964, 37, 64-65.

Jackson Pollock: An Artists' Symposium," *Art News,* April 1967, 29, 63-64.

with Rosalyn Drexler. "Why Have There Been No Great Women Artists?" *Art News,* January 1971, 40-41, 62-68; reprinted in *Art and Sexual Politics,* ed. Elizabeth C. Baker and Thomas B. Hess. New York: Macmillan, 1973.

"Ten Portraitists: Interviews/ Statements." *Art in America,* January-February 1975, 35-36.

"Jeanne Reynal: Mosaic Portraits." *Craft Horizons,* August 1976, 32-35.

"The Art of Raymond Johnson." In Garman, Ed. *The Art of Raymond Johnson.* Albuquerque: University of New Mexico Press, 1976.

"A Recollection." Introduction to Edwin Dickinson exhibition catalogue. New York: National Academy of Design, 1982.

"de Kooning Memories." *Vogue,* December 1983, 352-53, 393-94.

"Lamar Dodd: The Open Heart." In Richard Schneiderman. *Lamar Dodd, The Heart.* Athens, Georgia: Georgia Museum of Art, University of Georgia, 1984.

"Edwin Denby Remembered." *Ballet Review,* Spring 1984, 29-33.

"A Stroke of Genius." *Horizon,* May 1984, 37-43.

"Busa's Festive Imagery." *East Hampton Star,* August 8, 1985.

with Lawrence Campbell, Guy C. Kaldis, and Paul Resika. In *Aristodimos Kaldis.* New York: Artists' Choice Museum, 1985.

Grateful acknowledgement is made to the following publishers for their permission to reprint the writings of Elaine de Kooning:

"Edwin Dickinson Paints a Picture," *Art News*, September 1949, 26-28, 50-51.

"Hans Hofmann Paints a Picture," *Art News*, February 1950, 38-41, 58-59.

"Andrew Wyeth Paints a Picture," *Art News*, March 1950, 38-41, 54-56.

"Albers Paints a Picture," *Art News*, November 1950, 40-43, 57-58.

"Gorky: Painter of His Own Legend," *Art News*, January 1951, 38-41, 63-65.

"Kerkam Paints a Picture," *Art News*, February 1951, 42-45, 65-67.

"David Smith Makes a Sculpture," *Art News*, September 1951, 212-15.

"Dymaxion Artist," *Art News*, September 1952, 14-17, 40-42.

"The Modern Museum's Fifteen: Dickinson and Kiesler," *Art News*, April 1953, 20-23, 66-67.

"Venus, Eve, Leda, Diana, et al." *Art News*, September 1953, 20-22, 54.

"Vicente Paints a Collage," *Art News*, September 1953, 38-41, 51-52.

"Reynal Makes a Mosaic," *Art News*, December 1953, 34-37, 51-52.

"Subject: What, How, or Who?" *Art News*, April 1955, 26-29, 61-62.

"Renoir: As If by Magic," *Art News*, October 1956, 43-45, 66-67.

"Stuart Davis: True to Life," *Art News*, April 1957, 40-42, 54-55.

"Pure Paints a Picture," *Art News*, Summer 1957, 57, 86-87.

"Two Americans in Action: Franz Kline & Mark Rothko," *Art News Annual XXVII*, 1958, 86-97, 174-179.

"Franz Kline: Painter of His Own Life," *Art News*, November 1962, 28-31, 64-65.

"Painting a Portrait of the President," *Art News*, Summer 1964, 37, 64-65.

"Jackson Pollock: An Artists' Symposium," *Art News,* April 1967, 29, 63-64.

Reprinted with the permission of ART NEWS ASSOCIATES.

"A Cahier Leaf," *It Is*, Spring/Summer 1958.

"Participants in a Hearsay Panel," *It Is*, Winter/Spring 1959, 59-64.

"Statement," *It Is*, Autumn 1959, 29-30.

Reprinted with the permission of Phillip Pavia, editor of *It Is*.